DIGITAL VISIONS

# DIGITAL VISIONS

## COMPUTERS AND ART

Harry N. Abrams, Inc., Publishers, New York

Everson Museum of Art, Syracuse

CYNTHIA GOODMAN

"CTM E 20" ©1986 Mark Wilson

*Editor:* Charles Miers
*Designer:* Michael Hentges

*For Micha and Dara*

Published in 1987 by Harry N. Abrams, Incorporated, New York. All rights reserved. No part of the contents of this book may be reproduced without the written permission of the publisher

Times Mirror Books

Printed and bound in Japan

Dimensions are given as height × width × depth. When no dimensions are given for a computer-generated image, it exists only in film or in print form (in which case, its size may vary). Software and hardware information have been given whenever available. All works are collection of the artist unless otherwise indicated. Captions and credits for illustrations reproduced on pages 1–7 are listed on page 187.

Library of Congress
Cataloging-in-Publication Data

Goodman, Cynthia.
  Digital visions.

  Accompanies a touring exhibition sponsored by the IBM Corporation and the National Endowment for the Arts.
  Bibliography: p. 188
  1. Computer art—Exhibitions.
I. International Business Machines Corporation.   II. National Endowment for the Arts.   III. Title.
N7433.8.G66 1987    700'.28'5    87–1084
ISBN 0–8109–1862–5 (hc.)
ISBN 0–8109–2361–0 (pbk.)

Copyright © 1987 Cynthia Goodman

This book is published in conjunction with the exhibition *Computers and Art*, organized by the Everson Museum of Art, Syracuse, New York (September 17–November 8, 1987).

This publication and exhibition were made possible by a grant from the IBM Corporation. Additional support was provided by a grant from the National Endowment for the Arts, and the David Bermant Foundation: Color, Light, Motion provided support for the publication.

# Contents

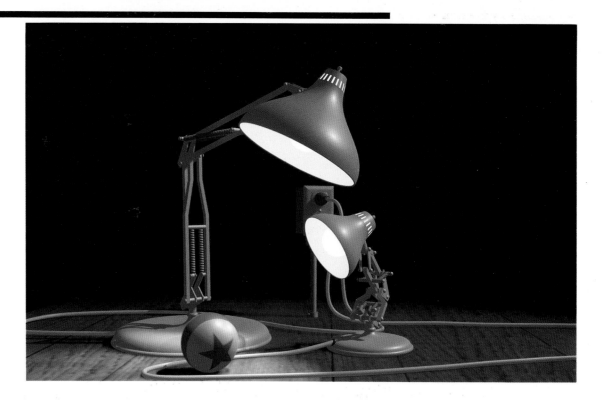

# Acknowledgments

Due to the foresight of Ronald Kuchta, director of the Everson Museum of Art in Syracuse, New York, this publication and the simultaneous exhibition were able to become realities. Dominique Nahas, curator at the Everson, coordinated the exhibition with eternal good cheer. Sandra Trop, associate director, Kristine Waelder, development officer, Thomas E. Piché, publications manager, and John Rexine, registrar, are all thanked for their efforts.

On behalf of the Everson Museum and myself I would like to extend our deep gratitude to the IBM Corporation for the generous sponsorship that made the book and the exhibition possible. I am also most grateful for the support of the National Endowment for the Arts. The David Bermant Foundation: Color, Light, Motion is also thanked for financial assistance toward the preparation of this publication.

1. John Lasseter, Bill Reeves, Eben Ostby, Sam Leffler, and Don Conway. *Luxo Jr.* 1986. Frame from film. Copyright 1986 by Pixar. All rights reserved. "Luxo" is a trademark of Jac. Jacobson Industries

*One of the sensations of the 1986 SIGGRAPH Film and Video Review,* Luxo Jr. *demonstrates the amazing capabilities of computer animation. The two extraordinarily realistic lamps play a friendly game of ball until Luxo Jr.'s toy accidentally breaks. This brilliant animation is able to convey emotions of compassion and remorse with the mere dip of a metallic head. The technique of "self-shadowing," in which a computer-generated image accurately projects shadow sources upon itself, is one of several remarkable technical achievements in this film.*

*Hardware:* Pixar Image computer. *Software:* Pixar proprietary

Numerous individuals have generously shared their technical expertise and read sections of this manuscript for technical accuracy. From the very inception of this project four years ago, Darcy Gerbarg has answered every query I posed and offered her help at all times. I am most deeply indebted to her unselfish assistance and encouragement. Her ideas for the book as well as the exhibition have been major contributions. I am also grateful to Gene Miller for his excellent technical suggestions. Louise Ledeen, Christine Barton, Vibeke Sorensen, Bill Etra, and Dean Winkler were extremely helpful with the video and animation passages. I also thank Arno Penzias, Joel Thome, Natalie Leighton, Wen-Ying Tsai, Phyllis Tuchman, and Russell Kirsch for their advice. Billy Klüver provided much information about the activities of his organization, E.A.T.

My special thanks are extended to all the artists in the show. Their suggestions have led to the discovery of other artists who are working with computers. Both the Everson Museum and I also express our deep appreciation to the many lenders for their generosity. We would also like to acknowledge the enthusiastic participation of the other museums on the exhibition's national tour and to thank key members of their staffs: at the Contemporary Arts Center, Cincinnati, Dennis Barrie, director, and Sarah Rogers-Lafferty, curator; at the Wight Art Gallery of the University of California at Los Angeles, Edith Tonelli, director; at the Dayton Art Institute, Bruce Evans, director, and Pamela Houk, curator; and the IBM Gallery of Science and Art, New York City. I would also like to thank Phillip S. Mittelman, John Shore, and Lynn Gordon for their assistance with the tour.

I have been most fortunate to have had Marci Rockoff and Theresa Rhodes as Great Lakes College Association museum interns. They provided invaluable assistance in the accumulation of photographic materials and research for the publication. Theresa Rhodes also carefully typed many sections of the manuscript. Veronica Herman and Faith Schornick also were helpful assistants. Anne Edelstein, my literary agent, generously offered advice.

At Harry N. Abrams, Inc., Michael Hentges, the book's designer, immediately responded to the project with enthusiasm and verve. His insightful understanding of the subject greatly enhanced this publication. Sherry Knable gave invaluable advice on the quality of materials to be reproduced in the book. Finally my deep thanks must go to Charles Miers, who took great personal interest in this publication. It is due to his receptivity to the subject that the book has been realized. His careful and sensitive editing made it a pleasure to work with him.

As always, it has been the support and encouragement of my husband, Micha Ziprkowski, that made my myriad tasks possible. My most profound thanks are due to him.

C.G.

# I. *Introduction: Art in the Computer Age*

Computers are making unprecedented aesthetic experiences possible and revolutionizing the way art is conceived, created, and perceived. The profound impact of digital technology on the art of the last twenty years and what it portends for the future is only beginning to be appreciated. Although the first computer-aided artistic experiments took place just twenty-five years ago, computers have since been applied to every facet of the artmaking process. No other medium has had such an extraordinary effect on all the visual arts so soon after its inception. Painters, sculptors, architects, printmakers, filmmakers, and video and performance artists, irrespective of their stylistic creeds, are responding to the rapidly developing possibilities of the new, quickly evolving technology and the dazzling array of options computers offer them and the art-viewing public alike.

Not long ago, artists were thrilled when quick-drying acrylic paints were perfected. Today, pigment is not even necessary; electronic color creation can be achieved instantaneously, entire compositions can be recolored in seconds, and lighting and positioning can be transformed with the mere touch of a light-sensitive cursor. Some computer systems offer palettes of over sixteen million colors, the maximum number discernible by the human eye on a video monitor. Other intriguing options that lure artists to experiment with computer-imaging techniques include the manipulation of compositional scale and format in ways for the most part impossible in physical mediums. Live video images can be transformed by electronic paint, and pictures may be saved at any stage of their creation, referred to later, or restructured without irreversibly altering the original art. Software programs for the three-dimensional modeling of images have enabled artists to create representations of astonishing verisimilitude that can be rotated, relocated, and seen from any viewpoint or in any perspective on the computer screen, as if they are objects in actual space. It is almost beyond conception that such amazingly realistic pictures — endowed with textured surfaces and lighting effects — exist only as binary digits stored in the memory of a computer.

The interactive abilities of computer systems hold the key to radical changes within the artmaking process. Ingenious developments of this potential by artists in every field are producing unique and previously inconceivable art forms. Through electronic implementation, sculptures and environments can be acti-

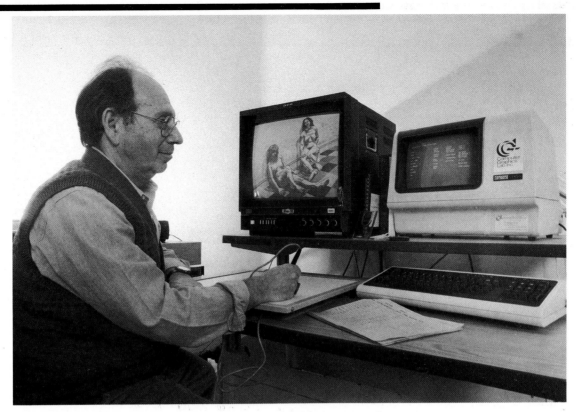

vated to follow programmed patterns of movement or even to respond to external stimuli. (Interactive transformations occur in "real time"; that is, the processing happens as soon as the stimuli are received, and the results are visible immediately.) In the case of some interactive installations, the presence of the artist is not required for the viewer to be both a participant in and observer of the creative process. Once an artist establishes certain boundaries, the interactive behavior of a piece is limited only by the inventiveness of the spectator. Such works may be capable of exhibiting a range of responses so enormously varied that it is virtually impossible to witness the same interaction twice. In a paradigmatic union of art and science, artist, viewer, and computer become collaborators in a cycle of both controlled and surprising events.

The new technology is affecting every aspect of our art-viewing lives. Calling up a painting on a computer screen may well become as commonplace as going to a museum. Digital art may soon be transmitted via a subscription channel on

2. Philip Pearlstein at work on the New York Institute of Technology's Images paint system. 1984. Photograph by Fred R. Conrad, *The New York Times.* Copyright 1984

*Pearlstein's experimentation with computers was initiated as a means of demonstrating his drawing process on video-tape for an educational videocassette about his work. The painter is one of many well-known artists who have recently experimented with computer-imaging techniques. With the help of a technical assistant, Pearlstein spent close to one hundred hours learning the system and becoming comfortable with the "mouse" as a drawing implement. Movement of the mouse on a digitizing tablet is recorded on the computer screen. Palette and type of brush are selected electronically from a menu of options. Although Pearlstein rented time on an elaborate commercial system, similar capabilities are widely available on home computers.*

11

television or rented for the evening as movies are today. Nam June Paik, the acclaimed pioneer of video art, envisions television screens the size of murals hanging on our walls to display video images as animated works of art.[1] Art will be sold like record albums, he predicts, and there will be a top ten chart of the most popular hits.

Developments in the computer field are occurring at an almost inconceivable pace. Eagerly anticipated capabilities, previously only possible on sophisticated "high-end" systems, are announced as within reach of the personal computer one year and widely available the next. Established guidelines for software and hardware hold true for minimal amounts of time. Major breakthroughs continually make the machines more capable, quicker, less expensive, and easier to use.

It must be noted, however, that numerous state-of-the-art capabilities are still costly to produce and require highly sophisticated programming and powerful computing systems. Many of the more advanced effects are therefore developed for television and motion pictures, whose budgets are commensurate with the computational requirements. In feature films, computer-generated special effects are increasingly commonplace, often convincingly situating actors in the unfamiliar regions of outer space. Yet, even supercomputers are still put to the test in the realm of digital-image synthesis. Images of photographic realism, in particular, are among the computer's most impressive technical accomplishments to date. The twenty-five-minute, ominously lifelike sequence in Lorimar's film *The Last Starfighter*, for example, required more than a quadrillion calculations.

Although enthusiastically welcomed by the film and broadcasting industries, computers have not been readily adopted by most artists. With their enormous potential as visualizing tools, the reticence of the art community is somewhat perplexing. Musicians and poets were considerably more accepting. As early as 1957, Lejaren A. Hiller programmed an electronic composition, "Illiac Suite," on the ILLIAC computer at the University of Illinois at Champaign. For musicians who had long worked with and been frustrated by the imprecision and unreliability of analog systems, the digital computer was welcomed as a means of creating highly defined sounds. Poets, who are always searching for novel means of restructuring language, were also quick to grasp the ability of computer programming to offer them unanticipated combinations of words. The enthusiasm and interest with which fine artists are just now responding to the mention of computers is as profound as their disinterest and antagonism only a few years ago. As "a digital sketchpad," an "electronic thinking cap," or a collaborative partner, artists as diverse in their interests and styles as Kenneth Noland, Jack Youngerman, and Nam June Paik are anxious to have access to computers that can realize some of their artistic goals.

This overwhelming change of attitude reflects the impact of computers on all aspects of our daily lives — a phenomenon directly attributable to recent develop-

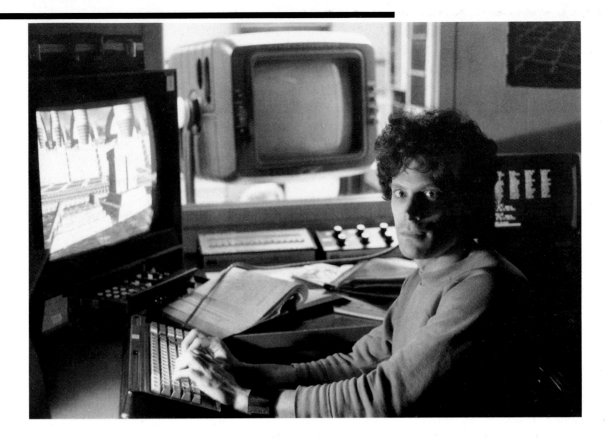

ments in microelectronics and the consequent impact on the cost of hardware. According to sculptor Milton Komisar, the only way he was able to acquire a personal computer in 1973, when he first became interested in making computer-controlled light sculptures, was to build one from a do-it-yourself kit, a challenge only a few artists were up to.[2] With the introduction of the microprocessor in the late 1970s, the capabilities available today on relatively inexpensive computers, costing as little as fifteen hundred dollars, are commensurate in some ways with those that existed only on mainframes, costing one hundred thousand dollars and up, a few years ago. Moreover, the enormous mainframes occupied entire rooms and required a large staff to maintain them. Their settings did not appeal to most artists, who understandably preferred the comfort of their studios to sterile laboratories and the seemingly labyrinthine procedures that often accompanied admittance to sophisticated computer systems. Both the ambience and the manner of working in an automated environment conflicted disturbingly with painters and sculptors who were used to realizing their creative ideas in pencil and paint or clay and metal.

3. David Em in his working environment at the California Institute of Technology's Jet Propulsion Laboratory. 1983

*Em makes computer-generated pictures using state-of-the-art technology. The typical daily business of this laboratory involves classified research for NASA, but for almost ten years Em has had access to the lab's programs and equipment for his artistic explorations.*

Komisar's example may seem extreme; before the late 1970s, however, computers were very much restricted to governmental, industrial, and academic workplaces. Even if an artist ingeniously gained access to a computer system, the successful realization of an image was a direct correlation of his ability to convey an artistic concept to a programmer, who then attempted to find a mathematical equivalent for it. No longer are such collaborations necessary. The personal computer software on the market today is "user friendly"; that is, easy for anyone to operate. Furthermore, the applications are diverse enough for artists to use regardless of stylistic constraints.

The potential applications of computers to artmaking are much broader than might be suspected. For some artists, the computer is merely a tool that facilitates design decisions; for others, the artwork itself assumes the form of direct computer output; still others think of computer output as the point of departure for further elaboration and execution in an entirely different medium. The most frequent practice, of course, is the generation of images on a screen that are then retrieved from storage in the digital memory of a computer and output in a tangible form called "hard copy." Hard-copy devices can produce images in many formats, including film, printer drawings, plotter drawings, color Xeroxes, textiles, and video—each with unique aesthetic values. Moreover, it is increasingly common for computer-generated imagery to be translated into traditional mediums. For a growing number of artists who have chosen to develop their images with computers, the thrill of filling an area with color by choosing the appropriate commands from a menu of options is still not comparable to squeezing pigment from the tube and being conscious of the smell and texture of paint as it is spread across a surface. Consequently, they have found ingenious ways to reintroduce the touch, the physical contact, and the immediacy of materials they miss when working with computer technology. One solution is to project a computer-generated image onto canvas and then to paint it by hand; another is to enhance hard copy with watercolor or pastel. Traditional mediums are used, and the artist benefits from the new range of design possibilities the computer offers.

Until recently, most artists who used computer technology considered themselves part of a relatively closed and small community. Today, a computer art community still exists, but its mandate is broad and its membership vast. Literally thousands of artists who consider the computer their primary medium attend yearly meetings of SIGGRAPH (Special Interest Group for Graphics of the Association for Computing Machinery) and NCGA (National Computer Graphics Association), which are to the computer graphics world what the annual meetings of the College Art Association are to traditional artists and art historians. SIGGRAPH's ranks swelled from five hundred attendees at its first conference in 1974 to more than twenty-five thousand in 1986.[3]

The most eagerly awaited events in the computer graphics world are the film

and video reviews at the SIGGRAPH and NCGA conventions, when the latest computer animation techniques are unveiled to the rousing cheers and thunderous applause of the appreciative audience. Since the common goal of much high-end research is the simulation of reality through three-dimensional modeling techniques, last year's sensation was an animation called *Luxo Jr.* (plate 1), featuring two Luxo desk lamps endowed with humorous personalities and the ability to communicate with each other. "Reality is a convenient measure of complexity," says Alvy Ray Smith, one of the developers of the computer that Pixar specially designed to create the photographic-quality, computer-animated imagery on which this film was made. "But why be restricted to reality?"[4]

That the term "computer graphics" is applied to animations such as *Luxo Jr.*, flying logos that announce the national news on television, and electronically generated images of nudes created by Philip Pearlstein is understandably confusing. Indeed, the mention of computer art usually conjures up widely seen commercial images rather than the less-publicized fine arts applications. Although the tools for commercial and artistic work may be identical and the look at times strikingly similar, this book's selections focus only on the artistic applications of computers. With the elimination of exclusively commercial work, some basic criteria can be established to evaluate this new medium strictly as an artistic tool. (That the boundaries between art and technical virtuosity are not more clear is largely a function of the structure of the computer graphics world, in which some of the most spectacular digital imaging is still being done at the Los Alamos National Laboratory in New Mexico, the IBM Thomas J. Watson Research Center in Yorktown Heights, New York, the Lawrence Livermore National Laboratory in California, and the Jet Propulsion Laboratory of the California Institute of Technology. It is these facilities that are equipped with supercomputers and research scientists who are developing the most advanced imaging capabilities for the entire field.)

Although the concern of this book is the fine arts, the work of some scientists is included in recognition of the fact that the arts are still inextricably intertwined with the achievements of computer researchers. There is a certain degree of irony in this situation. The same scientists who have done so much to advance computer graphics have also contributed to the confusion and criticism of the discipline. Indeed, rejection of computer art was initially based as much on the dubious aesthetic quality of early computer graphics accomplishments by scientists, who were mislabeled as artists, as on a fear of the machine itself. The computer's reception has been like that of photography's in the nineteenth century. Just as photography was initially scorned and engendered vicious hostility, only to gain increasing acceptance and widespread application, the use of computers by artists will inevitably follow suit. Artists have always experimented with the latest tools, and computers are now especially conducive to artistic improvisation.

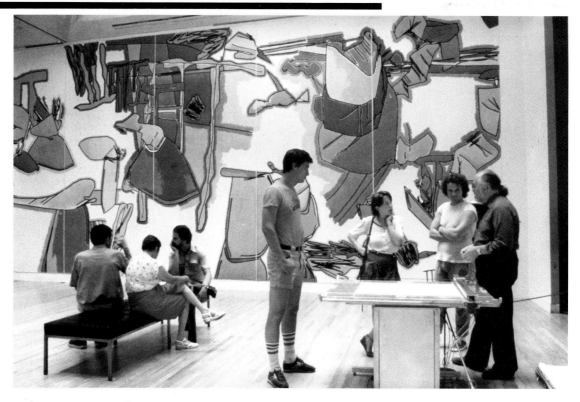

Before being accepted unquestioningly as a legitimate artistic medium, some of the challenging aesthetic and philosophical issues raised by computer-generated art must be solved. The most haunting questions concern the impact of the technology on the artist, the creative process, and the nature of art. More specifically, it is asked, to what extent do the available systems and software determine the results? Is an artist creatively restrained by the options available to him, either by available data or by the way in which it may be retrieved? Are new aesthetic criteria required to evaluate computer-aided art? Is the value of some computer art decreased by its non-unique nature and the fact that it may have been executed by a machine instead of by hand? Are all works displayable in hard copy merely multiples?[5] It is too soon for answers to these questions. Recent accomplishments, however, clearly demonstrate the ability of an individual working with computer technology to assert a distinct form of creative expression.

In spite of misconceptions, computers have had an impact on all the art forms and movements prominent in the last twenty years, including Conceptual Art, Earth Art, photo-realism, Performance Art, Minimal Art, holography, and robo-

4. Installation view of Harold Cohen's drawing machines at the Tate Gallery, London. 1983. Photograph by Becky Cohen. Copyright 1983

*Cohen (foreground) has been a leading practitioner of computer-generated art since the late 1960s. Strongly influenced by the principles of artificial intelligence, the artist has created computer-driven drawing machines that produce endlessly variable series of compositions rather than simply following a programmed design. Cohen often includes his elaborate computer system in museum exhibitions. In the background is a hand-painted enlargement of one of his computer drawings.*

tics, as well as the more traditional genres of portraiture, landscape, and still life. Moreover, many artists who were seduced by the seemingly limitless possibilities of electronic media have reevaluated and transformed their total approach to the artmaking process. For these artists, the commitment to digital technology is philosophical as well as aesthetic.

The challenge of artificial intelligence is but one area that continues to inspire provocative research. Sculptural environments and computer graphics systems are being developed to simulate the intellectual logic and methodology of humans. British artist Harold Cohen has taken the concept of an intelligent machine in a direction that embodies the dreams of both futuristic enthusiasts in the artificial intelligence field and the nightmares of many traditional artists. He has programmed a computer to control a mechanical drawing machine that is quite capable of making remarkably naturalistic drawings on its own.

With the increasing accessibility and affordability of computers, a growing understanding of the potential applications, the development of new software tailored to artistic requirements, and a generally more open-minded attitude about their use in creative endeavors, computers in all likelihood will soon be unchallenged as one of the implements available to an artist for the creation of a work of art. Research and development in computer graphics is proceeding apace around the world, suggesting future developments in electronic imaging capabilities that will be adaptable to the creative needs of virtually any artist.

## II. *Art and Technology: The Uneasy Liaison*

It is difficult to pinpoint the first time that a computer was used to make art. Not surprisingly, the first graphic accomplishments with computers were achieved by scientists, mathematicians, and engineers, who had access to powerful mainframes and were equipped with the technical skills necessary to master the cryptic machine-user dialogue (or "interface," in computer terms). Communication with a computer was often so difficult that producing a picture at all was worthy of accolade.

The pioneering "oscillons" or "electronic abstractions," created in 1950 by Ben F. Laposky, a mathematician and artist from Cherokee, Iowa, are considered to be the first graphic images generated by an electronic machine.[1] Laposky, who is still developing his oscillons today (plate 5), manipulated electronic beams across the fluorescent face of an oscilliscope's cathode-ray tube (similar to a television tube) and then recorded the abstract patterns using high-speed film, color filters, and special camera lenses. Variations in the intricacies of the patterns were achieved by modifying the basic electric wave forms in these compositions with different electronic input.

Laposky used an analog device. Most information machines, including the television, telephone, and video tape recorder, transmit information that imitates, or is analogous to, a pattern occurring in nature. Telephones, for instance, simply imitate with electrical waves the sound waves made by a human voice.[2] In such systems, numerical data is represented by analogous physical magnitudes, or electrical signals, that produce a continuous wave form. Laposky's images symbolized this relationship, but behind their elegant simplicity (if somewhat limited visual potential) was extreme technical ingenuity. Analog systems are difficult to program, and because the wave forms are prone to interruption by noise and drifting, it is virtually impossible to replicate a set of conditions. Today's computer imagery is created almost exclusively on digital machines, which process data in the form of discrete binary digits. They provide better control, and the effects are more easily reproduced.

In the decade following Laposky's first oscillon, there were important technological breakthroughs that suggested wider visual possibilities, but the use of computers for image making remained a purely scientific pursuit. The Whirlwind, a mainframe machine built at the Massachusetts Institute of Technology in 1949, was among the earliest computers to have a display screen like a television

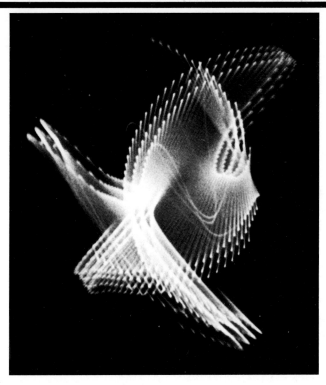

monitor. One of the first programs written for it pictured a ball bouncing up and down on the screen, losing height with every bounce as if it was affected by gravity. The magical capabilities of the Whirlwind were given a public airing in 1951 on Edward R. Murrow's popular television show "See It Now." The bouncing ball trick was followed by a graphic projection of mathematical information about a rocket, telephoned in live from the Pentagon. The highly successful demonstration ended with the computer playing "Jingle Bells." According to one viewer:

*Probably the most interesting part of the interview occurred when the rocket trajectory appeared on the screen. What it demonstrated was that (1) computer graphics might be used in practical ways, and (2) an obvious practical use of computer graphics was in transforming complex mathematical information (such as the mathematical description of a rocket trajectory) into a simple picture.*[3]

Although the Whirlwind showed that graphic illustrations of mathematical data were possible on the computer screen, there were still only limited means of generating the images in a tangible form. The problem of reproduction — of such importance to artists today — was then of little concern. "Hard copy" (as opposed

5. Ben F. Laposky. *Oscillon Number Four — Electronic Abstraction.* 1950. Photograph, $10 \times 8\frac{1}{8}$"

*Laposky's "oscillons" were the first graphics made on an analog computer. For many years, they represented the most advanced achievements of what was known as computer art. His oscillons are photographs of electronic wave forms displayed on a cathode-ray tube.*

　　*Hardware:* oscilloscope with sine-wave generators

to "soft copy," which exists in image form only on a video screen and disappears when it is turned off) could be "retrieved" by photographing the monitor—a method considered more than adequate to capture the type of data on the screen.

Producing permanent images in the 1950s, "before the concept of computer graphics existed," was also accomplished by "computer doodlers."[4] Charles Schultz's cartoon character Snoopy was a favorite subject for the doodlers, who created their pictures by sending coded characters to a teletype printer—producing images that were no more sophisticated in appearance than typewriter art.[5]

Shortly after Whirlwind's debut, a method for feeding pictures into a computer by scanning them on a rotating drum with a photoelectric cell and then processing the data in various ways was developed at the U.S. National Bureau of Standards on the Standards Eastern Automation Computer system. According to Russell A. Kirsch of the National Bureau of Standards, this picture-processing technique was revolutionary because it was "the first time that a computer could see the visual world as well as process it." The first image-processed picture produced on this system in 1957 was of Kirsch's baby son.[6] These unpretentious beginnings notwithstanding, image processing became a key component in the development of computer-generated pictures.

In 1959, the CalComp digital plotter, the first commercially available drum-plotting mechanism, ushered in the era of computer graphics. A plotter is a computer-driven mechanical drawing machine capable of delineating linear configurations. The data that the plotter follows are stored in the computer in the form of mathematical coordinates. In some systems, the robotic drawing mechanism moves over a flat paper surface like a mechanical arm on a drafting board; with other plotters, the stylus moves in straight lines across a revolving cylinder with a single sheet or roll of edge-perforated paper wrapped around the drum. The stylus can be instructed to interrupt its drawing to move to a new point on the picture plane. On still other plotters, the paper is moved but not the pen. Choices of color as well as thickness of pens and paper are available. (Today, entirely automated plotters can change nibs and inks as the program commands and can even be equipped with airbrushes.) On most plotters, once the mathematical calculations necessary to produce the design are complete, the size of the image to be output can be manipulated according to the size of paper, canvas, or other desired surfaces. In the 1960s, plotters offered practical possibilities and diverse hard copy alternatives for artists; but, like the computers that controlled them, they were restricted almost exclusively to industrial use.

It was William A. Fetter, a researcher with the Boeing Company in Renton, Washington, who coined the term "computer graphics" in 1960 to describe his purely technical, computer-generated plotter drawings of an airplane cockpit. In order to design a limited space that would be efficient, economical, and still

manageably comfortable for the pilot and copilot, Fetter wrote a computer program that instructed a plotter to draw all the possible positions they could occupy in such an area.

Although Fetter used a plotter with only technical aims in mind, "computer graphics" became a catchall designation. Any graphic work produced with the assistance of a computer was grouped under this confusing misnomer. Little distinction was made between graphics created by the pioneering artists who ventured into the technological domain in the mid-1960s and those of functional application made by scientists and mathematicians, whose computer-generated images were fascinating but not intentionally artistic and frequently of questionable aesthetic merit.

The work of most scientists and artists capitalized on the number-crunching feats computers excel at. Early computer graphics were difficult to program, computer memory was limited, and therefore visual options were restricted. The only software and machinery available were designed for the mathematical and engineering problems that the machines were developed to handle. Artworks and scientific studies alike were based primarily on the effects achieved by the transformation of a linear configuration through one or more mathematical functions. The mathematical processes most frequently used were randomness (that is, programming the computer to produce unpredictable results within a framework of established parameters); iteration (the repetition of an operation with slight changes at each repetition); and interpolation (the transformation of one linear image into another through the calculation of a variable number of new values between two existing values).

A major breakthrough for both scientists and artists occurred in 1962 when Ivan Sutherland completed his now-famous doctoral thesis at MIT in which he defined his Sketchpad system for interactive computer graphics (plate 6). With Sketchpad, the user could draw directly on the cathode-ray tube (CRT) with a light pen — a photoelectric cell inside a penlike device. Any movement of the pen across the monitor was demarcated on the screen by a path of light. The system had many drafting capabilities. Once two lines were drawn, a simple command, given by pushing a button, made the lines parallel or of equal length. A line could be instructed to join two points, or a circle could be drawn about a center point with a given radius. Simple geometric shapes could be rotated and relocated. The system even had a memory that could store and recall the forms. A film was made showing Sutherland operating Sketchpad that "became something of a cult object; everyone who was anything in the world of computers used to have a copy and would show it to the uninitiated at the drop of a hat."[7]

Sutherland's research was conducted primarily for engineering purposes. Funding for the development of interactive computer systems came largely from the

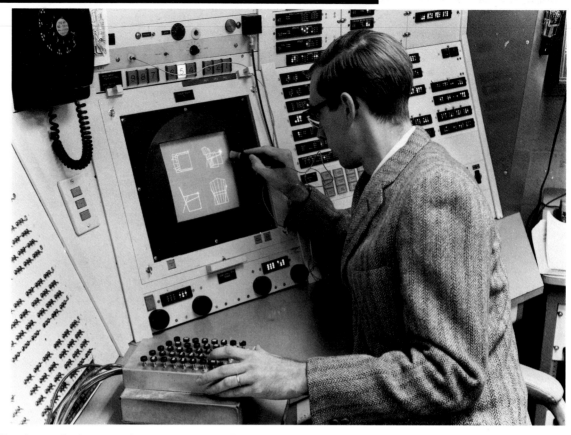

military, specifically for a flight simulator to train pilots, plan and rehearse strategy, and test expensive air force equipment without the pilots ever leaving the ground. The potential uses of computer graphics were quickly grasped by the Defense Department, who supported most of the early developments. As one observer recalled: "Almost all of the intriguing new art forms, the fascinating television commercials, and the incredible movie special effects that have become so entwined with our culture actually had their origins in military research."[8]

In 1963, the trade periodical *Computers and Automation* announced the first competition for computer graphics in which the winners were to be chosen on the basis of aesthetic merit instead of design practicality. Although there was minimal response to the announcement, the contest was considered an important event for those in the field with artistic aspirations. Perhaps not surprisingly, the first- and second-place winners were entrants from the U.S. Army Ballistic Missile Research Laboratories in Aberdeen, Maryland. First prize went to a plotter drawing of a "splatter pattern" and second prize to a plotter drawing of a stained glass window generated on the mathematical principle of the snowflake curve.

6. Ivan Sutherland using Sketchpad, the first truly interactive computer graphics system. 1963. Photograph reprinted with permission of Lincoln Laboratory, Massachusetts Institute of Technology, Lexington, Massachusetts

*The user of Sketchpad, the precursor of all modern interactive computer graphics systems, was able to draw with a light pen on the computer screen and see the results almost immediately.*

Although the images were significant more for their mathematical ingenuity than for their artistic achievement, the lofty recognition that art could be made with a computer had been attained.

Two years later, the idea of computer art began to receive general public attention both in the United States and Europe. Three mathematicians, Frieder Nake, A. Michael Noll, and George Nees, arranged the first exhibition of computer-generated art at the Technische Hochschule in Stuttgart, West Germany. That same year, the first exhibition of digital graphics in the United States was shown at the Howard Wise Gallery in New York, a gallery well known for its receptivity to and encouragement of technologically advanced art. Appropriately, the invitations for this historic exhibition were printed on punch cards used to input data and programs into the early computers. On display were photographic enlargements of microfilm plotter output conceived by Noll and Bela Julesz, both of whom worked at the Bell Telephone Laboratories in Murray Hill, New Jersey — a leading center of computer graphics, computer animation, and electronic music research and development since the early 1960s. That the exhibitors at the Wise Gallery were scientists and not artists was as revolutionary at the time as the fact that their works were drawn by a microfilm plotter instead of by hand. Even the

7. George Nees. *Computer Sculpture*. 1969. Aluminum, 40 × 40 × 1½″. Stadtisches Museum, Abeitberg Mönchengladbach, West Germany

*This relief was cut out of aluminum by a computer-controlled milling machine following the instructions of a program written by Nees. It was one of the first works of art made in this manner.*

*Hardware:* Siemens 4004 computer. *Software:* by the artist

background music for this exhibition was computer-generated, programmed at Bell Labs by research scientists John R. Pierce and Max Matthews and electronic composer James Tenney, who were using computers to research sound.

Noll and Julesz openly recognized the limitations of the system they were using: there were no color capabilities, and their only output device was a microfilm plotter capable of drawing pictures composed entirely of linear elements directly onto 35mm film, which was then processed into black-and-white prints. Included in the exhibition was Gaussian Quadratics, an experimental series Noll had begun in 1963 (plate 8). In the series, Noll investigated the visual effects of programmed randomness. Lines were instructed to zigzag across a plane with their vertical end points precisely stipulated, but the horizontal positions were generated with a certain degree of randomness. As the programmer, Noll had a fairly good idea of what the plot would look like; the exact composition, however, was always something of a surprise. Consequently, Noll insisted that the true work of art was the generating program rather than the computer-generated

8. A. Michael Noll. *Guassian Quadratic.* 1965. Photograph, 11 × 8 ½". Copyright 1965 by A. Michael Noll

*The Guassian Quadratics series was among the earliest examples of computer-generated imagery and the first to have its own copyright. Noll, whose later artworks frequently appropriated masterpieces of modern art as their points of departure, attributes his fascination with this work to its strong resemblance to the Cubist infrastructure of Picasso's* Ma Jolie, *one of his favorite paintings in the collection of The Museum of Modern Art in New York.*

*Hardware:* IBM 7094 computer, General Dynamics SC-4020 microfilm plotter. *Software:* by the artist

object. As a scientist, he was more interested in what a computer could be made to do than what he could do as an artist.

In spite of the technical limitations and the lack of artistic pretension—indeed, Noll hand-colored some of the Gaussian Quadratics in response to those for whom they weren't "artlike enough"—the Wise Gallery show successfully demonstrated the capability of computers to generate intriguing visual displays.[9] It was implied that there were now interesting options available for artists to explore. The art press, however, was not so sanguine. Criticism ranged from cool indifference to open derision. The reviewer in *Time* magazine noted that the pictures on display not only resembled "the notch patterns found on IBM cards" but also had "about the same amount of aesthetic appeal."[10] *The New York Herald Tribune* denounced the works as "cold and soulless."[11] Stuart Preston, critic for *The New York Times*, described with dread the day envisioned by scientists "when almost any kind of painting can be computer-generated. From then on all will be entrusted to the 'deus ex machina.' Freed from the tedium of techniques and the mechanics of picture making, the artist will simply create."[12] Most artists, too, believed the medium had not proved itself to be either accessible or refined enough to venture into.

Computer imagery may have been spurned by the art community, but its enthusiasts were not shy about borrowing artistic iconography. In one playful experiment, Noll produced a convincing facsimile of Bridget Riley's painting *Current* in the collection of New York's Museum of Modern Art. He expressed the top line of this Op Art composition as a mathematical sine curve and then instructed the computer to repeat it ninety times. His successful representation of the original led him to investigate whether the computer would do equally well with different forms of abstract painting. In a letter to fellow computer scientist Leslie Mezei, Noll explained: "One of the techniques used in teaching art students is to have them produce their versions of famous paintings. Well, there is no reason why the computer can't learn by a similar idea. Hence, I am presently trying to have our IBM 7094 computer produce its versions of Mondrian's *Composition with Lines* and [sculptor Richard] Lippold's *Orpheus and Apollo*."[13]

Using a digital computer and a microfilm plotter, Noll produced a semirandom picture remarkably similar in composition to the 1917 Mondrian (plate 9). He then presented Xerox reproductions of the original Mondrian and the computer-generated picture to one hundred people at Bell Labs. The subjects, who were informed that they were about to participate in "an exploratory experiment to determine what aesthetic features are involved in abstract art," were instructed to identify the computer picture and the picture of their preference.[14] Only 28 percent correctly identified the computer-generated picture, while an astonishing 59 percent preferred the computer's rendition to the actual painting by Mondrian. According to Noll's provocative conclusion, the people in this survey "seemed to

associate the randomness of the computer-generated picture with human creativity, whereas the orderly bar placement of the Mondrian painting seemed to them machinelike."[15]

The distinguished art historian Meyer Schapiro was among those intrigued by Noll's findings, and he made detailed observations about how this computer simulation of Mondrian's circular painting permits us to see more sharply the artist's refined and distinctive compositional order. He also concurred with Noll that the reason more people associated randomness with creativity was because of the randomness common to recent abstract paintings. He concluded: "Randomness as a new mode of composition, whether of simple geometric units or of sketchy brush strokes, has become an accepted sign of modernity, a token of freedom and ongoing bustling activity."[16] That Noll's picture—its philosophical merits notwithstanding—won first prize in the *Computers and Automation* 1965 art contest is an excellent indication of the status of the computer art field just over twenty years ago.

A programmer and engineer, Noll continued to research and write on a wide range of computer and art-related topics, making a major contribution to the development of computer graphics. At an early stage, he foresaw that the computer would have ramifications well beyond the creation of two-dimensional imagery. He pioneered three-dimensional movies (seen in stereoscopic views) and wrote programs for computer-generated choreography and holography.[17]

Another pioneering propagandist of the computer as an art medium was Noll's associate Leslie Mezei, a University of Toronto professor. Mezei's many predictions about the wide-ranging applications of the computer encompassed all the arts. He envisioned a "truly unusual artistic machine: music, dance, poetry, and film could be added to produce the dream of Joseph Schillinger: kinetic art utilizing all of our senses."[18] As early as 1964, he began a crusade to educate the uninitiated and the incredulous. He was to be unswerving in his belief that abstract artists, namely Piet Mondrian, Hans Arp, Jackson Pollock, and Barbara Hepworth, who in his evaluation explored one motif in depth throughout most of their creative careers, could benefit from the assistance of computers. He suggested that the ability of a program to modify an original concept randomly would give such artists endless formal variations for future elaboration.[19] In 1967, Mezei started producing his own computer-generated representational art. His inquiries focused on random transformations or distortions of animal, human, and letter forms, using relatively simple programs output on a plotter.

In 1966, one of the few people involved in computer graphics with a traditional art background was Charles Csuri, an artist on the Ohio State University faculty. Csuri is credited with producing the first examples of computer-generated representational art. In contrast to Noll's mathematically generated, abstract computer imagery, Csuri's compositions originated as pencil drawings of representa-

tional subject matter. The images were scanned and converted into digital information. Coordinates were then assigned to the outlines, and the compositions plotted either in their original form or completely transformed, according to the program Csuri desired. Although he had invented a mechanism capable of drawing transformations in the early 1960s, Csuri, who had also trained as an engineer, adhered to traditional artistic mediums until he discovered the computer (plate 12). One of his best-known computer-generated works is *Transformation*, in which he mesmerized viewers with a series of line drawings that portrays a girl's face gradually dissolving into old age.

Despite the investigations of artists such as Csuri, his contemporaries, for the most part, were unaware of computer graphics developments. In 1966, the art world focused on the potential liaison between art and technology largely due to the combined efforts of artist Robert Rauschenberg, who was a celebrated and influential figure after winning first prize at the 1964 Venice Biennale, and Billy

9. A. Michael Noll. *Computer Composition with Lines*. 1965. Photograph, 11 × 8½"

*This image, which was meant to approximate Piet Mondrian's* Composition with Lines, *was generated by a digital computer and a microfilm plotter using pseudorandom numbers. When Noll, in a much-publicized experiment, showed Xeroxes of both pictures to one hundred people, fifty-nine preferred the composition of the computer-generated picture.*

*Hardware:* IBM 7094 computer, General Dynamics SC-4020 microfilm plotter. *Software:* by the artist

Klüver, a physicist in laser research at Bell Labs. Klüver was not a newcomer to the New York art scene. In 1960, he had assisted Swiss sculptor Jean Tinguely in the construction of *Homage to New York*, a highly publicized machine that was carefully orchestrated to destroy itself in the sculpture garden of The Museum of Modern Art, much to the delighted astonishment of the audience. Since the success of that event, Klüver made himself available with missionary zeal as a collaborator, consultant, and impresario of numerous art and technology alliances. In 1963, he and Rauschenberg began to create a number of artworks in which common technological objects, such as radios and fans, were activated by various electronic systems (plate 10). Rauschenberg, too, was among the most vocal and consistent advocates of an alliance between art and technology. "A type of heresy is developing which affirms that technological progress is a monster, that the robot is the incarnation of evil," he surmised in a 1969 interview. "We are ashamed of technology, some are turning their backs on it, fleeing the technological present."[20]

To affirm the potential for artist-engineer collaborations, Rauschenberg and Klüver coproduced an ambitious performance series in October 1966 that lasted for nine evenings at New York's 69th Regiment Armory—the site of the revolutionary show that introduced modern art to America in 1913. Rauschenberg and Klüver called on forty engineers and ten well-known avant-garde artists to produce the technical equipment for the theater, dance, and musical extravaganzas to be performed. The engineering time alone required before and during the performances added up to more than three thousand hours. Although the audience became disgruntled by the shows' long delays and frequent breakdowns and the press generally panned the events, there were many technical successes and stunning visual effects. In *Grass Field*, for example, small amplifiers magnified the extraordinary range of normal internal sounds—"brain waves, cardiac sounds, muscle sounds"—occurring inside dancer Alex Hay's body while he performed in front of a huge television screen on which his image was projected to the audience.[21]

Stimulated by their conviction that interdisciplinary action would benefit not only the participants but also society as a whole, Klüver and Rauschenberg formed an organization called Experiments in Art and Technology (E.A.T.) to promote joint efforts between artists and engineers. The opening meeting in Rauschenberg's studio in 1967 received considerable coverage in the press. In addition to the attendance of numerous artists and scientists from prestigious institutions (AT&T and IBM among them), Senator Jacob Javits endorsed the activities of the group in a speech. When asked about his avid involvement in the

10. Robert Rauschenberg. *Dry Cell*. 1963. Assemblage: silkscreen, ink, and paint on Plexiglas; metal, string, sound transmitter, wire, circuit board, motor, and batteries, $15 \times 12 \times 15''$

*The artist collaborated with engineers Billy Klüver and Harry Hodges of Bell Labs on this piece, which was first shown in 1964. Viewers are invited to talk or make other sounds into a microphone on the face of the work. In response, a small propellerlike piece of metal begins to rotate. This sculpture was the first of numerous collaborative projects between Klüver and Rauschenberg.*

project, Rauschenberg explained: "If you don't accept technology, you better go to another place because no place here is safe. . . . Nobody wants to paint rotten oranges anymore."[22] E.A.T. solicited members from both the engineering and art sectors and began publishing a newsletter, *E.A.T. News*, whose second issue reported that over three hundred artists had expressed interest in the program. The newsletter also included a coauthored statement by Klüver and Rauschenberg announcing their goal "to catalyze the inevitable active involvement of industry, technology, and the arts."

In 1968, as part of an ambitious educational program, E.A.T. organized a lecture-demonstration series for artist and engineer members given by experts in various technological fields. At one group of lectures on the subject of "Computer-Generated Images," Leon Harmon, a researcher in visual perception at Bell Labs, spoke about "Computer Images"; Kenneth C. Knowlton, a researcher in computer programming at Bell Labs, and Stanley VanDerBeek, a pioneer computer-filmmaker, discussed "Computer Films"; Ron Baecker from MIT spoke on "Computer Animation"; and "Computer Music" and "Computer Poetry and Language" were the topics of other sessions. For many artists, including Hans Haacke, John Chamberlain, and Robert Whitman, this was their introduction to the artistic applications of computer technology.[23]

By the early 1970s, there were over six thousand E.A.T. members nationwide. Although E.A.T. still exists, the computer art–related activities began to wane once Klüver saw that the increasing popularity of the medium and the accessibility of computers obviated the basic premise of the organization to provide services that could not be realized without their intervention. As soon as universities and other facilities could provide technical support formerly provided by E.A.T., the organization turned to other projects.

With similar goals to E.A.T. in mind, Gyorgy Kepes, a multitalented designer, photographer, painter, and educator well known for his belief in the need for a symbolic alliance between art and science, founded the Center for Advanced Visual Studies at MIT in 1967. C.A.V. S. provided a collaborative environment in which artists could explore and realize projects with the assistance of scientists and engineers. The early fellows at the center included the noted art historian Jack Burnham and the artists Otto Piene (current director of the center), Stanley VanDerBeek, and Wen-Ying Tsai, each of whom played an important role in the movement to apply modern technology to art.

11. Edward Kienholz. *The Friendly Grey Computer, Star Gauge Model #54.* 1965. Motor-driven assemblage: painted aluminum rocking chair, metal case, two instrument boxes with dials, plastic case containing yellow and blue lights, panel with numbers, bell, "rocker switch," pack of index cards, directions for operation, light switch, telephone receiver, doll's legs, 40 × 39⅛ × 24½"; on aluminum sheet, 48⅛ × 36". Collection, The Museum of Modern Art, New York. Gift of Jean and Howard Lipman

*Kienholz's humorous yet leery interpretation of computers was one of the first responses by an artist to the new presence in society. Despite the subject matter, Kienholz's construction is entirely mechanical. Viewers were instructed to submit questions on an index card to the computer, which Kienholz "programmed" in advance to give random affirmative and negative responses. A flashing yellow bulb indicated that the answer was "yes" and a flashing blue bulb indicated "no."*

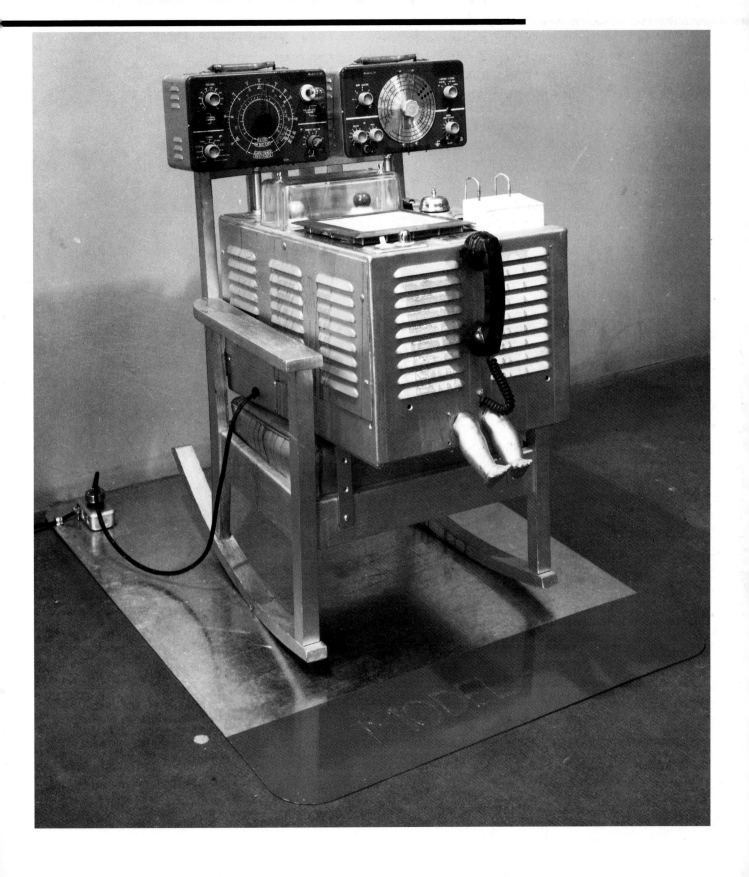

Between 1968 and 1970, major exhibitions in the United States and Europe brought attention to the art and technology movement, in general, and to the potential of the computer as a creative medium, in particular. In November 1967, K. G. Pontus Hultén, then director of the Moderna Museet in Stockholm, asked E.A.T. to collaborate on a section of the exhibition *The Machine as Seen at the End of the Mechanical Age*, which he was organizing for The Museum of Modern Art in New York. His plan was to document artists' attitudes toward technology, beginning with the scientific investigations of Leonardo, continuing through the machinist paintings of Francis Picabia and the "metamatic" machines of Jean Tinguely, and ending with the most advanced computer art of the day.

E.A.T. sponsored a contest in order to make their selections. One hundred and forty-seven entries were received, ninety-five of them art and science collaborations (plate 11). After ten were chosen by Hultén for inclusion in the show, Rauschenberg and Klüver were so impressed by the quality and variety of the submissions that they decided all the entries should be seen and arranged for the exhibition *Some More Beginnings: Experiments in Art and Technology* to run at the Brooklyn Museum concurrently with the show at The Museum of Modern Art. Their exhibition included paintings, reliefs, sculptures, constructions, environments, and films. A number of works employed computer technology either to run the installations or to create the graphics on display.[25]

Among the E.A.T. works chosen by Hultén was a composition by Leon Harmon and Kenneth C. Knowlton, who together created some of the best-known computer-generated pictures of the 1960s. Their first image of a twelve-foot-long nude (based on a photograph of dancer Deborah Hay) and the Studies in Perception series that followed (all generated at Bell Labs) were created by Knowlton's picture-processing method (plates 13 and 150). Each intriguing image began as a photograph of an object in the real world. A 35mm transparency was made of the photograph and scanned by a machine similar to a television camera. The electrical signals were converted into digital information processed by a computer. For the nude, the picture was divided into 88 rows with 132 fragments per row; 11,616 fragments in all. Each fragment was assigned to one of twenty-nine brightness levels ranging from black to white, and each level was assigned a symbol, such as a house, cat, lightning bolt, or stoplight, depending on the density of the dot patterns of the configuration. Up close, the viewer is aware of the tiny images within the picture, but from a distance only the overall form of the female figure is discernible. This highly acclaimed composition was a didactic demonstration of

12. Charles Csuri. *Sine-Curve Man.* 1966. Silkscreen on plastic, 36 × 40″

*Csuri, founder of the acclaimed Computer Graphics Research Group at Ohio State University, created this portrait with the assistance of programmer James Schaffer. One of the first figurative images produced by a computer for purely artistic purposes, this representation of a man's face began as a pencil drawing by Csuri. After the drawing was scanned by a special camera, it was digitized—a process that converts the image into binary, or digital, information read by the computer as X, Y coordinates. The image was then transformed with sine-curve functions, output with a plotter, and later transferred to silkscreen.*

*Hardware:* IBM 7094 digital computer, CalComp graphics drum plotter. *Software:* by the artist and James Schaffer

13. Leon Harmon and Kenneth C. Knowlton. *Studies in Perception I.* 1966. Photograph, 28 ½ × 70 ½". Collection Ed Manning, Stratford, Connecticut

*Harmon and Knowlton, research scientists at Bell Labs, jointly produced the picture-processed* Studies in Perception *series. Each of the images in the series, which includes a gargoyle, a telephone, and two flying seagulls, was based on a conventional photograph that was digitized. Both digitization and the various possibilities for manipulating an image through picture processing have advanced considerably since the time this nude was created in 1966. According to Knowlton, the reasons for their experiment were threefold: "to develop new computer languages which can easily manipulate graphical data; to explore new forms of computer-processed art; and to examine some aspects of human pattern-perception."[24]*

*Hardware:* IBM 7094 computer, Stromberg-Carlson 4020 microfilm recorder. *Software:* by Kenneth C. Knowlton

14. Lillian Schwartz (design) with Per Bjorn and Arno A. Penzias (engineering). *Proxima Centauri.* 1968: updated 1983. Plastic, ripple tank, slides, slide projector, motors, and microprocessors: base, 55 × 30 × 30"; globe, diameter 30". Photograph copyright 1969 by Peter Moore

Proxima Centauri *was one of nine pieces chosen to represent contemporary technology in the* Machine *show at The Museum of Modern Art in 1968. As a spectator approaches, the translucent dome emits a red glow and slowly sinks into a circular opening in the black base. When the orb resurfaces, it glows in blue. A series of computer-generated abstract patterns is continually projected on the surface of the dome, below which a water-filled rectangular tank moves up and down every thirty seconds, causing the image to vibrate and the dome to appear to be a soft, gelatinous mass. The Nobel Prize-winning scientist Arno Penzias updated the piece with microprocessors. Previously, it was activated when the current was broken by the viewer stepping on a proximity detector pad; now it responds to sound waves.*

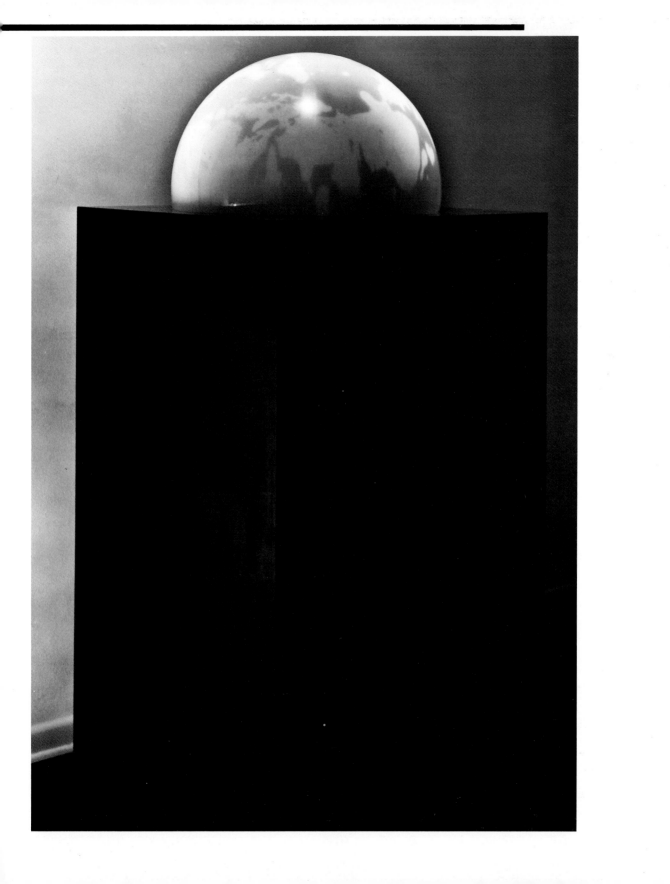

picture processing's versatile capabilities, complete with an undisguised reference to artistic precedents. Making art with computers, however, was still an exclusive activity. The technology was simply unavailable outside of research centers.

In response to the increasing computerization of society — and perhaps in direct acknowledgment of the growing interest in technological artistry — a number of important artists began to grapple thematically with the issues of the computer age. Although they were not disposed to incorporate the technology into their own artmaking processes, and even if they so desired they did not have access to it, the computer entered their world and their imagery as a potent force to be reckoned with rather than an applicable tool.

Among the works in the *Machine* show was Edward Kienholz's construction *The Friendly Grey Computer* (plate 14), which according to Hultén symbolized "a folklore [that] has rapidly developed about the computer. It has become a wonder

15. Frieder Nake. *Matrix Multiplication Series.* 1967. Plotter drawings: felt-tip pen on paper, each 10 × 10″

*Nake's drawing is one of many early examples of computer artworks made to illustrate mathematical principles. Nake assigned numbers to points on the gridded composition following elementary operations of matrix multiplication. Each number was then assigned a color, which was applied by a very early West German plotting machine (a computer-controlled drawing apparatus), the Zuse Z64 Graphomat. In order to enhance the colors, wide-tipped ink pens were inserted in the plotter.*

*Hardware:* Telefunken TR4 computer, Zuse Z64 Graphomat plotter. *Software:* by the artist

child, capable of answering any question, solving any problems. As he does so frequently, Kienholz here makes use of modern folklore."[26] His whimsical interpretation of the somewhat alien computer is seated comfortably in a rocking chair because, as Kienholz compassionately explained in his operating instructions for this piece, "computers sometimes get fatigued and have nervous breakdowns, hence the chair for it to rest in. If you know your computer well, you can tell when it's tired and sort of blue and in a funky mood. If such a condition seems imminent, turn rocker switch on for ten or twenty minutes. Your computer will love it and work all the harder for you. Remember that if you treat your computer well, it will treat you well."[27]

Computerization elicited a different response from painter Lowell Nesbitt. He has recalled how his reaction to the alluring array of machines in a window display at the IBM office on Madison Avenue in New York City prompted him to paint a group of paintings in 1965 he refers to as his IBM Computer series:

16. Miriam Schapiro. *Keyhole*. 1971. Acrylic on canvas, 72 × 107"

*Schapiro, whose art in the early 1970s focused on geometric abstractions, was one of the first fine artists to realize computers could play a role in painting. A program was written for her that instructed a plotter to draw all the possible variations of a simple design or letter of the alphabet. From each roll of plots, she selected one or two designs, which she then enlarged, projected onto canvas, and developed as paintings. In some paintings, she used the exact design generated by the computer; in others, she combined several computer-generated forms into one composition.*

*Hardware:* Hewlitt Packard 2116B computer, Hanston Omnigraphic incremental point plotter. *Software:* by David Nalibof

*So silent, cool, and aloof, beautiful really, those elegant, efficient, abstract machines. . . . I suddenly found them hauntingly paintable. My paintings, while emphasizing their forms, both their cool exteriors and their electric interiors, put them into the very human, hand-painted, oil-on-canvas world.*[28]

Drawn to computers as much for their powerful structural forms as for their implications for mankind, Nesbitt conveyed the intriguingly seductive effect of these machines (plate 17).

The English artist Eduardo Paolozzi expressed his fascination with computer technology in *Universal Electronic Vacuum*, a portfolio of ten screen prints issued in 1967, one of which he called *Computer Epoch*. Although the title of the portfolio and of this print in particular were indications of his preoccupation with the electronic age, his concern was made even more explicit by the title page and the stamping on the aluminum cover of each set, where the letters are printed to mimic computer type. In addition, in several of the prints he incorporated computer graphics as well as typographical references to computer technology; the graphics, however, were not his own.

Whereas Pontus Hultén's *Machine* exhibition was a broad technological survey designed to signal the end of the machine era and announce the new electronic age, *Cybernetic Serendipity: The Computer and the Arts*, curated by Jasia Reichardt at the London Institute of Contemporary Art in 1968, successfully confronted the art community with the radical implications evolving specifically from the computer field. By including computer-generated poetry (even haiku), paintings, sculptures, robots, choreography, music, drawings, films, and architectural renderings in *Cybernetic Serendipity*, Reichardt demonstrated how pervasive the use of advanced technology had become in the creative process. In spite of the comprehensiveness of the exhibition, Reichardt observed that she knew of only three artists, Charles Csuri, Lloyd Summer, and Duane Palyka, who were producing computer graphics; all other computer images were being made by scientists.[29]

Following *Cybernetic Serendipity*, Alan Sutliffe founded the Computer Arts Society in England to encourage the creative use of computers in the arts and to provide for the exchange of technical information. In order to accomplish these aims, the society began publishing a newsletter called *Page*, containing writings of interest to the computer arts community as well as lists of upcoming exhibitions and events. In 1969, an American branch of the Computer Arts Society was founded by Kurt Lauckner in Ypsilanti, Michigan, and a similar branch was founded in Holland. In keeping with Klüver's operational philosophy for E.A.T., once Lauckner's organization became active, E.A.T. became less involved with computer art.[30]

17. Lowell Nesbitt. *IBM #729.* 1965. Oil on canvas, 80 × 60"

*The previous work of this artist included groups of paintings inspired by New York facades and the sights outside his own studio. In this series, however, his attention was riveted on the most advanced computer equipment of the day, which he saw on display in the New York City showroom of IBM.*

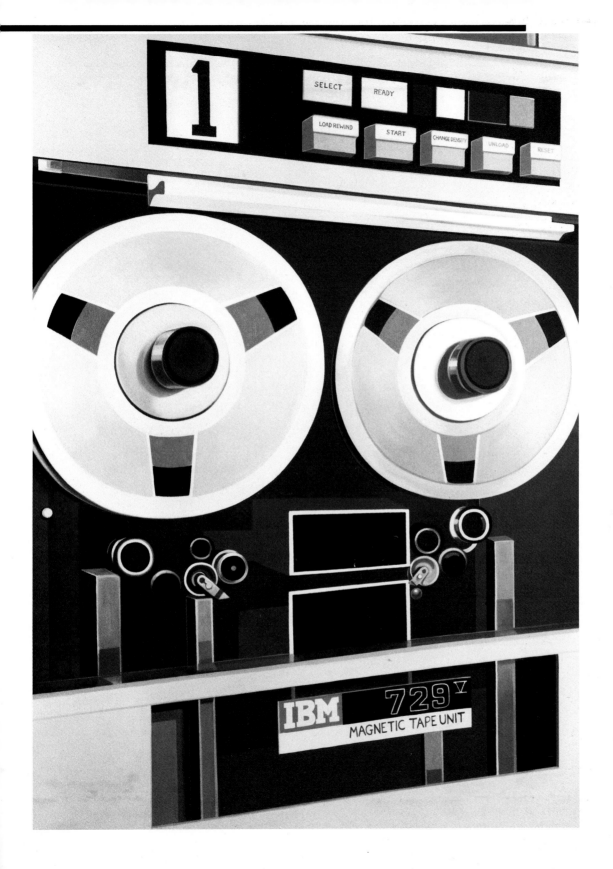

A major opportunity to explore the art and technology phenomenon was initiated by Maurice Tuchman, curator of modern art at the Los Angeles County Museum of Art, who developed the Art and Technology Program, or A and T. Tuchman's plan, conceived in 1966 but not implemented until 1968, was to "bring together the incredible resources and advanced technology of industry with the equally incredible imagination and talent of the best artists at work today."[31] To achieve this, he wanted to place approximately twenty accomplished artists in residence for up to twelve weeks at the leading technological and industrial corporations in California. His proposal was motivated by the belief that giving selected artists access to modern technology would greatly increase their artistic capabilities and could also be advantageous to industry.[32] Among the seventy-six artists and their corporate sponsors who eventually participated in this large-scale project were Andy Warhol, who was at Cowles Communications, John Chamberlain at Rand Corporation, Tony Smith at Gemini G.E.L., and Robert Rauschenberg at Teledyne. Many of the memorable objects they created were exhibited in the U.S. pavilion at Expo '70 in Osaka, including Rauschenberg's recreation of Yellowstone's "paint pots" in *Mud Muse*.

When Tuchman originally asked a group of artists to submit proposals for creative projects to the Art and Technology Program, Paolozzi, Haacke, Victor Vasarely, Robert Mallary, Walter de Maria, Jesse Reichek, and Ron Davis each requested to work with a computer. For a number of reasons, including cost and the feasibility of executing a work within a given period of time, none of these artists was able to reach a mutually satisfactory agreement with their potential corporate sponsors. In one last attempt to incorporate IBM into the program, poet Jackson MacLow was invited to participate, in the hope that his poetry, which utilized the computer as a linguistic medium, might be easier to realize than any of the visual artists' projects had been. However, MacLow's disheveled appearance and the scope of his wildly ambitious project, which included an elaborate computer system that could analyze and disseminate massive amounts of information about Los Angeles, were not favorably received by IBM's executives. A satisfactory match was finally achieved with MacLow and Information International, and ultimately his poetry was the only computer-assisted work in the exhibition. The encounters of the latter group of artists in the A and T project typify numerous less well-documented examples of artists' attempts to avail themselves of the resources of technology and partially explain why, until recently, access to computers has remained virtually unattainable for most artists.

In 1970, Jack Burnham organized *Software, Information Technology: Its New Meaning for Art* at the Jewish Museum in New York. It was Burnham's hope that

18. Nicholas Negroponte and the Architecture Machine Group, Massachusetts Institute of Technology. *Seek.* 1969–70

*First displayed in 1970 at* Software, *an exhibition of artistic uses of computer technology,* Seek *was a Plexiglas-encased, computer-controlled environment inhabited by gerbils, whose primary activity consisted of rearranging a group of small blocks. Once the arrangement was disrupted, a computer-controlled robotic arm rebuilt the block configurations in a manner its programmers believed followed the gerbils' objectives. The designers, however, did not successfully anticipate the reactions of the animals, who often outwitted the computer and created total disarray.*

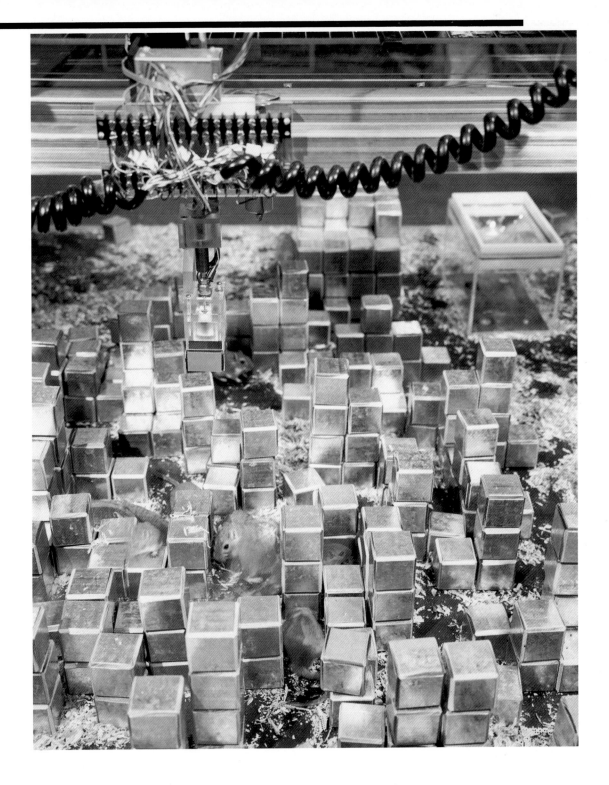

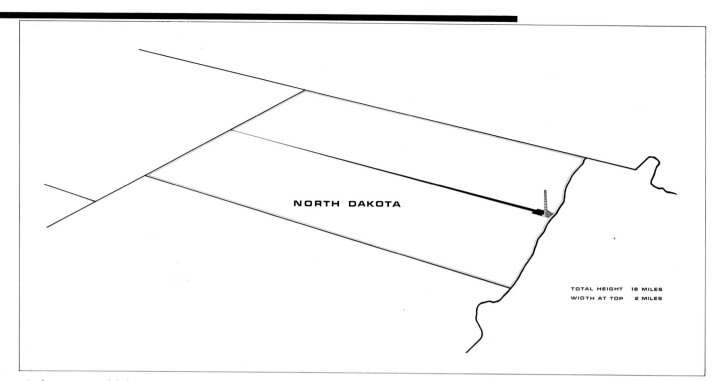

NORTH DAKOTA

TOTAL HEIGHT   18 MILES
WIDTH AT TOP   2 MILES

*Software* would demonstrate "the effects of contemporary control and communication techniques in the hands of artists," encouraging them "to use the medium of electronic technology in challenging and unconventional ways."[33] His expressed goal was to use computers in a museum environment so that the public could interact with the artists' programs. The most astonishing aspect of *Software* was that it contained only machines and no traditional works of art.

*Software*, unfortunately, was plagued by malfunctioning machinery that further alienated members of the art world, who were already somewhat skeptical about art and technology. One of the many pieces that never operated in this show due to technical problems was Hans Haacke's *Visitor's Profile*. Haacke's piece emphasized the processing of raw data, a theme central to Conceptual Art. Whereas most Conceptual Art pieces relied on such techniques as video, Xeroxing, and mimeographing for data processing, Haacke attempted to automate his process through computer technology. As planned for the Jewish Museum installation, *Visitor's Profile* was to have consisted of a teletype terminal with a picture scope connected on a time-sharing basis to an external digital computer. Using the computer keyboard, visitors to the exhibition were to have answered a

19. Siah Armajani. *North Dakota Tower*. 1968. Ink on paper, 12 × 24"

*For this Conceptual Art project, Armajani, who is well known for his fantastic wooden constructions, utilized a computer to process his data. He set out to determine the height, location, and shape of a tower that could cast a shadow over the whole state of North Dakota. The interactive computer system in the Space Department at the University of Minnesota was made available to him for his calculations. With the computer's assistance, the problem was solved and a plot of the proposed tower drawn. The project, of course, was purely hypothetical; in order to accomplish his goal, the tower would have to be eighteen miles high and two miles wide at the top. Armajani had this rendering made to illustrate his findings.*

list of questions, and a statistical profile was to be compiled based on the information they provided.[34]

What drew the most attention by far at the Jewish Museum were the gerbils in *Seek*, the collaborative installation of Nicholas Negroponte and the Architecture Machine Group from MIT (plate 18). The poor gerbils, who were trapped in an artificial environment and taunted to try to outsmart the computer that controlled the installation—a feat they often succeeded in doing—were described by critic Thomas B. Hess as looking like "shipwrecked victims after thirty days in an open boat." He continued with a warning typical of the antagonism provoked by this exhibition: "Artists who become seriously engaged in technological processes might remember . . . what happened to four charming gerbils." With a lack of sympathy also characteristic of the movement's adversaries, Hess concluded by advising those who were disconcerted by the poor performances of the equipment in the show to simply accept that "the big point in Art and Technology manifestations over the past ten years has been that none of the technology works."[35]

Thinking in sympathy with Hess was to dominate the critical climate throughout the next decade. In retrospect, Billy Klüver has bemoaned that some of the time spent educating engineers not to be afraid of artists was not spent educating curators and critics about realistic expectations for technological displays.[36] Many artists, however, were not deterred from experimenting with the new tools. In the late 1960s, although access to computers was still very limited and the machine-user interface was far from perfect, a number of professional artists in Europe and America adopted the computer as their medium. The *Cybernetic Serendipity* exhibition in 1968 continued to be the impetus for a steady proliferation of international exhibitions, conferences, and publications devoted to computer art.[37] Indeed, responding to the flurry of activity, the German physicist, aesthetician, and artist Herbert W. Franke appeared only three years later with simultaneous English and German editions of *Computer Graphics–Computer Art*. It was the first comprehensive attempt to analyze the movement historically and reinforced Jasia Reichardt's earlier effort to establish the use of the computer as a legitimate medium of aesthetic expression.

Although all of the works illustrated and discussed in Franke's book were lumped together under the single heading of computer art, the contributions were made primarily by scientists and mathematicians. By 1976, when pioneer computer artist Ruth Leavitt edited *Artist and Computer*, a slim but impressive volume, a truly international computer art community had emerged. Now, just over ten years later, there is still a dedicated group of artists who categorize themselves as part of a distinctive "computer art" community, but the use of computers to make art has spread to all the visual arts.

20. Jonathan Borofsky. *Counting from 1–4, 434*. 1969. Twenty computer sheets

*One of a series in which Borofsky and a programmer used a computer to perform different counting tasks. Borofsky's goal was to count to infinity. His experience with the computer is still apparent in the consecutive numbering system he uses to designate his works. The relationship of one work to another is therefore identifiable, much in the way that a time code identifies consecutive video frames.*

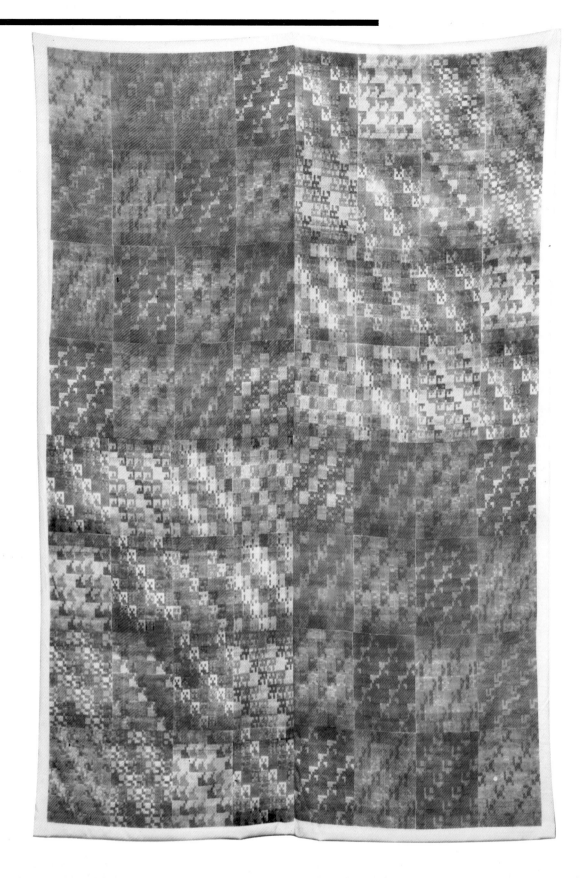

## III. *From the Plotter to the Electronic Palette: Two-Dimensional Computer Imaging*

The startling possibilities for visual expression that computers offer today are attracting artists of very diverse fields and aesthetic viewpoints to digital technology. The computer graphics field has grown so quickly and changed so dramatically that not only is it impossible to identify all of the artists who are working with the electronic medium, but it is also virtually impossible to identify all the processes they employ. The computer is now so much a part of everyday artistic creation that familiarity with an artist's working methods and considerable knowledge of the capabilities of a particular system have become necessary to ascertain the exact role of the computer in the development of an artwork or sometimes even to suspect it has been used at all.

Paint systems or plotters, two-dimensional or three-dimensional imaging, and interactive or passive control are among the many choices that demonstrate the computer's amazing versatility as an artistic tool. Recent hardware and software offerings continue to close the gap between the capabilities of personal computers and those of much larger systems. Indeed, software packages are currently on the market for microcomputers that integrate three-dimensional modeling with electronic paint. Developments in the computer graphics field are occurring with such mind-boggling rapidity that Ray Bradbury's characterization of the field "swiftly flowing and changing as a storm front stabbing its way across country, walking on stilts of electrical fire" is barely hyperbolic.[1]

Since the late 1960s, when enough artists began using computers to form a recognizable community, the major developments have been the introduction of the personal computer and the increasing availability of commercial software. Affordable, "user-friendly" systems have replaced the restrictions of the previous era, when all programming had to be customized to the task at hand. Although a number of artists, following in the path of A. Michael Noll, maintain programming is still an integral part of their artwork — indeed, those who write their own programs frequently express astonishment that others can be satisfied with

21. Joan Truckenbrod. *Electronic Patchwork.* 1978. 3-M Color-in-Color heat transfer on fabric, 82 × 55"

*Each fabric panel is a computer-generated design representing slight variations in the parameters of a program written by the artist. The program uses mathematical descriptions of normally invisible phenomena in the natural world, such as light waves traveling through space and reflecting off surfaces. Once each design was completed, the artist placed a computer monitor on a 3-M Color-in-Color copier machine and made a copy of it, which was heat transferred onto the fabric by ironing.*

*Hardware:* Apple® II computer, 3-M Color-in-Color copier. *Software:* by the artist

commercial software — the majority of artists do not wish to be concerned with programming. For them, there are now interactive systems that require neither technical sophistication nor mathematical conception. They can "paint" much as they always have but with the potential to choose from an infinitely variable palette of colors, save an image in progress at different stages for future elaboration, or recolor an entire surface with one touch of a cursor.

One of the primary reasons why artists resisted computers in the past was their fear that the computer would usurp artistic creativity and control. Equally problematic was the perceived relationship between the success or failure of an artist's work on a computer and the degree of programming proficiency that the artist attained. Artists expected to be disappointed or were concerned about the extent to which it was the collaboration with a programmer that produced the desired results. The mathematical basis of the artmaking processes prevented artists from considering using computers to make art or alienated them to such an extent that they rejected the idea outright. With recent software-hardware developments, the new hybrid of "artist-programmer" that programmer Kenneth C. Knowlton (who collaborated extensively with artists Stanley VanDerBeek and Lillian Schwartz at Bell Labs in the 1960s and 1970s) envisioned as the only solution to the often seemingly insurmountable impasse that divided artists and programmers, two generally very different personality types, is no longer the sole answer to artistic success with computers. Knowlton had an explanation for the early dilemmas:

*Both groups are creative, imaginative, intelligent, energetic, industrious, competitive, and driven. But programmers, in my experience, tend to be painstaking, logical, inhibited, cautious, restrained, defensive, methodical, and ritualistic. Their exterior actions are separated from their emotions by enough layers of logical defenses that they can always say "why" they did something. Artists, on the other hand, seem to me to be freer, alogical, intuitive, impulsive, implicit, perceptive, sensitive, and vulnerable. They often do things without being able to say why they do them, and one is usually polite enough not to ask.[2]*

A. Michael Noll also commented on the highly problematic nature of the early collaborations:

*The fallacy of collaboration is clearly evident when the computer is involved as a third party. Here the artist must communicate his ideas to a computer scientist or programmer who must then communicate his interpretation of the artist's ideas to a computer. This is most certainly a noisy process.[3]*

Today, commercial software circumvents intermediaries and invites artists to work on their own with computers.

Of equal importance to the current wave of artistic involvement is the fact that

computer graphics are no longer bound to styles easily accommodated by a particular system or programming language. At the end of the 1970s, artist Lillian Schwartz, for example, experienced a period of disenchantment with the state of computer graphics. Her concern was that remarkably repetitive images were being produced by those with access to the same program and equipment.[4] This occurrence was not only disturbing to Schwartz but to many in the field who could easily identify a particular system used to generate an image but not an individual artist's hand. As such obstacles are overcome by technological advances, a first generation of computer artists, those who entered the field before 1978, can be distinguished from a second generation, who entered after this date. Most of the first generation are either electronically knowledgeable or adept. The second generation need not be; the software does it for them.

Moreover, the medium itself is now conducive to experimentation. As Ruth Leavitt, one of the first artists with a fine-arts background to use computers, has remarked, "You can now race through what used to take years to explore."[5] Artists are encouraged to investigate the capabilities of various kinds of software. Computers seem to inspire improvisation in different media. Leavitt herself ex-

22. Mark Wilson supervising the plotting of one of his drawings on a Tektronix pen plotter. 1985. Photograph courtesy *Perspectives in Computing*, the IBM Corporation

*Computer-controlled plotters produce graphic representations of digital data. Pen plotters are capable of executing drawings with intricate detail in multiple colors—when a change in color is designated by the program, the mechanical drawing apparatus simply changes pens. With recent hardware developments, solid areas can be plotted; in the past, solid plots were enormously time-consuming and therefore impractical.*

emplifies the experimental spirit: she has been known to translate a single object in her artistic data base into sculpture, acrylic, and video.

It is tempting to try to classify computer-aided artworks according to either the software used to generate an image or by the means used to translate the image from digital information into hard copy. But so many artists now take computer-generated images as their starting point for explorations in other mediums, and the hard copy itself is so often enhanced through the addition of paint, pastel, or other materials that such classifications are really not applicable. Traditional categories of two- and three-dimensional forms are also not applicable. In computer graphics, a division of mediums does exist, but it is of a different nature. "2-D" and "3-D" are terms that have unique definitions in the computer field. Images generated with three-dimensional techniques are synthesized from mathematical descriptions of their forms and locations, generally in a cartesian coordinate system, by specifying the X, Y, and Z coordinates of every point. Three-dimensional images are often displayed as two-dimensional works of art. Nevertheless, they are related more to sculpture than to painting. Just like three-dimensional objects in actual space, they can be rotated, relocated, or viewed from any angle on the computer monitor. Some three-dimensional images are described only as linear "wire frames." Another option is to model images in solid form through a process known as "solids modeling." In computer graphics terms, "two-dimensional imaging" refers to work that is not modeled, whose description exists only in two dimensions. By definition, in most 2-D systems all the information in the data base can be displayed simultaneously.

A further distinction between "real-time interactivity" and "noninteractivity," sometimes called "active" and "passive" modes, is also important:

*Active computer graphics requires two-way communication between the user and the machine. Instantaneous feedback is necessary to provide effective participation between the user and the computer. How would one feel if one tried to draw, and the ink didn't flow from the tip of the pen as it moved, but the line appeared later? For "interactive computer graphics," the response must be immediate. When commands are invoked to position elements or to rotate objects, the displays must be generated fast enough to give the appearance of active user control. In contrast, the mechanical plotting of a drawing is an example of "passive" graphics and can occur any time after information has been input. This operation is frequently performed at locations different from the user site, and at periods of low demand, such as nighttime hours.[6]*

Working noninteractively is more foreign to most artists than working with an interactive system. Before an artwork or series of artworks is generated noninteractively, either the artist or the programmer must devise a program (assuming none exists) according to the artist's specifications. Although the artist can have a

fairly good idea what a design will look like prior to its execution and might preview its approximation on a screen, the precise image is often a surprise. The guidelines for noninteractivity, like those for two-dimensional and three-dimensional programs, are no longer invariable. Frequently today, plotters are interfaced with systems in which the data is visualized on the computer screen as soon as the coordinates are given. In this way, artists may edit drawings prior to plotting them and therefore have a certain degree of interactive control.

There are, furthermore, two fundamentally different approaches to the computer as a creative medium. In both cases, the computer may be thought of as an electronic sketchpad, capable of generating and processing compositional possibilities at a much greater speed than an artist alone would be capable of. For some artists, however, the computer is only a design tool, for others it is a means of fabrication. The actual artworks by the latter group are those that are not only

23. Ronald Davis. *Cones and Tetrahedron Eve.* 1983. Acrylic on canvas, 67½ × 86¼"

*This painting is from a series of paintings based on computer-generated imagery. To recreate the images on the computer screen, Davis used an opaque viewer that could project the compositions onto canvas, then he painted them. As early as 1968, when he submitted a proposal to the Art and Technology project, Davis was interested in using computers to help him design geometric configurations for his paintings.*

*Hardware:* Apple IIE computer. *Software:* Graforth

designed on but also are executed by the computer and ultimately are displayed as some form of hard copy. The three most frequent hard-copy formats are plotter drawings, printer drawings, and photographic enlargements. The problem of generating satisfactory hard copy still beguiles artists; but it has also led to intriguingly creative solutions.

24. Manuel Barbadillo. *Arseya*. 1976. Acrylic on canvas, 40 × 40″

*One of the early proponents of computer art in Spain, Barbadillo began researching the potential applications of computers to his painting in 1968, when he realized that the mathematical basis of his work was ideally suited to computer investigation. Barbadillo usually outputs his designs on a line printer rather than a plotter because it is quicker, and then he uses the designs as the point of departure for his paintings and drawings.*

*Hardware:* IBM 7090 computer. *Software:* by the artist and Lorenzo Carbonell

## Automated Drawing Techniques

A number of automated drawing techniques exist, including plotters and ink-jet, thermal, and electrostatic printers. These output devices may be interfaced with real-time or noninteractive systems. Many artists using passive systems rely on computers to produce images from a given set of algorithms that have been programmed to allow for a variety of solutions. Plotters continue to be one of the favorite mediums for artists concerned with exacting analytic formalism: the very elegance of a program may be part of the artistic challenge and revelry. Computer-driven plotters are frequently utilized for the remarkable rapidity with which they can visualize mathematical data. This capability recently motivated sculptor Alan Saret, best known for his work in surprising, untraditional sculptural materials, to turn to a computer for the realization of a project he began laboriously calculating by hand (plate 25). Saret's concept originated with the simple question, "What happens if to the edge of one square two squares are added, and then three squares are added to the edge of the two; then four to the edge of the three?"[7] A computer program that output the squares onto a plotter drawing diagrammed the answer. Although Saret's project is still concerned with mathematics, there has also been a basic change in artists' attitudes, from the earlier satisfaction with scientific principles as the point of departure for visual exploration to a concerted effort to utilize the plotter for more pictorial ends.

In Europe, in the late 1960s, artists with strong visual and conceptual alliances with the Constructivist tradition, including Manuel Barbadillo (plate 24), Edward Zajec, Vera Molnar, and Manfred Mohr, were the first to use computers for artistic ends. For the German artist Mohr, who explained the foundation of his art as "the invention and systematic development of two-dimensional signs," the computer is the perfect medium for conceptual investigations.[8]

Mohr first experimented with a computer in 1969. That year, inspired by a lecture given by Pierre Barbeau on electronic music, he and a group of approximately ten others, including Hervé Huitric, founded the *Art et Information* group at the Université de Vincennes in Paris. Their primary interest was to explore the computer's potential as a viable artistic medium. Only two years later, Mohr's solo exhibition of computer graphics at the A-R-C (Art, Research, Confrontation) section of the Musée d'Art Moderne de la Ville de Paris marked the first one-man exhibition of computer art organized by a museum. As part of the installation, Mohr included a computer and a plotter so that visitors could watch the machines execute his drawings. Every day, Mohr brought new tapes to the

25. Alan Saret. *Arithmetic Harmonic 217: 2/12/87.* 1986. Plotter drawing: felt-tip pen on paper, 40 × 24"

*Since 1983, sculptor Alan Saret has been "using the power of the entire number system to create a new kind of aesthetic" with computer assistance. This project was provoked by his curiosity to see the results of a diagrammatic study based on what happens when two squares are added to the edge of one and so on. The artist plans to create a seventy-foot version of the drawing. In its current form, which is thirty inches long and took thirteen hours to plot, Saret's investigation has been implemented to 217 squares.*

*Hardware:* IBM PC XT™ computer, Hewlitt Packard continuous plotter. *Software:* by David Kadish and Paul Lipsky

exhibition and supervised the plotting. He recalls the fascination of young and old visitors to the exhibition, as well as the blatant aggression of those between the ages of thirty and sixty years, who felt threatened by the automation process. Their sentiments were reflected in their responses to a questionnaire he pinned to the gallery wall: "What do you think of art made with a computer?"[9]

Mohr creates all his art, which consists primarily of direct plotter output, with computer assistance (plate 28). His palette is limited to black and white, so that color will not obstruct the content of his minimalist, exclusively linear vocabulary. Since 1973, the basic elements of his artistic language have been consistently fixed systems of cubes. He has expressed his awareness of a basic contradiction: "The paradox of my generative work is that form-wise it is minimalist and content-wise it is maximalist."[10]

26. Colette and Charles J. Bangert. *Grass Series Five*. 1983. Plotter drawing: felt-tip pen on paper, 11 × 13½"

*The Bangerts are one of several husband-wife teams that have been in the field almost since its inception — Charles does the programming and Colette is responsible for the artistic conception. They have been particularly successful at depicting naturalistic forms through mathematical programs. In* Grass Series Five, *their work attained a denseness that replicates the intricate, interweaving patterns of varicolored blades of grass.*

*Hardware:* Intertec Superbrain computer, Wanatabe WX 4671 plotter *Software:* by Charles J. Bangert

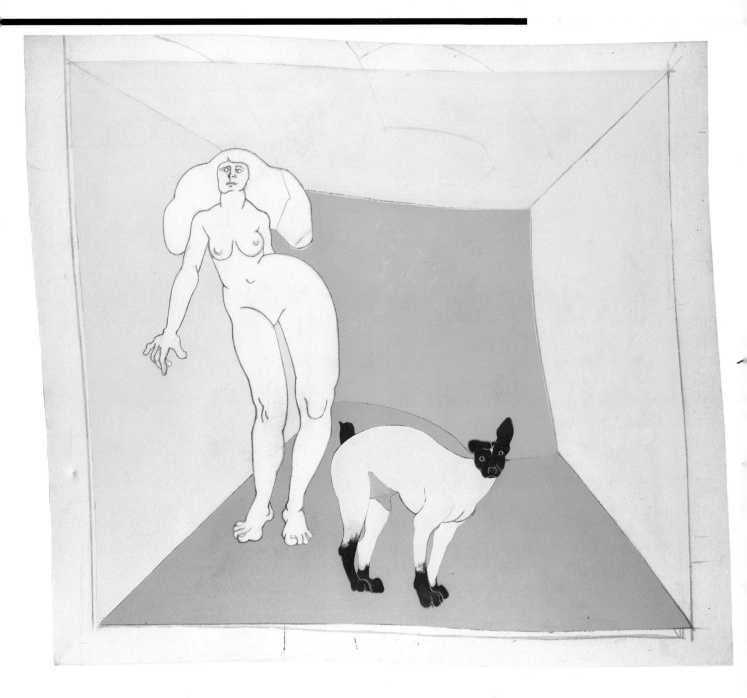

27. Enrique Castro-Cid. *Flora and Benjamin*. 1980. Acrylic on canvas, 61½ × 65″. Collection Robert S. Cahn and Nancy Weber. Photograph by Scott Bowron

*Castro-Cid uses the computer to transform representational compositions, often laden with psychological undertones, into unexpected distortions. The images are output on a plotter and sometimes developed into paintings.*

*Hardware:* Tektronix 4662 plotter and Tektronix 4010 series display, Harris 300 computer. *Software:* by Robert S. Cahn and the artist

The capacity of the computer to stimulate his imagination results in what Mohr calls "high-speed visual thinking."[11] His compositions begin with the simple form of a cube. He is able, nevertheless, to generate seemingly endless variations of this fundamental form through a number of programs, each of which takes the cube as a point of departure and then transforms it by distorting its lines into many different configurations (plates 28–29). In spite of Mohr's self-imposed restrictions, the cubic forms produced by his programs are enormously varied in composition and style. In addition to its philosophical underpinnings, there is necessarily a rigorous mathematical basis to all of his work. Yet, the visual interest is so compelling that the mathematical tour-de-force plays an unobtrusive role.

For French artist Vera Molnar, the computer was also ideally suited to facilitate her formal explorations. Before she discovered its rapid ability to process compositional data, she was only able to consider a few of the potentially innumerable transformations of her original geometric schemes. The computer program de-

vised for Molnar could not only modify her arrangements of sets of squares but could displace individual squares, eradicate entire squares or lines within the squares, and exchange them for segments of circles, parabolas, hyperbolas, and sine curves, requiring only the time necessary to print it out on the plotter. With the aid of the computer, it was literally possible to exhaust all the ways of modifying a composition.

As difficult as access to machinery was thought to be in the U. S., the environment was still far less restrictive than Europe. Equipment was more plentiful, and there were more academic and commercial centers actively involved in computer graphics research and development. The availability of computers, combined with the fact that the first artists to use computers in America—unlike their European counterparts—were not rooted in Constructivism, engendered a wider

28–29. Manfred Mohr. *P-300B* and *P-304B*. 1980. Plotter drawings: ink on paper, each 24 × 24″

*P-300B represents the "outlines" of a surface polygon and P-304B the "inlines." For each of the examples generated by the plotter in P-304B, the positions of the top left and top right quadrants of the polygons are constant, and the positions of the other two quadrants have been determined by turning the top left quadrant five degrees clockwise and the bottom right quadrant five degrees counterclockwise. Each of the drawings of the polygon represents only one of the possible rotations of the cube. Mohr utilizes the computer's incomparable capability to generate multiple compositions rapidly.*

*Hardware:* Digital Equipment Corporation PDP 11/23 computer, Alphamerics plotter. *Software:* by the artist

range of artistic responses. Colette and Charles J. Bangert began their collaborative experiments in 1967, when Charles, a computer engineer with a degree in art, was asked to test a newly acquired plotter at the University of Kansas. From their first experiments, Colette saw the computer as an amplification of her work in more traditional mediums. She does not distinguish qualitatively between her handmade drawings and acrylics and her computer drawings. Each body of work triggers and enriches the other:

*I now think much more clearly about my handmade work and have much more control as a result of having made computer drawings. In addition, I recognize that our computer efforts have led to unique and unfamiliar images, which I might never have considered introducing in my drawings. On the other hand, I consider that our computer drawings are extensions of my handmade drawings.[12]*

Midwestern landscape has been the source of inspiration for both bodies of work (plate 26). The calligraphic qualities of the terrain's windblown fields of crops are especially adaptable to the plotter, with its ability to depict repetition and randomness. Because every point of every line has to be accounted for in the computer artwork, placement, movement, and form become the objects of acute analysis. Colette Bangert found that "the computer . . . helped me to take apart, understand, then reconstruct more fully what a line and stroke can become."[13]

Chilean-born artist Enrique Castro-Cid, best known for his fanciful, unpredictable, and frequently kinetic combinations of unlikely objects, turned to the computer in 1978 after realizing that it was better equipped to achieve something he was attempting to do by hand. For Castro-Cid, like the Bangerts, the computer is capable of expediently creating specific effects. Inspired by his reading of D'Arcy Thompson, Castro-Cid spent ten years studying a branch of mathematics concerned with conformal transformations that preserve the angles between intersecting curves but not the shapes of the areas these curves enclose. His hand-drawn investigations were too laborious to achieve real progress. Determined to find a better way, he and mathematician Robert Cahn turned to a mainframe computer that was made available to him at a Florida hospital.[14] Each of his compositions now begins as a hand-drawn portrait. The drawing is then "digitized" on a homemade graphics table. Once the X, Y coordinates are stored in the

30. John Pearson. *Reflections 2: No. 1.* 1983. Pastel, 38 × 50". Collection Cynthia and Micha Ziprkowski, New York

*The starting point for Pearson's drawings (and many of his paintings) are lengthy rolls of plotted, computer-generated configurations. Once a selection is made for development, the design is executed in pastel, charcoal, and pencil. This drawing is then photographed and made into a slide, which is digitized by a video camera and manipulated on a computer screen. The image becomes the point of departure for his final pastels. Yet, to one unfamiliar with Pearson's working procedures, the importance of computers to his art is indiscernible in the finished pictures.*

*Hardware:* Tektronix 4013 terminal, CalComp graphics drum plotter #563, Xerox Sigma 9 computer, Comtal Vision 1-20 3-M computer, Digital Equipment Corporation VAX 11/780 computer, Matrix Instruments camera recorder.
*Software:* by Ed Angel, David Gold, and John Brayer of the VAX Research Center, University of New Mexico

computer, the composition is transformed according to the mathematical equations of the program, then plotted. Any number of variations of an original drawing can be created in this manner simply by changing the equation. The final image is either developed as a drawing or projected onto canvas and painted (plate 27).

English-born painter John Pearson also draws no distinction between electronic technology and traditional tools. He considers the computer simply one of many implements available to him in the design of the geometric images that serve as the foundation of his paintings. He uses computers primarily for initial structural and color investigations. (The first computer-aided artwork Pearson made consisted of ten stacks of computer printouts containing ten vertical bands of ten randomly selected colors arranged 3,628,800 ways. Even though the significance of the installation for Pearson was its testimony to "the paradox of artistic taste and the futility of absolutes," it also demonstrated both the "awesome scale of numerical permutations and the awesome capacity of the computer to handle them."[15])

Pearson's work is based on intricate geometric configurations constructed according to many time-consuming mathematical calculations. He has developed a set of programs to implement the electronic realization of these calculations in the form of long rolls of plotter drawings, which he thinks of as "storewells of visual data."[16] They contain hundreds of images based on the artist's original mathematical specifications. The exuberantly colored drawings that he began making in 1983, as well as many of his painted relief constructions, are derived from these computer-generated configurations (plate 30).

Pearson is careful to point out that all the final compositional decisions are intuitive and that both his pastels and painted relief constructions are entirely handcrafted works of art. The computer may offer the artist a wealth of alternatives, but they "remain solidly imbedded within the parameters of the main concept. In other words it often 'appears' to generate valuable new visual information but it does not and cannot generate new ideas."[17]

British artist Harold Cohen, who has explored the potential of artificial intelligence for art at Stanford University's Artificial Intelligence Laboratory, has different expectations for the computer-controlled drawing system he designed and built. Whereas most computer-generated drawings are made by plotters following programmed specifications, Cohen devised his own system for creating drawings with computers. One of the leaders of the New Wave of British painting, Cohen was introduced to computing at the University of California in San Diego in 1968. He learned some basic programming and initially experimented only halfheartedly, but as he became more conversant with the technology he was challenged by the prospect of determining whether it was possible for the machine to "simulate freehand drawing" resembling his own work:

*It was about a year before it occurred to me that what I was doing with the computer had any bearing, or could have any bearing, on issues that interested me as an artist, though programming turned me on in a way that other things hadn't in a long time. Then I started to see the machine as an analogy for human intellectual processes. At this point it was more exciting than painting.*[18]

Cohen was neither interested in being dependent on a programmer to execute his concepts nor in preprogramming the computer to make specified designs. Instead, he wanted to program the computer to reflect his artistic procedures directly and then leave it on its own to create. Indeed, his program can produce an endlessly variable series of "freehand" drawings remarkably similar to his own compositions.

In the first exhibition of his computer-generated artworks, at the Los Angeles County Museum of Art in 1972, Cohen exhibited a computer-controlled drawing machine that continuously executed a series of drawings. He included increasingly more elaborate systems in subsequent exhibitions. He later created a small mechanical drawing device with a pen on its underside attached to a computer by a long cord, which he called a turtle, in reference to its shape and crawling movements. In 1983, he designed a flatbed plotter equipped with a conventional stylus. A Digital Equipment Corporation MicroVAX computer starts the drawings on the drawing machines, each of which is equipped with a small computer of its own. These machines receive instructions from the VAX and determine accordingly how to drive the two motors in control of the movements of each pen. The main computer is run by a program called AARON, which was initially structured on a range of human perceptual behavior. Its capabilities include being able to differentiate "between open and closed, between inside and outside. It is capable of handling repetition. It knows when spaces are occupied and when they are not."[19] The artist has now developed his programs to such an extent that in addition to their former repertoire of abstract forms with tentative naturalistic references, the programs are capable of creating realistic drawings of plantlife, as well as convincing portrayals of the human body (plates 31–32). Cohen has compared the previous program to the current one:

*The AARON of 1972 [compared to the program today is] analogous to that of an adult to a small child . . . where the earlier AARON had been limited to knowledge of image-making strategies, the new AARON is more explicitly concerned with knowledge of the external world and the function of that knowledge in image-making.*[20]

Cohen looks forward to a time when the machines will be able to surprise him not only by drawing something he did not anticipate but by producing a drawing only possible by modification of the program. Cohen's goal is shared by all those who dream of a "thinking machine."

31. Harold Cohen. *Untitled*. 1985. Hand-colored, computer-generated drawing, 30 × 40″. Collection Robert and Deborah Hendel, New York

*Each of the drawings Cohen's program AARON (a reference to the artist's Hebrew name) produces is unique. Cohen selects certain drawings and enhances them with watercolor. Although his current system is limited to black-and-white output, the AARON of the future will probably be equipped with color capabilities.*

*Hardware:* Digital Equipment Corporation MicroVAX II®. *Software:* by the artist

32. Harold Cohen. *Untitled*. 1986. Oil on canvas, 100 × 67″. Collection Robert and Deborah Hendel, New York

*Cohen, like many other fine artists who now work with computers, sometimes translates his computer-generated imagery into traditional paintings on canvas.*

*Hardware:* Digital Equipment Corporation MicroVAX II®. *Software:* by the artist

## Interactive Imaging and Image Processing

The most popular way by far to generate interactive two-dimensional computer graphics in real time is with one of the many raster-display "paint systems" that have been commercially available since the early 1980s. There are two basic types of CRT displays: raster and vector. The differences between the two are determined by different ways of handling the need to refresh the phosphors on the inner surface of the screen in order to maintain an image. In raster graphics, a beam scans each of 525 horizontal lines on the screen at a rate of thirty scans per second. In a vector or calligraphic display, the electron beam records only the lines demarcating the actual image. In raster graphics, the memory capacity of the system must be sufficient to store information about every addressable pixel, or picture element, on the screen. Vector or "wire-frame" images contain less information and thus require less memory to store them. They are also quicker to generate images and consequently less costly.

A "paint system" is the generic term given to a computer with a "frame buffer" (a specific memory device for raster graphics), a color monitor, a computer terminal, a digitizing tablet, and a graphics input device such as a stylus or a "mouse." The software may either be a custom-made program or any one of the number of relatively user-friendly programs on the market. Paint systems allow the artist to work within a traditional framework: "brushes" are selected, colors mixed, and the results seen instantaneously on the video monitor. With a typical configuration of hardware and software, the artist draws with a stylus on a digitizing tablet and chooses at will from a palette of colors and selection of brushes displayed on the color video monitor. Movement on the tablet directly corresponds with movement on the computer screen (plate 36).

The resolution of graphics produced with paint systems varies from the low levels of some personal computer systems, typically with 150 by 200 picture elements, to a high of 2048 by 2048 on sophisticated computers. The pixel structure of a composition can be thought of as a superimposed grid. Each pixel is a small rectangle requiring at least one bit of computer memory corresponding to a position on this grid. Because the surface of low resolution pictures is divided into a relatively small number of pixels, diagonal lines look jagged and the transitions between colors are more noticeable. The removal of these telltale "jaggies" by a process called antialiasing has been the subject of much research in the computer graphics field. The more bits per pixel, the more memory there is, the greater the number of colors available in the palette, and the smoother the transitions between differently colored adjacent areas.

Credit for the development of the configuration of virtually all paint systems belongs to two men: Richard Shoup, founder of Aurora Systems, and Alvy Ray Smith, vice-president of Pixar. Shoup is credited with originating the idea for an

interactive animation system and for developing the first user-friendly raster display at the Xerox Palo Alto Research Center in 1973. Smith, who had worked with Shoup at Xerox, transferred in 1975 to the New York Institute of Technology Computer Graphics Laboratory in Westbury, Long Island (then and now one of the leading centers of computer graphics research). At NYIT, he produced PAINT, the prototype for most paint systems on the market today.

Millions of Americans were introduced to the instantaneous electronic realization of images during the Super Bowl in 1978, when Leroy Neiman was invited by CBS to experiment with a digital paint system the station referred to as an "electronic palette." Using an electronic stylus and a digitizing tablet, Neiman, who considers the computer the medium of the future,[21] captured the vivid actions of the professional football players for television viewers, who saw the images on their screens as quickly as he drew them. The Ampex system Neiman used was subsequently marketed as a commercial television product. Although audiences were captivated, similar technology for private use was not yet accessible and the demonstration had little impact beyond the broadcasting world. Not until the advent of paint software for personal computers was such a system widely available.

The enormous popularity of paint systems is attributable to their similarity to traditional painting techniques. Once an artist learns to make marks on one surface, such as a digitizing tablet or tabletop, that are visualized on another, the computer screen, the remaining adjustments are minor. The artist feels in control and can "interact" with a work in progress in the same way that interaction occurs with a work in a traditional medium. The artist is free of mechanical obstacles and can explore the computer's myriad offerings (plate 36).

Artist Darcy Gerbarg has commented on the facility with which she adapted to this medium:

*I use highly interactive, user-friendly computer graphic paint systems. Because of this, the transition from pigment (paint) to computers is not as great as one might imagine. Instead of mixing a palette of paint before beginning to paint, I mix light to create a colormap. Colormaps and palettes are very similar. Each contains a specific set of colors. When working with pigment, I would choose brushes of varying sizes according to my needs. On the computer I create the brushes I wish to use: thick ones, thin ones, multicolor ones. There is virtually no delay between the act of creating a picture on a computer and seeing it created. The picture happens in "real" time. If I choose to change a color or remove a line, I can do it easily on a computer. I can work and rework a picture until it is exactly what I want and then have the computer give me a full color slide of the image. The image can also be stored in the computer's memory, manipulated, or transformed.[22]*

David Hockney, Jennifer Bartlett, Howard Hodgkin, Andy Warhol, Philip Pearlstein, Keith Haring, Sir Sidney Nolan, Kenneth Noland, Peter Max, Larry Rivers, and Jack Youngerman are among the rapidly growing number of well-known artists who have already worked with digital paint systems (plates 33–41). Although some were initially resistant, they all became enthusiastic about the potential of the medium and excited by their results.

Philip Pearlstein, well known for his penetrating depictions of the human body, was not receptive at first to the suggestion of television producer Jerry Whiteley that he paint with a computer. Yet, once Pearlstein overcame his initial trepidation, he was astonished by the ability of the computer to create effects of amazing subtlety. He found the stylistic range comparable to conventional painting. He could even achieve the pointillism of Seurat, the transparent planes of Cézanne, and the faceted scaffolding of Analytic Cubism. Moreover, he could see the entire evolution of a composition by playing back the video on command.[23] For Whiteley and Pearlstein, the tape of Pearlstein working on the paint system goes "a step beyond the famous filmed sequence of Picasso painting on glass."[24] It is enormously educational because the viewer can concentrate on the artistic process without the interference of the artist's hands or brushes.

After much experimentation, Pearlstein decided that the digital paint box is "a medium unique unto itself" and that the images he created on it "should not be output"[25] into hard copy. Instead, they should be seen only in the animated form in which they were created. He did, however, develop one of his computer-generated images into a watercolor and a painting, both of which are called *Hands and Feet* (1984). They are traditional Pearlstein compositions, but the influence of the electronic palette is unmistakable.

Interactive systems have become the predominant medium of many artists. Darcy Gerbarg, one of the most active members of the computer art community, began searching in 1978 for a medium capable of achieving modern pictorial effects analogous to those produced by the audio-synthesizer in electronic music. The following year, when she learned about the user-friendly interactive paint system developed at NYIT, she realized it was what she was looking for. She spent the next eighteen months working on the system at NYIT.

In a series aptly named Digital Visual Images, Gerbarg realized her first computer-aided image in 1980: a three-color lithograph with a three-color viscosity etching superimposed upon it. Gerbarg's preoccupying interest in the creation of spatial ambiguity through color and line is evident in the lithograph's interpenetration of figure and ground. The form of an irregular shape of fairly uniform

33. Philip Pearlstein. *Hands and Feet*. Frame from *Philip Pearlstein Draws the Artist's Model*. 1983–84. Interactive laser-beam videodisc and videocassette. Courtesy Interactive Media Corporation, New York

*Pearlstein is one of many well-known artists who have recently experimented with electronic paint systems. Although artists using computers find basic pictorial concepts are unchanged, they are attracted to the computer for its ability to manipulate an image electronically and thereby create a seemingly infinite range of pictorial alternatives.*

*Hardware:* Images I System, Computer Graphics Laboratories. *Software:* Images I

34. David Hockney. *Untitled*. 1986. Frame from videotape, *Painting with Light: David Hockney*. Courtesy Griffin Productions, London

*Hockney was captivated by his opportunity to "paint with light" and to apply one "wet" color on top of another without any loss of saturation. He compared the new medium to stained glass.*

*Hardware:* Quantel Paintbox. *Software:* Quantel Paintbox

OPPOSITE

35. Jennifer Bartlett. *Untitled*. 1986. Frame from videotape. Courtesy Griffin Productions, London

*In 1986, Bartlett was invited along with several prominent artists—David Hockney, Howard Hodgkin, Sir Sidney Nolan, and Larry Rivers—to the plant in Newberry, Yorkshire, where Quantel manufactures Paintbox, a computer animation system developed for the broadcasting industry and commonly used to create logos and special effects for television. With this system, an artist can conduct an interactive dialogue with the computer by drawing with a light pen on a digitizing tablet and selecting colors and brushes from a menu of options on the screen. Paint systems allow the artist to take advantage of the computer's range of colors and effects, its memory, and its unique aesthetic without radically altering traditional working methods. As the artist draws, so results appear on the screen. But it does require an adjustment of hand-to-eye coordination, as evidenced by the photograph opposite. After the artists learned to use the computer, the series of images they produced shows the amazing versatility of the Quantel Paintbox.*

*Hardware:* Quantel Paintbox. *Software:* Quantel Paintbox

36. Jennifer Bartlett working on the Quantel Paintbox. 1986. Photograph courtesy Griffin Productions, London

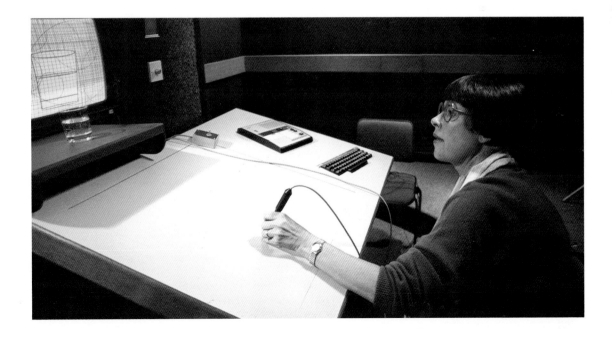

color in the center is echoed, although not precisely, by a linear configuration that surrounds it, the result of fluid handling of the electronic medium. After leaving NYIT, Gerbarg experimented with many of the sophisticated paint systems available (including Ampex, Aurora Imaging, Ramtek, and Digital Effects).

When she became interested in working on large-scale projects, she had four of the pictures in her Digital Visual Images series executed in limited editions as 3-M Scanamurals, a popular but expensive way to translate computer-generated imagery into large sizes. To have a Scanamural executed, an artist can send a transparency of the computer's final composition to the 3-M Company in Minneapolis. There, the photo is scanned and an ink-jet plotter creates the image on fabric at whatever scale is requested. Upon completion, the finished composition is mailed to the artist, who has little opportunity to influence the printing results. Translation into Scanamurals are often disappointing because of their uniform surfaces.

Gerbarg was frustrated by this and other attempts to translate computer-generated images into hard copy (plate 43). Too often, the intensity of an image

37. Howard Hodgkin. Set design for *Pulcinella*. 1986. Frame from videotape. Courtesy Griffin Productions, London
*Armed with the thickest brush the Paintbox system could provide, Hodgkin, known for his lush, decorative canvases, produced remarkably painterly set designs for Stravinsky's* Pulcinella, *a commission from the Ballet Rambert.*
*Hardware:* Quantel Paintbox. *Software:* Quantel Paintbox

radiating from the backlit illumination of a video screen is lost when the image is reproduced photographically. After numerous experiments, Gerbarg now achieves her final product by projecting 35mm slides of her computer-generated images onto canvas, tracing their outlines, and spray painting the forms. Her most recent group of paintings is distinguished by a subtlety of shading, a softness of forms, and a muted palette rarely associated with computer art (plate 44).

Barbara Nessim, an artist acclaimed for both her fine art and commercial work, has been devoting a great deal of time to the electronic realization of her images since 1982, when she was given access to the Teletex-Telidon IPS 2 computer at Time, Inc., and seduced by the possibility of "painting with projected light." On this relatively limited system—offering only six drawing modes (a dot, a line, an arc, a rectangle, a polygon, and a circle) and six basic hues—she created a series of boldly colored, highly stylized female heads.

Nessim, who draws with great facility and speed, finds the computer is particularly useful for its flexibility: "It allows [me] to change color and composition in ways impossible with other mediums."[26] Recently, Nessim has been using the popular Easel paint software on an IBM PC. Through her adept use of the airbrush mode available in this software package, she has achieved the delicacy of the pastels she more frequently makes by hand (plate 45). Photographic enlargements

38. Howard Hodgkin. Set design for *Pulcinella*. 1986. Frame from videotape. Courtesy Griffin Productions, London

39. Jack Youngerman. *Untitled*. 1985. Cibachrome print

*Youngerman is one of many painters receptive to the computer as a design tool. He has discovered that many of the time-consuming studies he now does by hand before beginning a composition can easily be painted on the computer. For Youngerman, who often takes a single theme through many variations, the computer functions as a sketchpad that can electronically alter colors and rotate compositions, offering him multiple options.*

*Hardware:* Images II+ System, Computer Graphics Laboratories. *Software:* Images II+

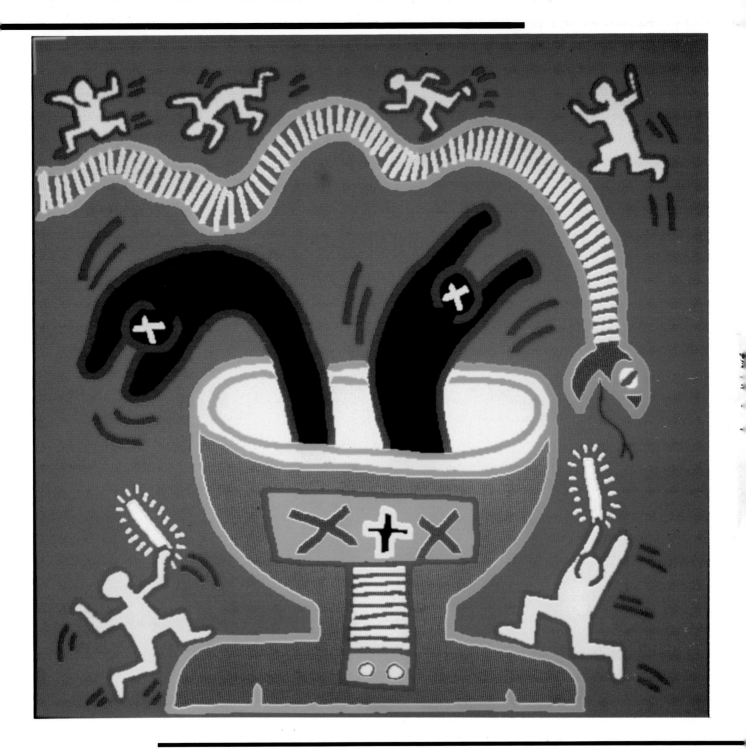

40. Keith Haring. *Untitled*. 1983. 35mm slide

*Graffiti artist Keith Haring has experimented with computers several times. This paint-system image belongs to a series he made while on a visit to Tokyo in 1983. He commented in an 1984 interview in* Flash Magazine: *"Living in 1984, the role of the artist has to be different from what it was fifty or even twenty years ago. I am continually amazed at the number of artists who continue to work as if the camera were never invented, as if Andy Warhol never existed, as if airplanes, and computers, and videotape were never heard of."*

of her computer-generated images are her final hard copy.

Nessim's work often examines the relationships of men and women, and her drawings are charged with an eroticism and sexual energy evoked as much by the frenetic quality of her lines as by the subject matter—a feeling conveyed even more effectively by the heightened video palette of the computer. In a surprising group of drawings on the Apple Macintosh, a system limited to black-and-white output, Nessim, whose studio shelves are lined with notebook after notebook filled with reflective drawings that are her visual diary, has found a way to convey the intimacy and delicacy of drawing by printing her paint-system images on high-quality rag paper and enhancing them in watercolor and pastel (plate 46). Artists like Nessim, Gerbarg, and Pearlstein have used digital paint boxes in the most traditional manner possible with this electronic medium. For them, the computer is a direct extension and amplification of their work in other mediums. Other artists manipulate and enhance images electronically through image processing. Rather than creating images with electronic paint, image-processing techniques manipulate digitized images stored in the computer's memory. Image processing, which can occur in real time and be interfaced with a paint program, has far-reaching computer graphics applications outside the fine arts:

41. Larry Rivers. *Green*. 1986. Frame from videotape. Courtesy Griffin Productions, London

*Figurative artist Larry Rivers drew a portrait of Green, lead singer of the English rock group Scritti Politti, on the Paintbox system.*

*Hardware:* Quantel Paintbox. *Software:* Quantel Paintbox

Image processing underlies much of what in television is called "digital special effects," in which the television raster itself is digitized and then manipulated in various ways to squeeze it, flip it, rumble it, break it into pieces, mirror it, and so forth. It also underlies the most modern techniques used for medical diagnosis, including CAT scans and NMR. Image processing is of increasing importance in applications such as remote sensing (the study of the earth's surface based on satellite photographs) and machine vision (which uses artificial sensors that can "see" patterns and detect movements).[27]

42. Jean-Noël Duru. *Untitled.* 1985. Acrylic on acetate, 47 × 63″

*French artist Duru has devised a clever way to expand upon the black-and-white output of the Macintosh computer. He transfers enlargements of his paint-system images to sheets of acetate that he then paints in bright, brassy colors, befitting his erotic depictions of scantily clad female dancers.*

*Hardware:* Apple Macintosh®. *Software:* Billboard MacPaint®

43.

44. Darcy Gerbarg. *Gentlemen*. 1986. Acrylic on canvas, 62 × 88″

*Gerbarg is fortunate to have a very sophisticated paint system with customized software written for her by Gene Miller, former director of Research and Development at MAGI (Mathematical Applications Group, Inc.) SynthaVision, one of the leading commercial computer graphics companies. She generated the image on which this painting is based using this system. Upon completion on the screen, the image was output to 35mm film as a slide, projected onto canvas, taped, and spray-painted one color at a time.*

*Hardware:* Digital 68,000 computer, Digital Graphics Cat 24 bit frame buffer, Dunn camera. *Software:* by Gene Miller for Digital Visuals, Inc.

43. Darcy Gerbarg. *May I*. 1981. Ceramic tiles, 100 × 50″

*Gerbarg frequently translates her computer-generated imagery into traditional mediums. In this way, she can use the design options offered by electronic paint systems as well as a wide variety of formats for their formal representation. For this work, color separations were made from one of Gerbarg's computer-generated designs, which she then silkscreened onto the tiles (created under the New Works in Clay Project directed by Margie Hughto at the Syracuse Clay Institute of Syracuse University). Later, Gerbarg made a silkscreen print from the same computer design used for the tiles; only the image was reversed and the colors changed, an easy feat for the computer to accomplish.*

*Hardware:* Cromemco computer. *Software:* Easel by Time Arts

45. Barbara Nessim. *Communication Disc.* 1986. Cibachrome print, 16 × 20″

*In an attempt to make her computer-generated images more like her work in traditional media, Nessim, who is particularly fond of drawing on paper with deckle edges, electronically painted a deckle-edged background for this drawing. On the computer, she is able to change the color of the "paper" for different images she chooses to draw. This amusing play on the concept of a machine-made "handmade" piece of paper is one element in Nessim's commentary on means of communication (the man relates to the woman with a communication disc).*

*Hardware:* IBM PC. *Software:* Easel by Time Arts

46. Barbara Nessim. *Memory Swirls.* 1986. Ink-jet print with pastel on Arches paper, 18 × 24″

*Like many other artists who are active in the computer art community, Nessim is constantly searching for new hard-copy options for the images she generates on the paint system. Rather than be restricted by the standard 8½-by-11-inch format and quality of computer paper, she has begun plotting her drawings in sections on high-quality rag paper. To enhance their colors, she adds pastel.*

*Hardware:* Apple Macintosh 512 computer/Apple Imagewriter I printer. *Software:* Billboard MacPaint

"Memory Swirls"                    ©Barbara Nessim 11/20/86

47.

48. Lillian Schwartz. *After Picasso*. 1986. Cibachrome print, 50 × 67⅞". Copyright 1986 by Lilyan Productions, Inc.

*Picasso is the inspiration for Schwartz's most recent body of work. She has "painted" on a Symbolics computer system a series of brightly colored, imaginative recreations of his paintings. One of the most exciting capabilities of the Symbolics system is its combination of both two- and three-dimensional capabilities. In this image, for example, the brow of the profiled female figure on the far right was first modeled then enhanced with paint. Schwartz was therefore able to endow physiognomic features with full volumetric qualities.*

*Hardware:* Symbolics 3600 computer. *Software:* Symbolics

47. Kenneth Noland. *Untitled*. 1987. Handcolored monoprint on paper, 17 × 16¾"

*One of the most dedicated converts to computer technology is painter Kenneth Noland, who has become absorbed in computer-processed techniques. For some artists, the computer is a tool for expanding on or changing images; for Noland, its greatest significance is its ability to set colors into motion and to wash a scene with different hues. In a recent series of monoprints, he output a group of his computer-generated images as 35mm slides and had them photoengraved. After they were inked and printed, he enhanced them by hand with acrylic paint.*

*Hardware:* Compaq AT 286 computer, AT&T Targa Board, Sony Chromakeyer CRK 2000, CalComp 2000 Digital
*Software:* Lumena by Time Arts

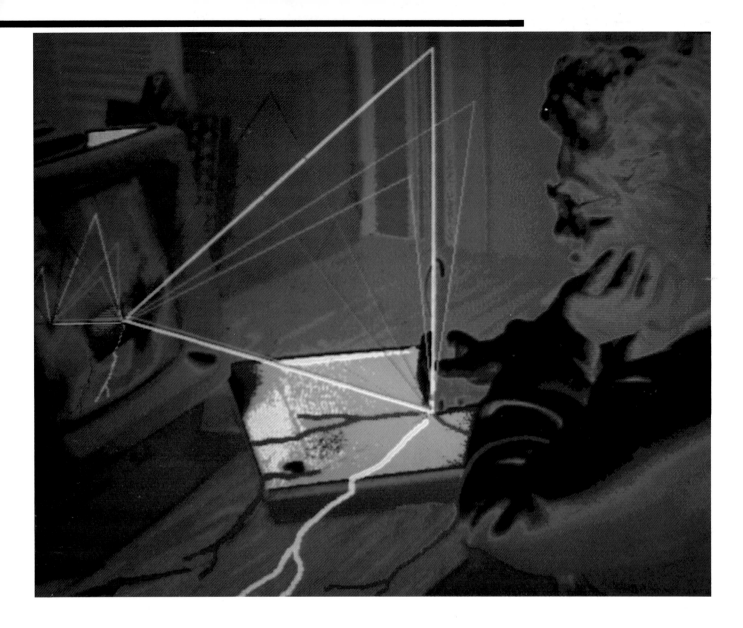

49. Sonia Landy Sheridan. *Drawing in Time.* 1982. Ektachrome print, 16⅝ × 27½"

*Sheridan, Professor Emeritus at the School of the Art Institute of Chicago, established the Generative Systems Program, an interdisciplinary art and technology laboratory at the institute in 1970. Sheridan's major contribution has been the development of the 3-M Color-in-Color copying machine into a sophisticated graphics system with numerous artistic applications. Her Drawing in Time series illustrates one of the many possibilities for electronic self-portraiture with a paint system. Video-digitized images can be manipulated through enlargement, rotation, colorization, variation of texture, or any number of picture-processing techniques. The vastly popular Easel software, with which this image was generated, was written by Sheridan's former student John Dunn in response to her desire to enable students to be able to paint easily with a computer with only minimal use of a keyboard.*

*Hardware:* Cromemco Z-2D computer, Digital Graphics Cat 400 boards. *Software:* Easel by Time Arts

For many artists, image processing offers an otherwise unobtainable visual vocabulary. Video-recorded images of live action can be scanned, and with the push of a button the image appears in digital form on the CRT. (In fact, photographs and inanimate three-dimensional objects are often used rather than live subjects.) Once an image has been digitized, picture-processing techniques can colorize or increase the size of the pixel components (so that the pixel structure of the composition is emphasized), and matte (electronically cut and collage) the composition.

It was Leon Harmon's and Kenneth Knowlton's image-processed portrait of the nude in the *Machine* show at The Museum of Modern Art in 1968 that first attracted Lillian Schwartz to the digital computer. Schwartz, who had a work in the show, met Harmon there and through him was invited to Bell Labs, where she

50. Nancy Burson. *Number Five.* 1985–86. Cibachrome print, 10¼ × 13¼″

*Burson frequently fuses two or more photographs of disparate entities into a composite image, using software specially written for the purpose. In this image-processed work from a series in which Burson appropriated works of art by noted masters, one of Cézanne's famous depictions of Mont Sainte Victoire is combined with van Gogh's* The Huth Factories at Clichy. *Although in this example she has used the computer fancifully, her combinations often have provocative social or political messages. Using a newer technique, Burson has been able to project how a person will age so convincingly that on several occasions the FBI has successfully located missing children with the assistance of her reconstructions.*
*Hardware:* IBM PC AT. *Software:* by Richard Carling and David Kramlich

has since collaborated with computer scientists, psychologists in visual perception and color, hardware engineers, and electronic music composers in order to expand the potential of computer-generated images. For Schwartz, Knowlton's and Harmon's algorithms initially offered a way of transforming her traditional portraits and figure studies into computer-generated images. For Knowlton and Harmon, Schwartz presented a new source of imagery for their processing techniques. No longer were they reliant on photographs as a point of departure: they could use her original works of art. Schwartz, in turn, has found the computer to be a superb tool for appropriation art.

In 1983, Schwartz was commissioned to design a poster for the 1984 opening of the newly renovated Museum of Modern Art. In the choice of a computer-aided design, it was the museum's intention to demonstrate its recognition of the computer as an exciting new medium of artistic expression. Schwartz digitized numerous photographs of paintings, sculpture, drawings, prints, and photography from the museum's collection. Once these objects were stored in the memory of a computer at the IBM Thomas J. Watson Research Center, where she worked on the project, she was able to change their proportions, use them as transparent overlays, and combine them with architectural renderings of the museum's new facade and unusual perspectival depictions of the interiors. She created seamless collages only possible with a computer. Recently, Schwartz began painting again. This time, however, she is painting on a Symbolics computer system, which she is testing for artificial intelligence capabilities at AT&T.

A growing number of artists with backgrounds in photography are attracted to computer-imaging techniques. Through image processing, artists such as Nancy Burson (plate 50) and Thomas Porett have not only found it unnecessary to relinquish their former manner of working, but they have also found a way to wed old and new technologies. Porett, director of Computer Studies at the Philadelphia College of Art, has explained that his involvement with computers evolved naturally out of his interest in achieving even greater control over his images than photography offered. Porett begins all his compositions by digitizing a photograph. He can then electronically alter its color or value with a program that he has written or by using a light pen (plate 54). As he has said of the process, "At this point, photographic and painterly attitudes merge into a most natural blend."[28] Porett's studies of people juxtapose single figures and groups or isolate parts of the human body, such as the face, lips or breasts, sometimes repeating and recomposing an image in the process. Porett refers to the method by which he structures his compositions using video or photographic digitization as "electronic collage." In

51. Lillian Schwartz. *It Is I*. 1987. 35mm slide. Copyright 1987 by Lilyan Productions, Inc.

*While she was juxtaposing images on the computer screen, Schwartz was astonished by the physiognomic similarities between a self-portrait of Leonardo and his famous painting of the* Mona Lisa. *The striking resemblance resulted in her controversial conclusion that the true identity of the mysterious sitter is the famous artist himself. Although her pictorial explorations were conducted purely for compositional inspiration, she has shown that visual research on the computer may well become an integral part of the art historical process.*

82    *Hardware:* Symbolics 3600 computer. *Software:* Symbolics

his description, this technique allows him to "structure the visual elements, edit and change meaning in ways that are analogous to the flexibility of using a word processor when writing."[29]

The electronic collaging of stored images has been achieved with particular success by members of the Visible Language Workshop, founded in 1976 at MIT, under the direction of Muriel Cooper. Among the artists who have utilized the various reproductive tools of the VLW workshop, including its interactive computer graphics system, are Rob Haimes, Alyce Kaprow, Ron MacNeil, Joel Slayton (plate 52), Joan Shafran, and Francis Olschafskie. In their work at the VLW—by contrast with their work at other facilities, where digitization was either not available or not stressed—all these artists incorporated into their graphics photographs of the human figure and other stored data either already created for them or which they input with a video camera. They could then collage and manipulate, colorize, and even add script to the images.

52. Joel Slayton. *Markface*. 1981. Polaroid print, 68 × 40"

*Slayton is drawn to the computer for its ability to synthesize the effects of photography, video, painting, and graphics. He began this computer-generated portrait by digitizing his sitter with a video camera. Thereafter, using the Visible Language Workshop system, he was able to manipulate the entire picture or any section of it through the addition of text and other picture-processing techniques. Upon completion, he displays his computer-generated compositions as photographs.*

*Hardware:* Perkin-Elmer 3220 computer, Grinnell frame buffer. *Software:* Massachusetts Institute of Technology–Visible Language Workshop system

53. Nam June Paik. *Laurie Anderson*. 1985. Laser photograph, 17¾ × 21¾". Courtesy Holly Solomon Gallery

*Paik, whose first computer-generated images were part of a film entitled* Confused *(made with the help of A. Michael Noll at Bell Labs in 1967), combined several state-of-the-art techniques to create this image of Laurie Anderson, the performance artist. The image was a frame he "grabbed" from his television program* Good Morning, Mr. Orwell, *manipulated with a computer, and then transferred to film through laser scanning.*

Joan Truckenbrod's concerns with the ambiguities of natural phenomena and interpersonal relationships unify much of her work. Recently she has explored her relationship to herself and to her daughter in a series of photographs constructed from digitized imagery. The emotional complexity of their interactions is conveyed by her effective interpenetration and juxtaposition of their fragmented visages. Truckenbrod has used the capabilities of the computer to collage and layer shapes as an effective metaphor for the psychic interplay between a mother and an adolescent daughter.

In 1986, Andy Warhol embraced the inexpensive Amiga as his latest tool with the same enthusiasm and uncanny sense of timing with which he made high art out of commonplace objects. The easy-to-use Amiga and the virtual ability of the system to simulate his own way of working made his transition to computer-aided art seem effortless. He worked extensively with image-processing effects — only a step away from the photographic silkscreen technique of his famous portraits of Elizabeth Taylor and Marilyn Monroe (plates 55–56). The video palette and the pixel-based imagery — the epitome of today's popular new look — is an aesthetic with which Warhol was immediately comfortable. Moreover, by colorizing a picture-processed photograph (which was then recorded on film), he completed in minutes a portrait that looks astonishingly like those it normally took him weeks to produce. He even had an Amiga installed in his studio — a remarkable system that for approximately fifteen hundred dollars can offer many capabilities not long ago available only at the high end of the industry. From self-portraiture to special effects for MTV videos, he had just begun to explore the myriad applications offered to him by this promising tool when he died.

Steve Miller also relies on picture processing for his computer-aided artworks, which comment on the fate of man and nature in our computerized society. He begins each composition by digitizing a photograph that either he or a friend has found: cityscapes and waterfalls are recurrent themes. His diptychs juxtapose recognizable depictions of waterfalls against versions of the same image in which the pixel structure is more pronounced, unmistakably subjecting nature to the power of the computer. His cityscapes subject urban terrains to a similar process (plate 59). Miller draws witty analogies between his cities and those of French painter Robert Delaunay. In Delaunay's work, the dabbed pointillist brush strokes function as a screen through which Paris is seen; in Miller's paintings, the pixillation occurs only in selected areas. The curtained treatment of Miller's cityscape as well as certain other forms he uses are appropriated from Delaunay

---

54. Thomas Porett. *Ikons: An Interactive Image Journey.* 1983. Ink-jet print on paper, 12½ × 12½"

*This is one of many images a viewer may see while interactively selecting a program from Porett's computer graphics disc, which runs on an Apple 2 +. Sometimes, as in this example, Porett displays his images in hard copy as ink-jet prints. This portrait was created by electronically collaging several images, which first had been video digitized and then enhanced with a paint system. The format in which Porett chose to realize the image accentuates the low resolution of the Apple computer.*

*Hardware:* Apple 2 + computer. *Software:* by the artist

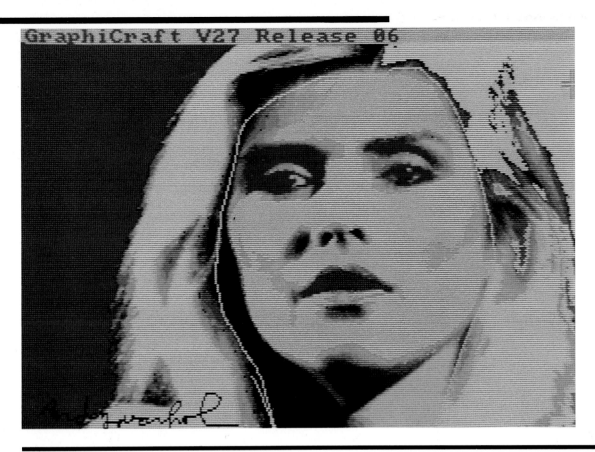

56. Andy Warhol. *Deborah Harry*. 1986. Lithograph print on 85lb Reflections cover, 16 × 20″. Courtesy Commodore International Ltd.

*Hardware:* Commodore Amiga 1000 computer. *Software:* Graphicraft by Commodore Amiga, Inc.™

55. Andy Warhol. *Self-Portrait*. 1986. Photograph. Courtesy Amiga World

*Warhol was intrigued by colorizing video-digitized images, which he could use as studies for portrait commissions. The ability to change hues electronically is similar in concept to his popular silkscreened serial images—the computer, of course, offers the possibility for endless serial imagery. The accentuation of the individual pixels in this self-portrait was achieved by issuing a single command to the computer. Above: Andy Warhol with the self-portrait in progress. Photograph courtesy Amiga World.*

*Hardware:* Commidore Amiga 1000 computer. *Software:* Graphicraft by Commidore Amiga, Inc.™

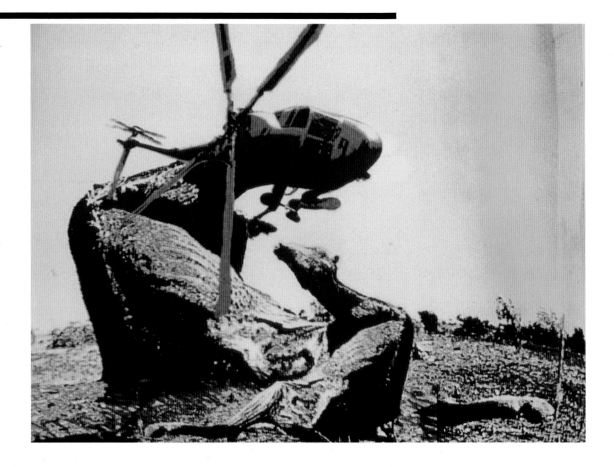

57. Sir Sidney Nolan. *Image Five*. 1986. Frame from videotape. Courtesy Griffin Productions, London

*One of Australia's most distinguished artists, Nolan explored the potential of the Paintbox system, making electronic collages of his native landscape through the video digitization of his existing paintings. Once an image is stored in the memory of the computer it can be combined with others, recolored, or totally transformed. The process allows new and startling creations—even a surrealistic encounter between a helicopter and a fallen kangaroo.*

*Hardware:* Quantel Paintbox. *Software:* Quantel Paintbox

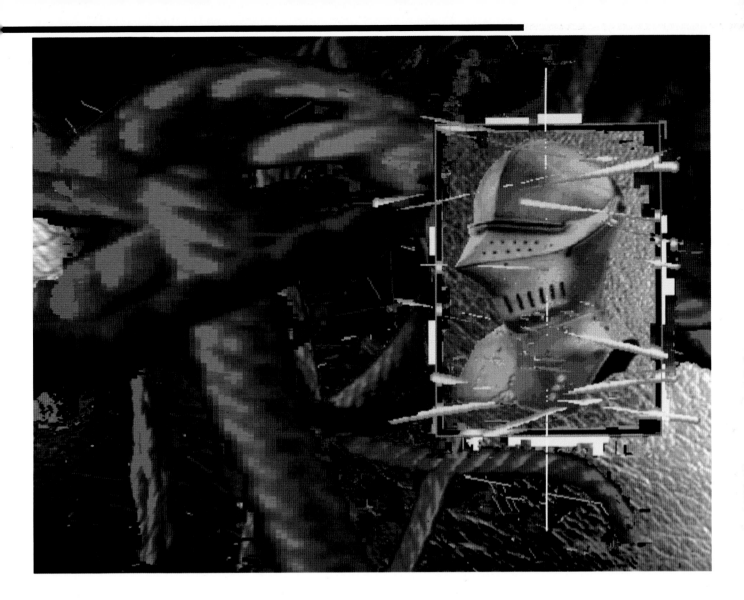

58. Byron Sletten. *Desire I*. 1986. Scanamural, 96 × 120″

*Through digitization, Sletten is able to explore the juxtaposition of real objects (the rope) and photographs (the helmet), both of which are recorded by a video camera. Once the images are stored in the computer, he manipulates them by adding color, recompositing, and overlaying the different elements. To realize this composition in hard copy on a large scale, Sletten turned to the 3-M Scanamural process, in which a transparency of the image was scanned with a beam of light and reconverted into digital information. A plotter responding to this information sprays four jets of paint onto a canvas stretched over a large drum. As the drum slowly rotates, the painting is completed line by line in full color.*

*Hardware:* IBM PC AT computer, Imaging Technologies board, 3-M Scanamural. *Software:* Lumena by Time Arts

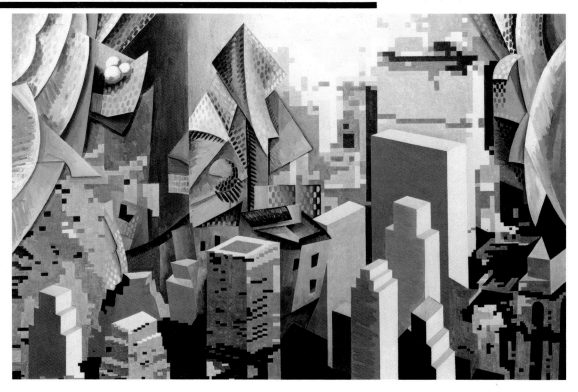

and explore the latest technological advances within the Cubist framework of modern art. Although the medium is startlingly new, Miller notes that computer-aided art is, of course, produced by artists influenced by the traditions of twentieth-century art. A new digital vocabulary and image bank is evolving, yet the computer aesthetic is still not autonomous—small wonder since the medium is barely twenty-five years old.

Les Levine, who has long been involved with the incorporation of technology and information media in his work, was among the artists chosen for the *Software* exhibition at the Jewish Museum in 1970. He invented the term "media art" to describe his work in this show and has continued to identify himself as a "media sculptor." He now uses the computer frequently and has experimented with the capabilities of a number of different systems. He is not interested, however, in creating computer artwork but rather in using the computer as a "modeling tool."[30]

For a more recently executed series of "computer-assisted drawings," Levine used the Fairlight CVI, a computer system with limited "paint" capabilities most frequently used for video special effects. He began with photographs and drawings, which he digitized. Through certain commands Levine issued, images were reproduced that were related to the originals, both in subject matter and coloration, yet they could be distorted through magnification, rotation, or various other

59. Steve Miller. *Zoo Zoo.* 1985. Oil on canvas, 48 × 72". Collection Raymond J. Learsy, New York
*Miller uses the electronic collaging capabilities of the computer to bridge old pictorial traditions and new technology.*

image-modification capabilities of the Fairlight system. The artist projected 35-mm slides of the completed images onto canvases and recreated the pictures in oil-stick crayon. Most of the drawings in this series boldly combine words and images. They are concerned with a wide range of subjects, including social issues and the structure of language (plate 60). The verbal messages are a crucial component for Levine. In an essay for *New Observations* he has explained:

*Images are always in search of meaning. The combination of image and word in the computer age is episodic in nature, desiring to perform a similar task as the printed circuit . . . an entire circuit being born in one piece as opposed to an architecture of constructed parts. . . . Language gives the clearest picture.*[31]

Levine has accepted the computer as an integral part of his artmaking process, just as it is an integral part of our society. Although none of his works are characteristic of those associated with computer art, the computer has offered him otherwise unattainable perceptions of the world.

## Computer Iconography

In spite of the newness of the medium, every artist seems to be coming to terms with the computer. For some, it is a source of imagery; for others, a tool; and for others, an object of fascination. There are artists, including Gretchen Bender, Donald Lipski, and Margot Lovejoy, who express their interest in digital media by incorporating computer output of different varieties in their art rather than

---

60. Les Levine. *Appear—Mirror—Reflect.* 1985. Acrylic on canvas, 68 × 148"

*Levine's use of computers was a natural extension of his earlier experiments with video. He began this powerful two-panel painting by digitizing his own drawing of the right panel and manipulating it on the computer he used until the image on the left panel was generated. Then it was output to film, projected as a slide onto canvas, and painted.*

*Hardware:* Fairlight CVI computer

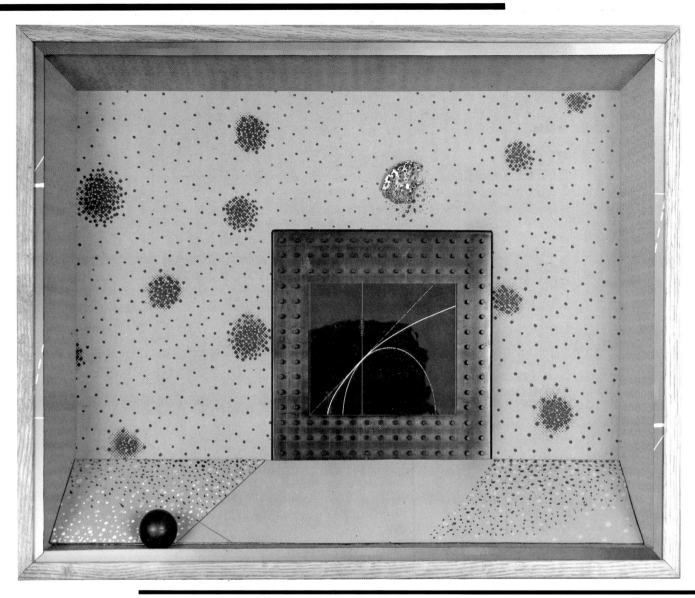

62. Margot Lovejoy. *Flux III*. 1982. Mixed-media construction, 14 × 18″

*Lovejoy, who endows even the most mundane objects with cosmic significance, is among a growing group of artists who incorporate into their artwork computer-generated material they did not produce themselves. The paper that lines this box is a computer-generated printout with barely perceptible numbers printed on it. The clustering of the dots represents stellar constellations, the black rubber ball is a reference to the universe, and the diagram is of Hubbel's Law, a paradigm of visual and theoretical appeal to Lovejoy.*

PREVIOUS PAGES

61. Donald Lipski. *Passing Time–#297*. 1982. Fanned Chemical Bank computer printout, 25 × 12 × 15½″

*One of the objects Lipski, a sculptor with an uncanny knack for finding sculptural material in unlikely places, made from computer printouts he found in a pile of refuse. Although his choice of subject matter may appear haphazard, he was attracted to printouts because of their color, the magnitude of the numbers, and the highly classified nature of the data. In another series, Lipski, who is often attracted to an object because of its obsolescence, constructed a group of provocative objects from punch cards formerly used to input data into computers.*

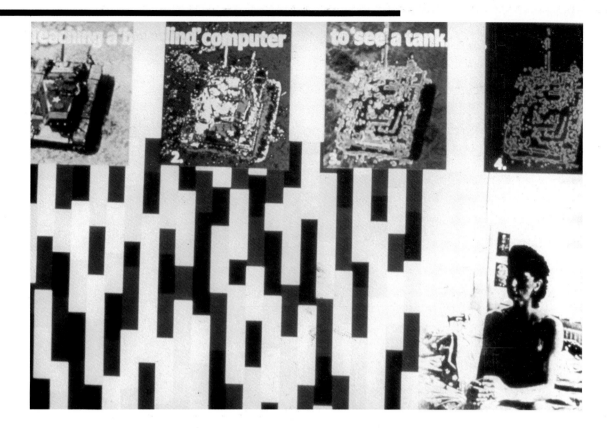

working directly with the technology themselves. Lovejoy, for example, culls images from meteorological data and other computer printouts that are aesthetically appealing to her. She then transforms them into lyrical visions in various media (plate 62).

Instead of taking data-processed information as her point of departure, Gretchen Bender uses "state-of-the-art" computer imagery in her two-dimensional works as well as in her multiple-monitor performance installations (plate 63). For Bender, this vocabulary appropriately reflects the concerns of our society. In her multiple-monitor video installations, she bombards the viewer with high-tech images at a pace akin to the rapidity of the computer's processing speed.

Donald Lipski, who is renowned for transforming the detritus of society into poetic objects, has often used baled paper from a local company for his sculptures. He was particularly intrigued when the handwritten ledgers and traditionally printed materials that he had found there were replaced by voluminous quantities of computer printouts. His use of these printouts for a number of sculptures was provoked as much by his anticipation of their forthcoming obsolescence in a more

63. Gretchen Bender. *Autopsy*. 1983. Enamel silkscreen on sign with color photo on masonite, 64 × 96″

*In order to create this portrait of the environment in which we live, Bender, best known for her multimonitor video performances, culled the imagery from one of the reels of film and videos compiled by SIGGRAPH in conjunction with their annual convention. Bender's use of this imagery reflects the iconic role that computer-generated imagery now assumes in our society.*

fully automated society as by his amazement that confidential material was so carelessly discarded as soon as it was replaced by more current data. A number of his recent pieces fold, twist, and paste sheets of computer paper (sometimes beyond recognition) into works of art (plate 61).

While some artists have incorporated the iconography of computers but do not actually use the machines, Joseph Nechvatal submitted his conventional drawings to 3-M for execution on a large scale (plate 64). He had been contemplating the Scanamural process for two years before it was financially feasible for him to have some of his works executed in this manner. (Reproducing his conceptual works of art in another medium was already familiar to him. His previous exhibitions had included photographic enlargements of drawings.) The first paintings in his Scanamural series were executed from black-and-white drawings that Nechvatal tinted by hand after the process was complete. For the later works, he submitted colored transparencies to the 3-M Company and trusted the coloration of the works to the process itself. Indeed, his embrace of the Scanamural process was equivalent to a manifesto:

*The computer is the social organizer of production in the '80s — it frees us from the psychic condition of the nineteenth-century factory worker — which has been the universal condition of the twentieth century. The computer's work is free from sweaty compromise, self-doubt, and human fallibility. The computer/ robotic paintings address this faith in the infallibility of the computer technology which is rapidly changing all of society. Through the theme of control and release, they confront the potentially totalitarian technology of the digital society which symbolizes and appeals to both external order (efficiency, hierarchy, security) and internal order (tidy compartmentalization, strict logic). Information technology is meant to make all of society run on time through control under the guise of benevolent connectedness.[32]*

Although he is ambivalent about the aesthetic ramifications of the computer, Nechvatal's use of the Scanamural process may be construed in itself as another kind of statement about computers. No matter how antithetical digital technology may seem initially either to an artist's working methods or ideology, by sheer virtue of its capabilities this new electronic medium is one with which all artists must come to terms.

---

64. Joseph Nechvatal. *The Informed Man.* 1986. Computer/robotic-assisted acrylic painting on canvas, 82 × 160″. Collection of the Dannheiser Foundation, New York. Courtesy Brooke Alexander, New York

*Nechvatal's recent series of Scanamurals was the result of his first encounter with computer technology. By calling the works that were generated with this technique "computer/robotic paintings" rather than identifying the specific process, he deliberately tried to mystify their origins and to align himself with the technology of our information-age society.*

*Hardware:* 3-M Scanamural

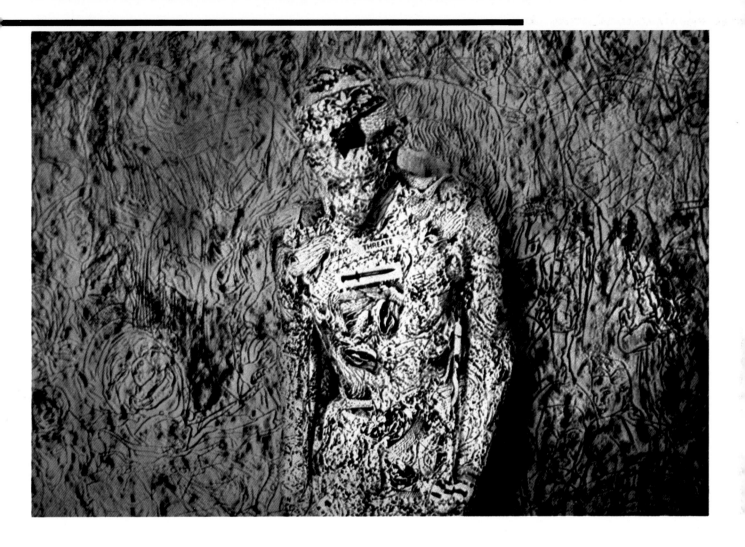

65. Michael Collery/Cranston Csuri Productions. *Vases on Water*. 1983. Cibachrome print, 20 × 24″

*Through Collery's adept use of image-compositing techniques, the glistening vases are convincingly situated on the shoreline of a body of water, in which their forms are reflected. In this early attempt to simulate depth of field, the background is slightly out of focus, appearing as if it were photographed. In fact, it was mathematically constructed: color of surface, source of light, viewing point, orientation of object, intensity of light, as well as numerous other attributes may need to be designated for every pixel on the display. Only with three-dimensional modeling techniques, requiring programs quite different from two-dimensional software, can this degree of verisimilitude be achieved. Today, such a complex image is often composited from separate images, each using a special program for specific effects of color, texture, shading, and reflection.*

*Hardware:* Digital Equipment Corporation VAX 11/780 computer, Marc 4 frame buffer *Software:* Cranston/Csuri rendering software

# IV. *Three-Dimensional Computer Imaging*

## *The Mathematical Synthesis of Reality*

Three-dimensional modeling has produced some of the most stunning and captivating images in the computer graphics field. That these images, which exist in three dimensions in the data base and therefore can be viewed from any perspective, have been completely synthesized from mathematical descriptions is as remarkable as their visual appeal. Certain conditions we take for granted in the natural world — the diffusion of light or its reflection and refraction, as well as the surface texture of such ordinary objects as the peel of an orange or the bark of a tree — all require extremely sophisticated mathematical descriptions in order to be displayed realistically on the computer screen. Although the imaging capabilities of personal computers are quickly approaching the power of larger systems, the majority of the "state-of-the-art" pictures are still being produced by staff members with access to the large systems that only government, industry, and commercial production facilities can afford. Consequently, many of the images popularly associated with computer graphics have been produced at such seemingly unartistic places as the IBM Thomas J. Watson Research Center, Los Alamos National Laboratory in New Mexico, Lawrence Livermore Laboratory in Livermore, California, and the Jet Propulsion Laboratory of the California Institute of Technology. It is in these facilities that the scientist cum artist is still a viable breed. The algorithms of computer researchers Richard Voss, James Blinn, and Nelson Max set the standards for the commercial, scientific, and artistic fields.

Until the late 1960s, all three-dimensional models were depicted as linear wire frames. Only the edges of objects were visible. The first developmental milestone was the removal of "hidden lines," achieved by algorithms written by Lawrence G. Roberts at MIT in 1963. Before, all the lines of a modeled cube, both its front and rear structure, had to appear on the screen. The computer was unable to obscure any of the structure's lines and still retain the modeled image. If part of another cube were placed in front of the first one, it would not block any of the first structure — as it would in our real vision. The computer had no abilities to distinguish between lines that were visible from a certain perspective and those that were not. It had a kind of all-encompassing X-ray vision.

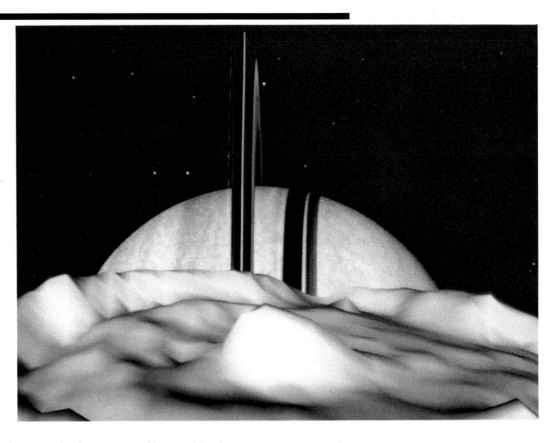

With the new algorithms, only lines actually visible from a certain angle appeared in wire-frame images on the computer screen. It was a useful breakthrough for scientists and engineers because the images on the screen more closely resembled objects in the real world. The primary impetus and most of the funding for further development came from military advisers anxiously awaiting the tools for a realistic flight simulator.

The next major visual advancement created seemingly solid images on a raster screen. This was developed in the late 1960s simultaneously at MAGI SynthaVision in Elmsford, New York, and the University of Utah, one of the most important centers of computer graphics research. Researchers at MAGI developed one solution for modeling solids. They devised a system based on primitive mathematical shapes such as spheres, cubes, and cones that could be rendered directly in

66. James Blinn, Computer Graphics Laboratory, Jet Propulsion Laboratory, NASA. *Mimas Day*. 1981. Still frame from film

*Blinn, a leading computer scientist, has revolutionized the appearance of computer graphics with the numerous algorithms he has written for modeling techniques. Foremost among his programs is "bump mapping," which enables a user to choose a "texture" to apply to a computer-generated surface. Before bump mapping, computers could only produce images with smooth surfaces.*

*Using data transmitted from a spacecraft, Blinn constructed this view of Mimas, the closest moon to Saturn, as it looks during daytime.*

*Hardware:* Digital Equipment Corporation VAX 11/780 computer, 24 bit frame buffer, Evans and Sutherland PS2. *Software:* by the artist

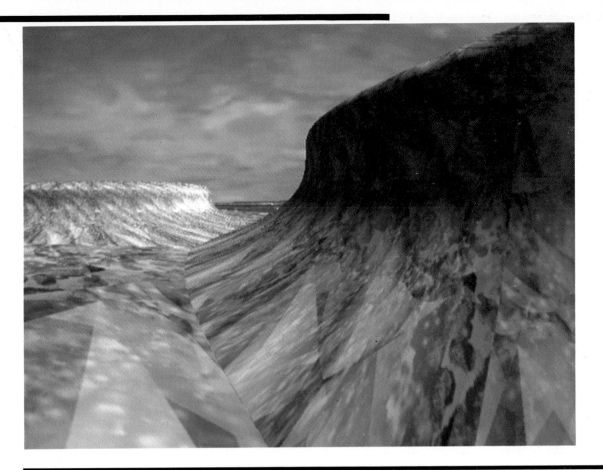

67. David Em. *The Far Away.* 1986. Cibachrome print, 30 × 40″. Copyright David Em

*Recently, Em has moved away from science-fiction imagery. Showing both his and the computer's versatility, he has digitally created a group of landscapes inspired by the topography of northern New Mexico, where he spent a year.*

*Hardware:* Digital Equipment Corporation VAX 11/780 computer. *Software:* by James Blinn

the system. Their approach had the benefit of allowing for modeling with constructive solid geometry, in which a complex solid is built out of simpler solid primitives.

An alternative solution was pursued at Utah, where the evolution from wireframe models on a vector display to shaded surfaces with an impression of solidity on a raster screen was accomplished by using shading algorithms. Solids modeled in this manner were mathematically described as a series of connected, polygonally bounded planar surfaces. This development in turn required algorithms to remove hidden surfaces.

OVERLEAF

68. David Em. *Transjovian Pipeline.* 1979. Cibachrome print, 30 × 40″. Copyright David Em

*To many observers, Em's cosmic fantasies epitomize the aesthetics and subject matter of computer-generated imagery. As futuristic as his visions may appear, Em thinks of them as paintings in very traditional terms; his tools, however, are those of the computer age.*

**103**    *Hardware:* Digital Equipment Corporation PDP 11/55 computer. *Software:* by James Blinn

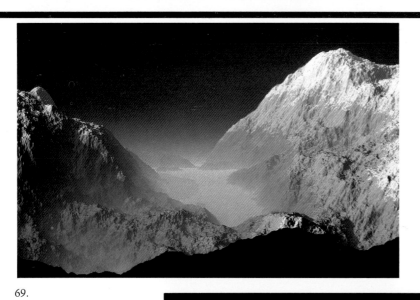

69.

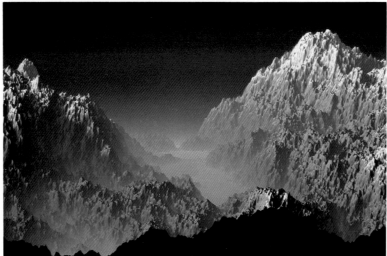

70.

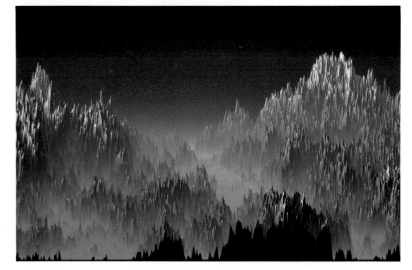

71.

72. Jean-Paul Agosti. *Les Soixante-Treize Jardins*. 1985. Watercolor on paper, two panels, each 40 × 60″

*Agosti's recurrent investigations of nature are indebted both visually and philosophically to his understanding of Mandelbrot's construction of natural phenomena through fractal geometry. Although he does not use the computer himself, Agosti is one of many artists influenced by the computer aesthetic.*

Although the effects of solidity and the removal of these obscured surfaces were impressive, the angularity of the separate facets was particularly disturbing in the representation of curved surfaces (one sphere was approximated by hundreds of small planar facets). In another improvement to shading capabilities, Henri Gouraud, a computer scientist at Utah, perfected a technique that blurred the shading of the facets and gave a polygonally defined model a smooth appearance. The rendering of modeled objects was also improved by Edwin Catmull, then at Utah and currently president of Pixar, who defined surfaces directly as curves in space rather than as series of facets. In addition, he laid the groundwork for James Blinn's "bump mapping," a way to generate unevenly textured surfaces. In the mid- to late 1970s, high-end computer graphics research focused on the simulation of light, shade, and surface quality. By 1975, Bui-Tuong Phong, another Utah scientist, had created a lighting model that provided the effect of realistic illumination from a direct light source. It was now possible to represent highlights and therefore to achieve even greater subtlety of vision.

In 1976, James Blinn, who was a doctoral candidate at the University of Utah and is currently at the Jet Propulsion Laboratory, defined a set of algorithms

69–71. Richard Voss. *Changing the Fractal Dimension*. 1983. Cibachrome print, 10×14″

*The extent to which these simulated landscapes resemble landscapes in the real world may be attributed to fractal geometry, or the Mandelbrot set, as this new branch of mathematics is frequently called. Fractal geometry has won amazing popularity in the computer graphics world as a way to model natural phenomena. Mandelbrot has observed that due to his research the structures of objects are no longer restricted by geometric rules. In his words, fractals take into account the "morphology of the amorphous." They allow an artist or programmer to build infinite degrees of detail into an image. The different visual effects of these three landscapes were created simply by changing the fractal dimension of the program, thus every module was altered, increasing the perceived overall surface roughness and the roughness of individual details.*

**107**      *Hardware:* IBM 3081 computer, IBM 4381 computer, Celco CFR 4000 film recorder. *Software:* by the artist

73. Isaac Victor Kerlow. *Pattern 1.5.* 1985. Cibachrome print, 20 × 24"

*Hardware:* Digital Equipment Corporation VAX 11/780 computer, Grinnell frame buffer. *Software:* CARTOS

74. Isaac Victor Kerlow. *Ornament over the Grand Promenade.* 1985–86. Acrylic on linen, 66 × 50"

*Kerlow portrays the ancient myths and traditions of his native Mexico with modern technology. One of his primary artistic concerns is the successful translation of computer-generated imagery into other media. The striated, labyrinthine form suspended in the pointillist sky of this painting is based on a mathematical construction of a classic Pre-Columbian motif, which he modeled on a powerful computer (plate 73). Some of his motifs also reflect computer-imaging techniques. The stepped pyramids, for example, symbolize the jaggies of low-resolution systems.*

*Hardware:* Digital Equipment Corporation VAX 11/780 computer, Grinnell frame buffer. *Software:* CARTOS

OVERLEAF

75. Rob Cook, director; Loren Carpenter, Tom Porter, Bill Reeves, David Salesin, Alvy Ray Smith. *The Road to Point Reyes.* Cibachrome photograph. Copyright 1986 by Pixar. All rights reserved

*Verisimilitude is a primary objective of the computer graphics industry, but this degree of photographic realism is only possible with sophisticated compositing techniques and highly specialized programming. Each effect, from the haze in the sky to the ripples in the puddles, has to be constructed separately, in order to create the necessary variety of texture and light. The result is a technical tour de force, or a "one-frame movie," as Alvy Ray Smith has described it.*

*Hardware:* Digital Equipment Corporation VAX 11/780 computer, Ikonas frame buffers. *Software:* Pixar proprietary

74.

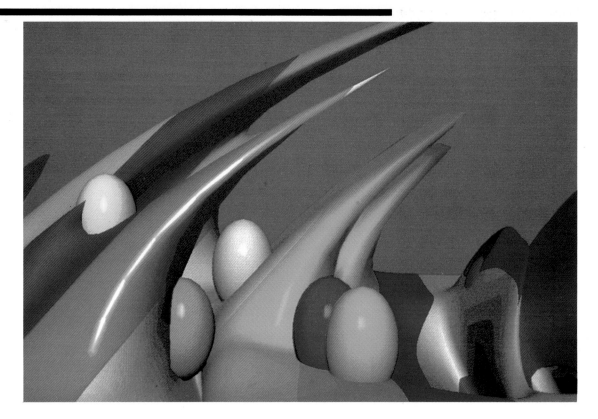

for bump mapping, creating the illusion of texture on the surface of a three-dimensional object. In some of his early experiments a strawberry was given a convincingly dimpled surface and an orange a bumpy skin. Blinn's next major accomplishment was to devise a model to create even more refined depictions of illuminated surfaces. In 1979, the Jet Propulsion Laboratory used Blinn's advanced computer graphics software program to make convincing simulations of the Voyager I spacecraft as it passed Jupiter — the famous Jupiter "fly-bys" — which astonished the computer graphics community as well as the general public. Blinn's three-minute animation shows the cloud-enshrouded planet as it would appear from a spacecraft traveling past it, complete with accurate depictions of every star and planet in the sky.

Although Blinn's images are created purely for scientific purposes, his fly-bys are among the most frequently reproduced images in the computer graphics field. They are endowed with considerable beauty, and their enigmatic combination of verisimilitude and unabashed artifice is remarkably compelling. If Blinn's

76. Melvin L. Prueitt, Motion Picture Group, Los Alamos National Laboratory. *Elation*. 1980. Ektachrome print

*Prueitt, author of* Art and the Computer, *an important publication on his work, has been able to achieve high-resolution images that have a remarkable organicism. Using three-dimensional modeling techniques, he is able to create effectively the illusion of dense, curvilinear forms. Not all of his images are made for purely artistic purposes: many visualize mathematical data that are otherwise difficult to conceptualize.*

*Hardware:* Control Data Corporation 7600 computer, Information International, Inc., FR80 film recorder. *Software:* by the artist

programs lack artistic intention, they nevertheless offer extraordinary visual possibilities.

The artistic applications of Blinn's programs have been developed most successfully by David Em, who holds the fortunate and unlikely position of Artist in Residence at the Jet Propulsion Laboratory. Since 1978, Em has had access to powerful computers and to software developed by Blinn. The space-age look of his otherworldly visions may be attributed to the fact that the programs he uses were not developed for art purposes but for scientific research, primarily for NASA (plate 68). His data bases contain outer space phenomena transmitted back to earth from Saturn or the Jovian moon. Em manipulates the available imagery with programs that enable him to simulate shadows, textures, and reflections. He

77–78. Melvin L. Prueitt, Motion Picture Group, Los Alamos National Laboratory. *Manifold* and *Curvilinear.* 1983. Ektachrome prints, each 12 × 40″

*The appearance of computer-generated images greatly depends on the type of graphics device used. Prueitt executes some of his compositions with a computer-driven plotter; others are photographic reproductions of images created on a raster screen. He frequently plots panoramic images, requiring a strip of film five times wider than a standard frame. To achieve this, the computer calculates all the endpoints of the lines and then divides the image into five separate frames, each of which is plotted sequentially. Seemingly solid areas are created by plotting the lines very close together.*

*Hardware:* Control Data Corporation 7600 computer, Information International, Inc., FR80 plotter. *Software:* by the artist

can create compositions of incredible complexity by applying texture-mapping data from photographs of the surfaces of Saturn's moons to simple geometric shapes. Through rotation, mirror imaging, and scaling, he can transport the viewer into richly patterned surrealist landscapes.

As successful as the algorithms discussed above have been for modeling many three-dimensional effects, they have been less adept with some natural phenomena. Great success in the mathematical modeling of many of the random and complex shapes found in nature has been accomplished by fractal geometry, conceived and developed from 1975 to 1980 by Benoit Mandelbrot, a mathematician at the IBM Thomas J. Watson Research Center. The central principle on which fractals are modeled is that of "self-similarity": every large form is composed of smaller, virtually identical units, themselves comprised of progressively smaller replications.

Fractals were welcomed enthusiastically by a computer graphics world anxious for more convincing abilities to depict landscape. Richard Voss, also at IBM, has done extensive research on the application of fractals to computer graphics imagery. He has produced some breathtakingly beautiful constructions of mountainous terrains and cloud-filled skies. Moreover, fractals offer Voss the chance to transform his images by changing the fractal dimension. Because of the structure of the picture, its overall effect can be modified easily. A mountainous landscape can be made more craggy and treacherous with one dimensional value change or can be made to resemble rolling hills with another (plates 69–71). The geometry of fractals, with its seemingly magical capacity to recreate our world as a mathematical construction, has caught the imagination of artists as no other modeling technique has.[1]

The computer technique most successful in defining light, and therefore most successful in the depiction of convincingly realistic scenes, is called "ray tracing." The first work on ray tracing was that of nuclear physicist Phillip Mittelman at MAGI in the late 1960s. His original research was conducted in an attempt to develop nuclear radiation shielding.[2] Mittelman's research was further developed by Turner Whitted, a professor at the University of North Carolina at Chapel Hill. The pictorial marvel of ray tracing is that "it not only takes into account hidden surfaces, highlights, shading, and shadows, but also copes magnificently with reflections, refractions, transparency, and textures."[3] In ray tracing, hypothetical beams of light are traced from the viewer's point of vision back to the light source. Each pixel on the display requires multiple rays. Over a million rays are necessary to compute a high-resolution picture. Unfortunately, ray tracing is so computationally intensive and therefore so expensive that it must be used sparingly.

With all the various algorithms that may be necessary to render one seemingly realistic composition, the execution of a three-dimensional picture sometimes

necessitates collaboration. A list of those who contributed to one still image may look like the credits to a movie. One of the most impressive examples of a group effort for the creation of a single image is *The Road to Point Reyes* (plate 75), produced by the Computer Graphics Division of Lucasfilm in 1983. To create this deceptively simple landscape, which depicts a forsythia-lined highway with a double rainbow dipping from the sky, different members of the Lucasfilm team constructed various components of the image, which were then composited into one still frame. Loren Carpenter constructed the mountains, rocks, and lake with fractals; Tom Porter provided the texture for the hills; the grass was modeled using Bill Reeves's particle systems software (which models phenomena such as clouds or water as a system of random particles rather than as a single object); and the border of forsythia plants along the roadside was rendered by Alvy Ray Smith with his graftals technique, a model particularly successful for creating plants and trees.

Although they cannot tackle computer graphics issues of such complexity in one image, a few artists have been able to create accomplished three-dimensional images without needing an entire support team. Melvin Prueitt, like David Em, utilizes the mathematical capabilities of the computer to create intriguing sur-realistic landscapes. Prueitt is a physicist at the Los Alamos National Laboratory. He left the field of nuclear weapons design in 1981 to work full time on the development of advanced computer graphics. Prueitt now creates whimsical visions of brightly striated, spiky terrains defined by a series of random numbers. Frequently, his imaginary landscapes are inhabited by colorful egg-shaped forms that are calculated separately as ellipsoids. In a composition such as *Elation* (plate 76) different programs determine the angularity of the striated peaks and the direction in which they bend, as well as the placement of the eggs on the shiny surface. Prueitt is astonishingly forthright about his debt to the computer for its ability to generate pictures of startling beauty: "The computer gives those of us who can't draw the chance to express our deepest artistic ideas."[4] Yet Prueitt's remarks misleadingly suggest his images are easy to accomplish. Not only has he years of programming knowledge, but he also has the extraordinary computa-tional speed of a powerful Cray computer available to him.

Danish-born artist Vibeke Sorensen worked exclusively in video until 1978, when she began exploring two- and three-dimensional computer graphics. One of the few fine artists today working extensively with three-dimensional modeling techniques, Sorensen credits her training in architecture and science for provid-ing her with the analytical expertise that enhances her proficiency with the new tools. Sorensen frequently presents her computer-generated images as stereo pairs, which let the viewer actually experience the modeled images in three dimensions. Her witty compositions parody the very technology she uses. In

79.                                                                 80.

*Paroty Bits*, a play on "parity bits," exotically plumaged tropical birds perch inside a colorful cage. In *Fish and Chips*, she mates a school of goldfish with the chips of computer technology (plate 81). She once explained:

*In* Fish and Chips, Microfiche, *and* Paroty Bits, *I byte off what the computer can chew. I employ stereopsis in order to heighten the perception of spatial depth. I play with the language of technology as a reminder of the technological basis of the work and as a reminder of the apparent structural duality of computers. I am interested in the synchronicity of the senses and the intellect and in the visual equivalent of the one-liner. It is this interplay of technology, perception, and language which draws me to my current state of involvement with computers.*[5]

The simulation of reality is a challenge of unabating interest to the computer graphics world. Researchers continue to push their refinements of more accu-

---

79. Monique Nahas and Hervé Huitric. *Eve*. 1986. Cibachrome print, 16½ × 23"

*Huitric and Nahas began using computers to make art in 1970 at the University of Paris. They continued to upgrade their computer systems, and by 1981 they were able to work in three dimensions on a VAX 11/780. They have since modeled objects by using bicubic b-spline surfaces (a simplified method for modeling continous or complex curves) with a program they call RODIN. The algorithms they have written, expanding upon James Blinn's texture algorithms, can generate rocky and grass-covered landscapes, leafy environments, and even realistic depictions of human hair.*

*Hardware:* Digital Equipment Corporation VAX 11/780 computer. *Software:* RODIN, by the artists

---

80. Nicole Stenger. *Pantheonne up nec Mergitur*. 1986. Mixed-media construction, 160 × 180"

*Stenger is a French artist actively working with computers. In this futuristic, rocketlike sculpture, the two antennae are computer screens on the surface of which transparencies of Heaven (on the right) and Hell (on the left) have been superimposed. These pictures were created with three-dimensional modeling software developed by her teachers Hervé Huitric and Monique Nahas. According to Stenger's allegory, as the rocket-insect soars, it attracts the members of its strange family, each of which is illuminated by pulsating lights.*

*Hardware:* Digital Equipment Corporation VAX 11/780 computer. *Software:* RODIN by Hervé Huitric and Monique Nahas

rately illuminated, smoothly shaded, shadowed, and naturally landscaped scenes, some even populated by humans with convincing body motions. For the most part, however, the three-dimensional domain has been technically and financially outside the reach of fine artists. Moreover, one frequently hears the questions, "Is it art?" and "Why is the simulation of reality preferable to photography?" especially as the majority of the three-dimensional images are produced by scientists and researchers. The tools have simply not been accessible and around long enough to be more fully developed for the arts, and as Vibeke Sorensen has explained, the systems are still very clumsy and there are no comfortable interface capabilities.[6] For the moment, there are works of impressive technical and compositional beauty, which may well be the beginnings of an entirely new genre — neither painting, nor photography, nor sculpture yet having characteristics in common with all three. One must keep in mind that just five years ago today's virtually ubiquitous paint systems were rare. Five years from now, three-dimensional and two-dimensional capabilities will commonly coexist in commercially available software, and today's designations will be made obsolete.

81. Vibeke Sorensen, Caltech Computer Science Graphics Group. *Fish and Chips.* Cibachrome print. Copyright 1985
*Sorensen usually displays this image with a stereo pair. In her method of stereopsis, two renditions of the same image, each representing the computer's calculation of the image as if it was seen by an individual eye, are recorded on one slide. Such images achieve startling three-dimensionality.*

*Software:* by Brian Von Herzen and Dan Whelan

## Sculpture and Architecture

Artists who work in three dimensions—architects, sculptors, designers—have also turned to the computer as a powerful tool and a creative medium. CAD/CAM (computer-aided design/computer-aided manufacturing) is a branch of computing with potentially vast applications to almost every design field. The scale-translation difficulties encountered when taking a design for a sculpture, for example, from a line drawing into a three-dimensional solid have always plagued the sculptor. Equally, it is arduous to move tons of steel on location, but it is relatively simple to move a model of even the largest sculpture on the computer screen. Not only can the computer aid the sculptor in translating his designs from two dimensions into three, but with a three-dimensional model on the computer screen the piece can be rotated, viewed from any side, or from any distance. This capability is particularly helpful for large sculptures commissioned for public spaces, where any number of complex considerations may become a sculptor's

82. **Mary Miss.** *Study for Field Rotation.* 1981. Pencil and photo collage, 40 × 40″

*Miss' plan for a large outdoor sculpture for Governor State University in Park Forest South, Illinois, called for the construction of a pinwheel structure of wooden poles set into the ground over an area of four and a half acres. More than one hundred poles in the configuration had to maintain a constant height. Once at the site, Miss found that the slope of the land was much greater than the contour map she had been working with had indicated, and she was faced with the laborious and difficult task of recalculating the correct heights for all the poles. An expedient and precise solution was for a computer to do the calculations, which it completed within a matter of hours.*

vital concern. The siting of a monumental artwork can be shifted from an urban setting to the seaside or a mountain terrain without any physical exertion beyond the activities on the CRT. The importance of the opportunity to preview a sculpture on site also increases as the fabrication of complex pieces from designs becomes commonplace. Many CAD/CAM systems available today enable computers to be used from design to execution. There is software that can even determine the necessary quantity of materials from the design alone.

Robert Mallary was one of the earliest sculptors to use both computer-aided design and computer-controlled milling for sculpture. Mallary first used a computer in 1967, when he learned of its ability to generate and transform images. By the following year, he was able to develop TRAN2, his first program for the computer-aided design of abstract sculpture. He implemented the program for his Quad series, a group of laminated sculptures constructed of superimposed slabs of marble or veneer. These sculptures were designed on the computer screen. Computer-generated templates were then drawn by a plotter and transferred to the slabs which were cut by hand (plate 86).

Motivated by his interests as an environmentalist, Mallary has also been involved since the mid-1970s in projects for land reclamation after strip mining. His concept is to sculpt mountaintops to provide both aesthetic beauty and usable

83. Kenneth Snelson. *Soft Landing*. 1983. Plotter drawing: pen on paper, 14 × 24″

*The Denver office of the Skidmore, Owings & Merrill architectural firm produced this drawing of Snelson's sculpture (which is sited next to one of their buildings) in order to investigate the reflexive properties of the structure.*

*Hardware:* Digital Equipment Corporation VAX 11/750 computer. *Software:* SOM proprietary

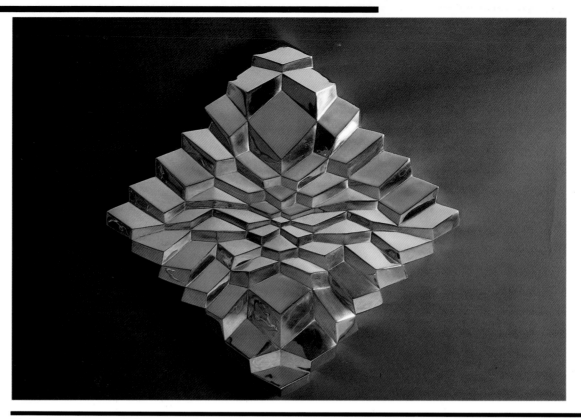

84. Ruth Leavitt. *Untitled.* 1983. Polished bronze, 27 × 27"

*Enlivening static designs with kinetic energy is the preeminent concern of Leavitt's work. She uses computer programs developed with her husband, Jay Leavitt, designs interactively on a computer screen, and then creates the templates with a plotter. Since 1982, she has cast sculptures made by this method in bronze, a material she believes both reflects the perfection of the form and "the perfection of the machine" that produced it.*

*Hardware:* Control Data Corporation 6600 computer. *Software:* by Jay Leavitt

landforms after the terrain has been surface-mined, rather than following the customary practice of returning the land to its original configurations. In response to his awareness of the need to combine artistic as well as environmental considerations, Mallary and a multidisciplinary research group at the University of Massachusetts have developed a program called ECOSITE, which includes an interactive graphics program for land design. This program takes reclamation factors into consideration and through computer assistance produces illustrations of sculptured, reclaimed land as it could look after mining. Mallary chooses to see his project in terms of the Earth Art, Site Art, or Environmental Art of the late 1960s and 1970s, when artists like Robert Smithson and Michael Heizer were no longer content to limit their creations to the confines of their studios.

85. Ronald Resch. *Seashell.* c. 1970. 35mm slide

*The form of this exquisitely delicate shell was calculated by a computer program. PVC sheeting was then cut out by a computer-controlled plotter into which Resch had inserted an X-acto knife instead of a pen. The program also enabled Resch to preview the placement of a variety of shell-like shapes and colors on a computer screen.*

*Hardware:* Digital Equipment Corporation PDP 10 computer, Gerber plotter. *Software:* by the artist and Ephraim Cohen

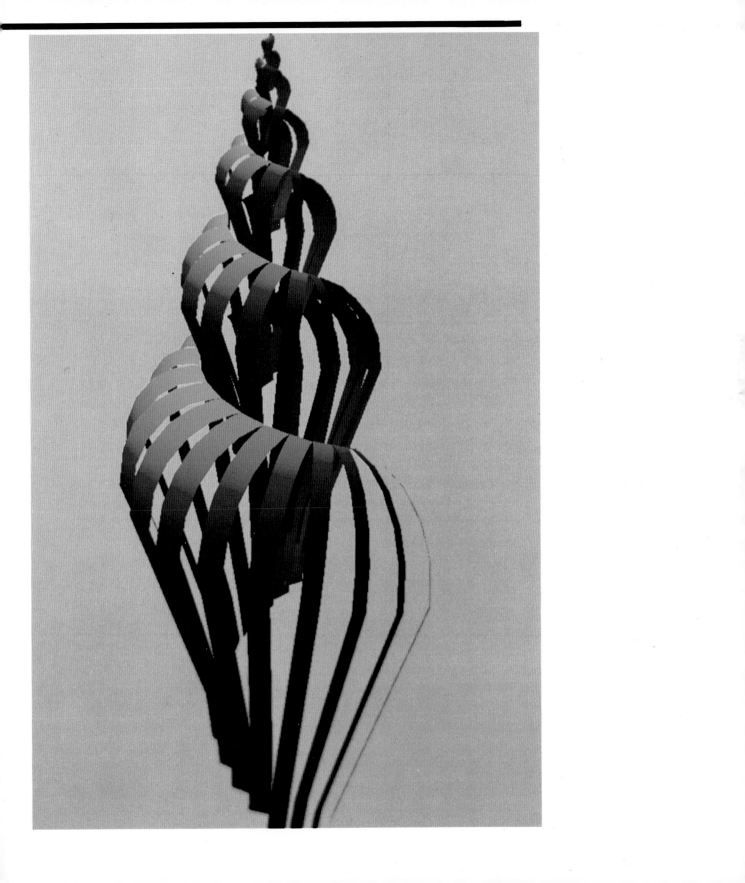

Jaacov Agam was one of the first internationally recognized artists to use a computer. While a visiting lecturer at the Carpenter Center for the Visual Arts at Harvard University in 1968, he discovered both the "beauty and sensitivity" of computer programs.[7] Although he does not employ a computer in the design of his paintings or sculpture, once a composition has been completed in either medium, he frequently transfers the image to the CRT and observes its possible transformations for inspiration for future work.

Since 1968, the majority of Dutch artist Peter Struycken's diversified projects, which have included paintings, sculpture, video, and drawings, as well as commissions for architectural, urban, and landscape settings, have involved computer programming. His large-scale works include a sculpture for the Winkelsteeg traffic circle in Nijmegen, Holland (completed in 1983). For the project, the artist utilized a computer program that he helped to design.

The sculpture is composed of various numbers and combinations of bewitchingly colored pink, purple, and gray cubes arranged at random distances from each other (plate 87). The sizes, colors, and the angle of rotation of each block are determined by a program Struycken calls BLOCKS: "An attempt to determine spatial forms using as few elements as possible. . . . The relationships of the box-

86. Robert Mallary. *Quad IV.* 1968. Laminated marble, 10" high

Quad IV *was one of the first sculptures made with a computer-aided design technique that enabled the user to generate a design and view it from multiple angles on a computer screen, making necessary adjustments before construction.*

*Hardware:* IBM 1130 computer. *Software:* TRAN2 by the artist

shaped elements . . . are determined by the organization of their sizes and degrees of tilt, and by differences in color."[8]

While each one of Struycken's sculptures is being designed, the changes to which the cubes are subjected are visualized on a display screen that shows the forms both in perspective and from any desired angle. In the design of the Winkelsteeg sculpture, Struycken utilized the capability of his program to draw the site in successive pictures on the screen, simulating the illusion that one is experiencing the sculpture from inside a car passing through the traffic circle. The final design comprises four sets of two steel cubes positioned on four different sites about the intersection.

Perhaps the most extraordinary application of the computer for a monumental piece of public sculpture is the three-story *Ukrainian Pysanka*, or *Easter Egg*, designed and erected by computer scientist Ronald Resch for the community of Vegreville, Canada, to commemorate the centenary of the Royal Canadian Mounted Police in 1976.

When he was chosen for this commission, Resch, one of the pioneers in the field of computer-aided design, was a professor at the University of Utah. He had already been experimenting with geometric patterns and folded-plate systems for more than ten years. Completed, the egg stands thirty-one feet high, eighteen feet wide, weighs five thousand pounds, and has 3,512 visible facets. Its complex structure is composed of 2,732 pieces of aluminum, each of which was made on a computer-driven plotter with a custom-made tool capable of scoring or cutting the aluminum to indicate where it would connect to another piece. Each aluminum component of this multistructure was cut out individually, had holes drilled in it, and was engraved by the plotter with an identifying number to indicate its assembly position. Resch was assisted on this project by James Blinn and Robert McDermott, who were then University of Utah doctoral students. Resch's design achieved nine mathematical, architectural, and engineering firsts, including the original applications of the newly developed "B-Spline" mathematics.

87. Peter Struycken. *Blocks.* 1983. Enameled steel, 55 × 267′

*Struycken is one of the foremost artists in Europe creating art with the assistance of computers. The design for this public sculpture was actually completed in 1976, using a program that can create a variety of spatial forms given limited sizes, shapes, and colors.*

*Software:* BLOCKS by C. Thijs

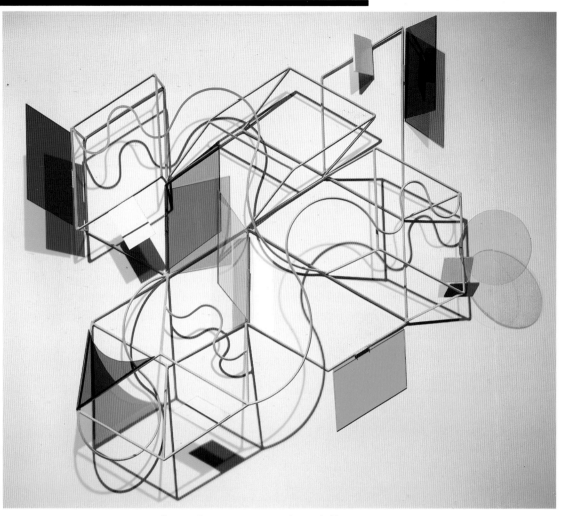

Resch began writing computer programs in the early 1960s to explore different possibilities for folding sheets of paper. One of his subsequent areas of concentration in computer-aided design has been the creation of three-dimensional structures using folded edges and developable surfaces. His investigations have not only had practical applications for structural design but have produced delicate three-dimensional structures of exquisite beauty constructed out of such diverse materials as vinyl, folded aluminum, and paper (plate 85). Resch's varied works in computer graphics and computer-aided design have had a wide range of applica-

88. Tony Robbin. 86-5. 1986. Colored Plexiglas and wire, 30 × 48 × 8″

*Since 1982, Robbin, who has long been interested in artistic visualizations of the fourth dimension, has been pursuing his investigations with computer graphics techniques. He has written a set of programs similar to the hypercube theorems of Thomas Banschoff, the scientist known for his research that popularized the concept of the fourth dimension. These programs have helped Robbin create a geometry for four-dimensional figures as the basis of his works of art. The results of his investigations are applied to the construction of the colored Plexiglas and steel reliefs he builds by hand. He is also developing a CAD/CAM (computer-aided design/computer-aided manufacturing) system for his sculpture.*

*Hardware:* IBM PC AT. *Software:* by the artist

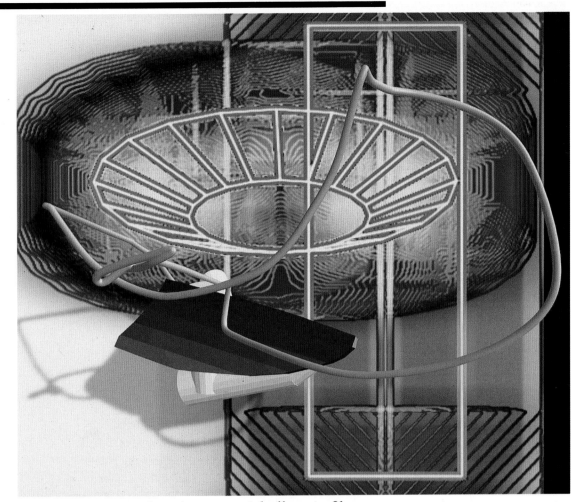

tions from architecture to aerospace engineering to special effects in film.

Ruth Leavitt, a pioneer in the computer field who has realized her work in two and three dimensions in both computer and traditional mediums, has had access to a three-dimensional system since the 1970s. In 1978, her programs were expanded to include three-dimensional design possibilities that enabled her to work either in color for animated videotapes or to make computer-milled sculpture. For her sculptural pieces, she begins with a grid of regular cubes. This grid is manipulated while she works interactively on a vector display terminal, watching transformations of the cubes. When she is satisfied with a design, she directs the output describing the sculpture to a computer-driven plotter that produces a

89. Michael O'Rourke, Computer Graphics Laboratory, New York Institute of Technology. *Childhood Blue Slucid.* Cibachrome print, 40 × 50″

*As a member of the staff of the Computer Graphics Laboratory of the New York Institute of Technology in Old Westbury, New York, an important center for computer graphics research, O'Rourke has access to an impressive array of computer equipment. This image was produced through a combination of three-dimensional modeling and rendering techniques (the tubular forms) as well as two-dimensional image processing (the background).*

*Hardware:* Digital Equipment Corporation VAX 11/780 computer, Genisco frame buffer, E&S Multi-Picture System, Dicomed D48 film recorder. *Software:* NYIT proprietary

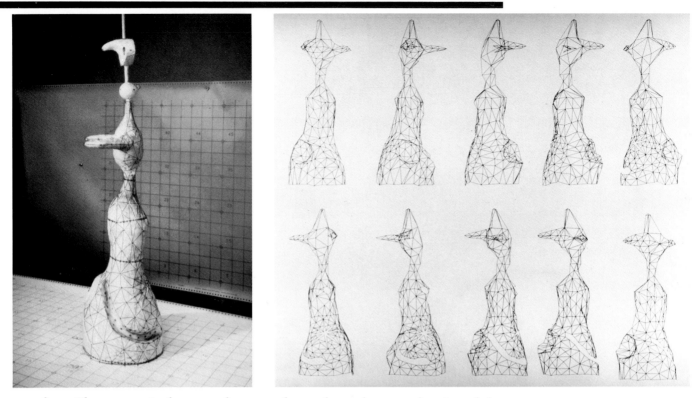

template. The output is then taped onto a plywood panel cut to the size of the desired sculpture into which she has drilled holes. She also cuts dowels according to the desired height of the various cubes and glues them at each of the vertices of the panel. Then she covers the structure created by this configuration of dowels with surgical bandages in order to simulate the cubes. Finally, she either plasters, sands, seals, and paints a piece or just simply plasters it — or, as she began to do in 1982, casts it in a limited edition of polished bronze (plate 84). The imagery determines the finish of each piece. Leavitt's application of computer-aided design may be seen as a prototype of future investigations by individual artists on both large and small scales.

Computer-aided design can help sculptors overcome many formerly insurmountable design problems. An example is the thirty-foot high bronze, concrete,

90. Skidmore, Owings & Merrill. Maquette and multiple computer-generated plotter drawings of maquette for Miró's *Chicago*. 1981. Courtesy Skidmore, Owings & Merrill

*The architectural firm of Skidmore, Owings & Merrill was responsible for the final armature for a thirty-foot-high sculpture by Joan Miró, which was to be erected adjacent to the Brunswick building designed by Skidmore, Owings & Merrill in Chicago. The structural organization remained unclear until data taken from a three-foot-high maquette (now in the permanent collection of the Art Institute of Chicago) through digitization — in which an analog image is scanned and converted to X, Y coordinates readable in digital form — of photographs of the model and CAT scanning was processed by a computer. SOM created triangulated mesh models, which are linked triangulated surfaces constructed from X, Y, Z data points and are generally used by architects to study terrain related to the siting of buildings. In this case, the technique was used to facilitate the analysis of Miró's model prior to the construction of his large public sculpture.*

*Hardware:* Digital Equipment Corporation VAX 11/780 computer, Xynetics plotter. *Software:* Skidmore, Owings & Merrill proprietary

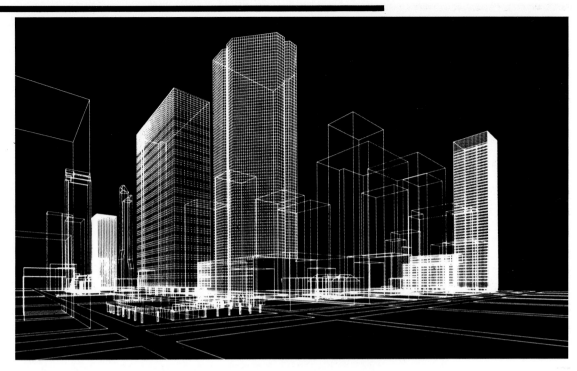

and ceramic sculpture of a woman by Joan Miró, now situated in Chicago on the plaza of the Brunswick building designed by Skidmore, Owings & Merrill (SOM). This sculpture (plate 90) was first analyzed in the architecture firm's computer center to determine its structural viability. The Skidmore, Owings & Merrill publication *Computer Capability* explains the intricate process of analysis used for this piece:

*The geometric description of a 36-inch high maquette was put into the computer to generate various sections and perspective views. . . . The resulting triangulated form could be viewed from any position or sliced into sections along any axis . . . a second process employed to increase accuracy involved passing a maquette through a CAT body-scanner. The SOM computer processed 120 cross sectional X rays to extract the edges of each section. These were stacked vertically for visual verification.[9]*

Computer-aided design techniques are also transforming the field of architecture since computer analysis enables an architect to submit to scrutiny a plan ranging in scale from the design of an entire city to one minute structural detail.

91. Skidmore, Owings & Merrill. *875 Third Avenue, New York.* 1981. Courtesy Skidmore, Owings & Merrill.

*Using CAD (computer-aided design) techniques, a computer can be programmed to generate wire-frame models of a prospective building. Drawings like this, which are studied on the computer screen as well as in the form of plotted output, are an enormous help to architects in planning and finalizing a building's design and its siting. On the screen, adaptations of the original design as well as different perspectives can be viewed virtually as soon as new coordinates are input into the computer.*

*Hardware:* Digital Equipment Corporation VAX 11/780 computer, Xynetics plotter. *Software:* Skidmore, Owings & Merrill proprietary

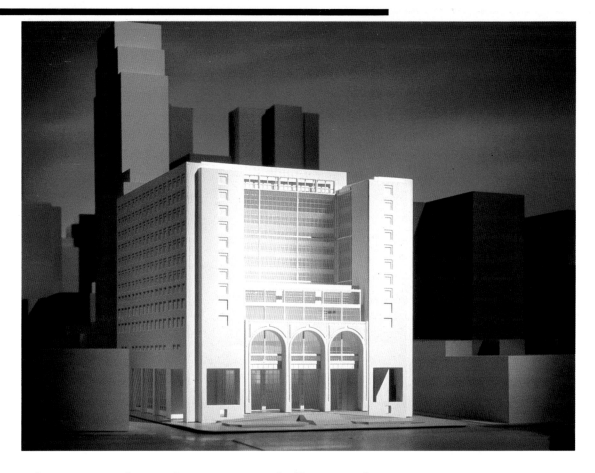

The implementation of computer analysis enhances structural efficacy, productivity, and the aesthetics of a design. The architectural firm of Skidmore, Owings & Merrill—which installed its first computers in 1963—has led the field in the application of computers to architecture.

Architects at Skidmore, Owings & Merrill, I. M. Pei & Partners, and other automated architectural firms around the world often "draw" directly on the computer screen. Either small changes or major revisions can be viewed instantaneously rather than waiting up to several weeks for a rendering. Axonometrics, perspectival views, floor plans, and sections can be generated once the data about a structure has been input into a computer.

Three-dimensional views help architects, engineers, designers, and clients visualize spatial relationships and the projected appearance of a building and its setting prior to construction. Some interactive graphic systems are capable of

92. Skidmore, Owings & Merrill and Norman Rosenfeld, AIA. Model of St. Luke's Hospital, Roosevelt Center, New York City. 1986. Painted Plexiglas and vinyl, 36 × 60"

*SOM's computer research has recently developed to such an extent that architectural models are now cut out by a computer-driven laser cutter following instructions input from the SOM CAD system. In this way very elaborate models can be constructed with more accuracy and detail than when they are cut by hand.*

**128**    *Hardware:* IBM RT PC, Tektronix display, custom laser by Laser Machining, Inc. *Software:* SOM proprietary

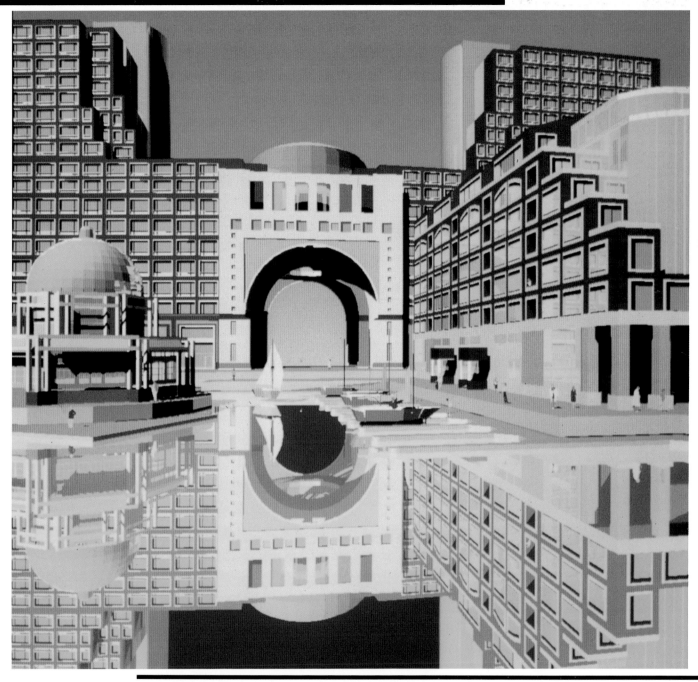

93. Skidmore, Owings & Merrill. *Harbor Elevation of Rowes Wharf, Boston.* 1985. 35mm slide. Courtesy Skidmore, Owings & Merrill.

*Although wire-frame modeling is one technique for visualizing buildings, it is usually desirable to construct a surface model that can be colored and shaded. On occasion, SOM uses ray tracing, a computationally intensive technique that produces photographic-quality images by calculating imaginary light beams to create reflections and refractions of light like those in the natural world. Ray tracing is the computer graphics technique most capable of approximating of a final architectural design.*

*Hardware:* Digital Equipment Corporation VAX 11/780 computer, Tektronix 4115 display screen with 256 color capability. *Software:* Skidmore, Owings & Merrill proprietary

giving the viewer the sensation of movement through an architectural space with the option to stop and zoom in on specific details. Such systems offer a far more accurate replication of an architectural setting than conventional models and perspectives afford. The computer graphics system developed by Skidmore, Owings & Merrill is capable of analyzing the "environmental impacts of the building on the skyline, increased traffic patterns, and solar intensity on the building and on its neighbors."[10] Systems are currently under development that will provide both interior and exterior tours of buildings, replete with the sensation of sunlight as it will appear in various spaces at different times of day. Not only are computers changing architects' design capabilities, the output of these programs, from wire-frame images to solid-modeled hard copy, are radically altering the aesthetics of architects' drawings (plates 91–95).

94. I. M. Pei and Partners (Rendering by Paul Stevenson Oles and Rob Rogers). *Interior View of Addition to the Louvre (from the Pyramid Looking into the Court Napoleon).* 1986. Plotter drawing: felt-tip pen on paper with pencil, 18 × 22"

*I. M. Pei's highly controversial addition to the Louvre is projected for completion in 1988. The construction was planned with computer-aided design techniques. By combining the computer-generated drawing with a traditional rendering of the site, both architect and client are given a very exact idea of what the finished building will look like.*

*Hardware:* Digital Equipment Corporation MicroVAX computer, Tektronix display. *Software:* McDonnell Douglas GDS edition 4.6

95. I. M. Pei and Partners. *Atrium of IBM Building, Somers, New York*. 1987. Plotter drawing. Courtesy CAD/East, Inc.

*For this project, various perspectives were generated so that the architect would have a better sense of how people will move through the interior space and the potential vistas they might encounter. The computer offers both greater variety and more accuracy than normal drafting techniques. As with many three-dimensional imaging techniques, once the basic coordinates of an image are input, different views can immediately be called up on the screen.*

*Hardware:* Prime computer, Tektronix workstation, CalComp electrostatic plotter. *Software:* McDonnell Douglas GDS

# V. *Cybernetic Serendipity: The Worlds of Interactivity and Computer Control*

For the past twenty years, computers have endowed certain works of art with visual effects of unprecedented complexity. The entire relationship between viewers and art has been profoundly transformed by the development of increasingly sophisticated and powerful interactive computer systems that control artworks that are capable of being different literally for each viewer and at each moment in time. One may no longer so much "view" as "experience" art. The viewing itself is part of an event. The new interactive systems are of increasing importance to the future of video and Performance Art as well as to sculpture, installations, and Environmental Art. Artists are also utilizing the infinite variety of computer programming to control and coordinate effects of movement and light.

Artists exploring these computer systems are often influenced by the philosophy of cybernetics. The concept of cybernetics was first expounded in the late 1940s in the highly influential texts of Dr. Norbert Wiener, a mathematician at MIT. In a popular discussion of his ideas, *The Human Use of Human Beings: Cybernetics and Society*, which he published in 1950, Wiener explained the basic thrust of cybernetics:

*It is the thesis of this book that society can only be understood through a study of the messages and the communication facilities which belong to it; and that in the future, development of these messages and communication facilities, messages between man and machines, and between machine and machine, are destined to play an ever-increasing part.*

*It is the purpose of cybernetics to develop a language and technique that will enable us indeed to attack the problem of control and communication in general, but also to find the proper repertory of ideas and techniques to classify their particular manifestations under certain concepts.[1]*

96. Wen-Ying Tsai. *Cybernetic Sculptures, A and B*. 1975: updated 1986. *A:* fiberglass rods, electronic vibrator, diffraction gratings, stroboscope, electronic feedback control, and microprocessor, 78 × 28". *B:* fiberglass rods, electronic vibrator, stroboscope, electronic feedback control, and microprocessor, 120 × 28"

*The introduction of a microprocessor updated this piece, enabling it to operate with two different patterns of movement: one created as an interactive response to audio input (such as clapping hands), the other as a pre-programmed pattern. Once the piece is activated, the graceful fiberglass rods vibrate at a constant rate, although their movements appear to vary in accordance with the intensity and speed of the stroboscopic light that illuminates them. The louder the noise, the quicker the pulsing of the lights — and the more frenetic the movement, the greater the number of rods the viewer seems to see at one time.*

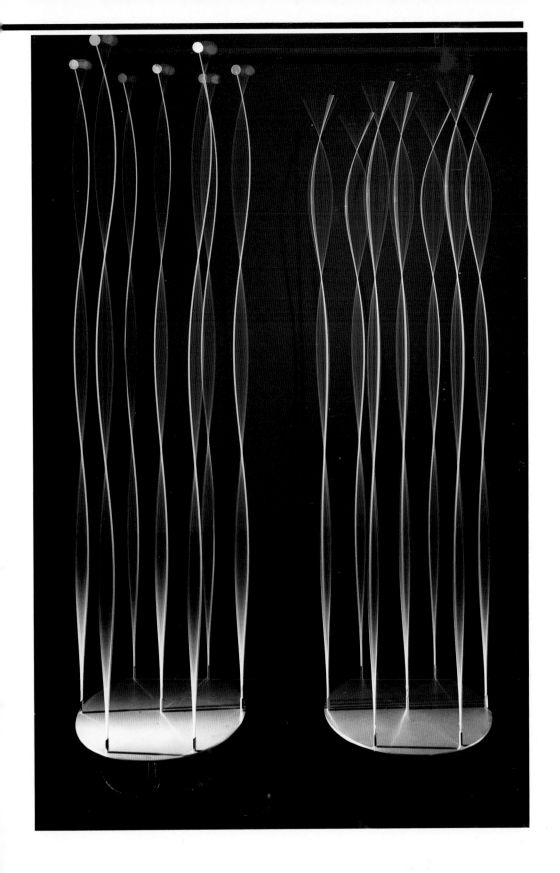

Wiener's ideas were fascinating to artists, who found ways of incorporating this all-encompassing philosophy into their art. As noted by sculptor Robert Mallary in his important article "Computer Sculpture: Six Levels of Cybernetics," published in *Artforum* in 1969, cybernetics is interdisciplinary and links many areas, including information theory, control systems, automation, artificial intelligence, computer-simulated intelligence, and information processing. Mallary's article was one of the first attempts by an American to discuss the aesthetic implications of cybernetics for artists. He defined six distinct stages for the integration of cybernetics into the sculptural process. In the first stage, the computer merely performs tedious mathematical calculations. In the second, the computer becomes an indispensable component in the art-making process. By the third stage, the computer makes "not only routine discriminations but decide[s] on alternative courses of action governing the whole system." The guidelines for these options, of course, have been strictly defined by the programmer. At the fourth stage, the computer becomes capable of making decisions not anticipated by the programmer. In the penultimate stage, "the computer has arrogated [*sic*] to itself both human and machine functions," doing both in such a superior way that the sculptor "like a child, can only get in the way." By the time the sixth stage is attained—if ever—the very term sculptor may no longer have a meaning, and the machine may "have achieved some kind of organic, self-replicating mode of existence, or will have evolved into a state of pure, disembodied energy or spirit."[2]

Artists interested in cybernetics and its applications to art have already been able to create machines that are increasingly successful at simulating, interpreting, or translating human responses. Computer scientist Myron Krueger, who has been refining cybernetic concepts for almost twenty years in an attempt to develop a new art form he calls "Responsive Environments," has made some of the most advanced technical contributions to the field. According to his definition:

*A Responsive Environment is an environment where human behavior is perceived by a computer, which interprets what it observes and responds through intelligent visual and auditory displays. Since many kinds of displays, including discrete lights, video, computer graphics, and electronic music, are amenable to computer control, a rich repertoire of relationships can be established between an individual and the Environment. The Environment can be completely controlled by a preexisting program, or operators can intercede and use the computer to amplify their ability to interact with other people. In either case, a programmer anticipates the participant's possible reactions and composes different response relationships for each alternative. The program is a composition that can respond and learn on its own after it is completed.*

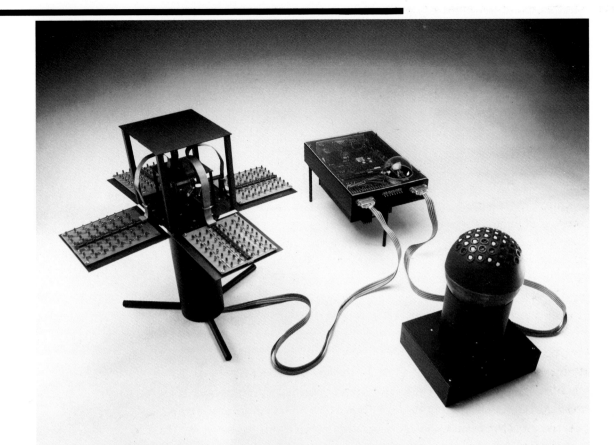

*It represents a unique melding of aesthetics and technology in which creation is dependent on a collaboration between the artist, the computer, and the participant. The artist composes a network of intelligent response relationships. The participant explores this universe, initially triggering responses inadvertently, then gradually becoming more and more aware of causal relationships. The computer perceives and interprets the participant's actions and responds intelligently. The art form is the composed interaction between human and machine, mediated by the artist.[3]*

To date, Krueger's definition represents Mallary's "paradigm for our future interaction with machines." Although the state of the art is still several stages removed from Mallary's sixth level, artists and programmers have made distinct progress toward the attainment of his latter modes and the application of artificial intelligence to the arts.

97. James Seawright. *Houseplants I*. 1986. Metal, plastic, and electronic parts in two units, 26½" high and 29½" high

*Houseplants I is one of a series of computer-controlled sculptures that can either follow preprogrammed patterns of movement or respond interactively to light levels. In both modes, each with a different sequence, light patterns flicker across the LED (light-emitting diode) units on the leaves of the taller plant, and the flip disks on the domed plant click open and shut, creating a rustling noise.*

*Hardware:* Custom-built microprocessor and control circuitry. *Software:* by the artist

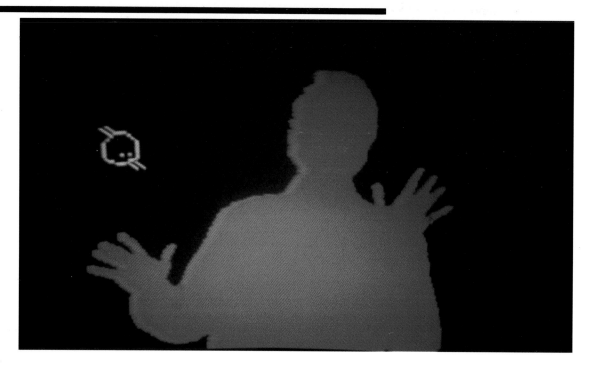

## Interactivity

The possibilities of cybernetic machines have lured artists and scientists into unprecedented collaborations. The impetus first came from major corporations and research centers interested in investigating communications. Artists who had the technical proficiency to appreciate the creative capability of computer systems joined forces with financial and scientific sponsors. In 1954, sculptor Nicholas Schöffer became "one of the first artists to realize (and implement) the potential of control devices in art" when he helped to design the first cybernetic sculpture, a sound-equipped structure for the Parc St. Cloud in Paris that was realized by the engineers of the Philips Corporation, a leading European electronics company.[4] Two years later, Schöffer teamed up with Philips engineer François Terny to make the first programmed cybernetic sculptures, which he called his Cysp series (an acronym for cybernetics and spatiodynamics). These Constructivist structures of steel and duraluminum were rather like robots. They were mounted on four rollers that gave them the capability to move. Photoelectric cells, microphones, and rotating blades powered by small motors were connected to their scaffoldlike structures. Controlled by an electronic brain developed by Philips, a Cysp responded to variations in color intensity, light, and sound:

98. Myron Krueger. *Videoplace: Critter Interaction.* 1983. Interactive video environment: projection screen, video camera, back-lighting assembly, and customized computers

*The small critter taunts the participant, whose video-digitized image appears on the screen as he tries to catch it. Among the "intelligent" responses of Krueger's computer-controlled environment is its ability to detect and respond to moving shapes.*

*Hardware:* National 32016, eight specialized processors and interfaces, and structure designed by the artist. *Software:* by the artist

*It is excited by the color blue, which means that it moves forward, retreats or makes a quick turn, and makes its plates turn fast; it becomes calm with red, but at the same time it is excited by silence and calmed by noise. It is also excited in the dark and becomes calm in intense light.*[5]

*CYSP I* was introduced to the public in a 1956 performance of a Maurice Béjart ballet accompanied by electronic music. Thereafter, Schöffer's projects frequently assumed a grandiose scale.

The financial support and technical assistance of the Philips Corporation was also crucial to British artist Edward Ihnatowicz, who was commissioned by Philips to build *The Senster*, a long-necked and long-legged sculpture (approximately fifteen feet long by eight feet high) resembling a space-age giraffe, for the *Evoluon*, the company's permanent technological exhibition in Eindhoven, Holland. Ihnatowicz was suggested to Philips by designer James Gardner, who had seen the much smaller electrohydraulically operated and environmentally sensitive mobile that Ihnatowicz had exhibited at the *Cybernetic Serendipity* exhibition in London in 1968. Three years in construction, the computer-controlled *Senster* is composed of a head with a moving array of four sensitive microphones that pick up sounds, so that its direction can be computed, along with two close-range radar devices at the end of the long neck, powered by electrohydraulic systems. A digital computer directed the sculpture's behavior patterns in re-

99. Paul Earls and Otto Piene. *Icarus.* 1982. Computer-controlled laser drawing

*Earls and Piene think of their computer-controlled laser drawings as "lightmusic." The pitch of the music triggers the controls to emit different beams of light. Earls's multimedia opera* Icarus *has been performed around the world in both indoor and outdoor settings. Outdoors, a performance genre Earls calls a Sky Opera, the images are projected into the sky.*

**137**     *Hardware:* Apple computer and Alpha Syntauri music computer. *Software:* by Paul Earls

sponse to the sounds and motions of visitors in the vicinity. According to author Jonathan Benthall, a champion of art and science collaborations, *The Senster* is no monument to an artist's genius, but a step towards new forms of creative collaborations on the highest level between scientists and artists."[6] Ihnatowicz's integration of the computer as a processing device for a work of art was to have considerable ramifications for future cybernetic creations.

Without corporate assistance, the possibilities were much more limited. One example of an artist in the field thwarted in his attempts to realize his goals by a lack of sufficient support is Polish-born sculptor Piotr Kowalski, currently living in Paris. Like so many of the most outstanding artists who wed art and technology, he was to become a fellow at the Center for Advanced Visual Studies at MIT. He first became obsessed with the idea of a time machine capable of reversing time in 1970. Because there was no digital technology available to him, he devised a less sophisticated analog system only capable of audial effects. It was not until he arrived at C.A.V.S. in 1978 that microprocessing was within financial reach. With the help of his engineering colleagues he began at last to build a digital time machine.

Sensitive electronic creations like Schöffer's were virtually unheard of in the United States until the mid-1960s. Jack Burnham attributed the five- to ten-year lag "in part to a crisis recognized in modern music by French and German avant-garde composers as early as the late 1940s. Both the structure and continued tonality were seen as at an end. . . . Electronic synthesis was one technique for achieving a structure which encompassed much more than the range of tonal organization."[7] In addition to the artistic precedent electronic music established, as well as its concomitant acceptance by European audiences, Burnham credited the appearance of writings on information theory by influential aestheticians such as Max Bense (whose pupils included George Nees and Frieder Nake) for helping to establish cybernetic principles in the European art community.[8] Moreover, the electronic aesthetic was supported by major sponsors in Europe, like the Philips Corporation, whose financial and technical assistance was not only a precondition for success but for experimentation too.

It was during the heyday of E.A.T.'s activities, a time when artists were particularly receptive to art and technology alliances, that cybernetic principles had their debut in American art. Wen-Ying Tsai and James Seawright, both of whom had formal training in engineering as well as fine arts, were among the first artists inspired to experiment with their technical knowledge. Their artistic development has been quite independent, but their careers exemplify the evolution of cybernetic sculpture.

James Seawright incorporated primitive programming into his constructions as early as 1963, when he was a stage technician for the avant-garde choreographer Alwin Nikolais and an instructor at the Columbia-Princeton Electronic Music

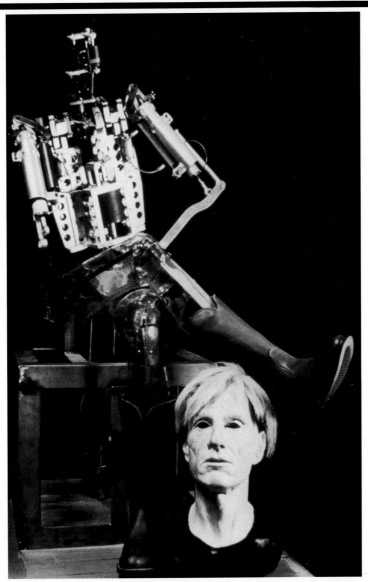

Center. *Tower*, Seawright's first electronic sculpture, consists of a series of wires in vertical rows supporting close to a thousand tiny light bulbs. The flashing lights introduced waves of movement into the infrastructure of the delicate sculpture. Seawright had a successful one-man show of his constructions at the Stable Gallery in New York in 1966, and a number of his works were bought by museums, including The Museum of Modern Art and the Whitney Museum of American Art. Although museums had purchased kinetic art before, Seawright's sculptures were their most sophisticated technological acquisitions. Reviewers commented on both his engineering brilliance and the compelling aesthetic

100. *Andy Warhol Robot.* 1984–87. Collection Lewis Allen. Photograph copyright Mark Wexler/Wheeler Pictures

*Warhol's amazingly lifelike robotic counterpart was constructed by former Walt Disney animator Alvaro Villa. This robot was made to go on tour as a one-man show, requiring only a stage manager and a technical assistant.*

101. Milton Komisar. *Four of a Kind.* 1985. Plexiglas, polystyrene, and Apple ® computer, 6 × 12 × 12′

*Komisar's works require viewers to spend some time with them in order to be fully appreciated. They vary from moment to moment as different intensities and patterns of light are transmitted through complex networks of polystyrene tubes. This piece consists of four separate modules that can be rearranged in several different circular or linear configurations according to the specifications of each site.*

*Hardware:* Apple ® computer. *Software:* by the artist and Michael O'Malley

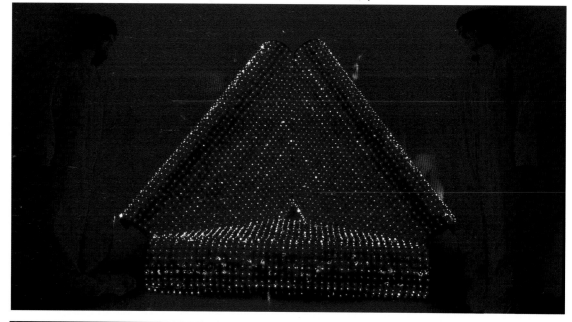

102. Eric Staller. *Girlfriend.* 1983. Miniature light bulbs, masonite, and microprocessor, 72 × 72 × 72″. Collection Everson Museum of Art

*Staller's primary objectives with his computer-controlled light sculptures are new effects of light and the creation of different sensations of colors and patterns of movement. Each of his pieces is composed of thousands of tiny light bulbs, which the artist colors himself by dipping them into vats of paint. The computerized controller running this piece controls the speed, relative intensity, and direction of the lights.*

*Hardware:* Electronic Designs, Inc., four-channel light-sequencer with microprocessor. *Software:* by the artist and Electronic Designs, Inc.

presence of his constructions—intricate assemblies of functioning electronic circuitry and equipment. Seawright's pieces were programmed to respond to sounds and light levels, and each was sensitive to the noises output by his other machines. Thus, in the Stable installation, the pieces interacted with one another to provide "a continually varying pattern of independent and collective activity,"[9] modifying their own programs in an early attempt at demonstrating artificial intelligence. Seawright explained the effect he wanted in an article in *The New York Times*:

*The machines process information. Their cells and sensors collect information on light and sound, and they behave accordingly. My aim is not to "program" them but to produce a kind of patterned personality. Just as a person you know very well can surprise you, so can these machines. That's the crux of what I want to happen.*[10]

Seawright's work has evolved through the incorporation of increasingly more elaborate electronic systems. Until the end of the 1960s, his sculptures were

103. Eric Staller. *Lightmobile.* 1985

*This 1967 Volkswagen Beetle is illuminated by 1,700 light bulbs, which are wired in rows and can flicker in twenty-three different patterns of movement that are determined by a computerized lighting controller mounted above the windshield. On special occasions, Staller takes his memorable automobile onto the streets of Manhattan—to the delight and astonishment of everyone he passes.*

*Hardware:* Electronic Designs, Inc., ten-channel light sequencer with microprocessor. *Software:* by the artist and Electronic Designs, Inc.

driven by analog devices with gear and linkage systems, precursors to today's digital computer. *Network III*, an installation at the Walker Art Center in 1970, was the first piece in which he powered his sculptures with a digital computer. More importantly, it was the first sculpture ever to incorporate a digital minicomputer—an extraordinary inclusion for 1970, when a privately owned computer was still an astounding concept.[11]

In *Network III*, a group of pressure-sensitive plates concealed under a carpet were installed on the museum floor. When people walked across the carpet, a programmed computer assigned each person a different pattern. Their movements were then visualized in corresponding patterns that flashed on a grid of lights suspended directly overhead. The concept of participatory interactivity was further refined for *Network IV* (1970–73), a computer-programmed panel composed of sixteen rows of sixty-four light bulbs. Installed at the Seattle airport, where it has become a favorite pastime for travelers waiting to catch flights, *Network IV* is controlled by the manipulation of sixty-four buttons on a lectern several feet away from the wall-sized grid of lights. Once three buttons have been pushed, the piece is activated; as the participant continues to push buttons, it becomes apparent that this activity both inputs data into the system and gives increasing control over the patterns generated on the array. *Network IV* allowed the artist to explore his "ability to use the computer in real time to create artworks."[12] If there is no one at the lectern, the sculpture enters a "default routine," during which a circular pattern floats through the panel's lights at random speeds.

From 1973 to 1978, Seawright's programming innovations were not designed for sculptures but instead for computerized lighting systems coordinated with electronic music during the performances of the Mimi Garrard Dance Company. The interdisciplinary investigations of Seawright and Garrard, his wife, helped to demonstrate the possibilities for computer-involved performance art at an early date. More recently, Seawright has completed several interactive sculptures that incorporate advanced technology to depict naturalistic themes. The title of one of these pieces, *Night Blooming (Serious)*, both pokes fun at the critics who claimed kinetic art was not serious and is also appropriate to the sculpture's domestic garden setting. Like its floral namesake, the cereus cactus, the sculpture unfolds at night. It reveals inside its dome-shaped cover flickering rows of red LED (light-emitting diode) lights, their patterns controlled by a computer in the owner's house. The program running these animated panels is sensitive to temperature and humidity. In anticipation of rain, for example, sensors direct the piece to close.

Whereas *Night Blooming (Serious)* was designed to be activated only at night, the five "flower" units of Seawright's *Electronic Garden #2* (1983) installed in the Long Ridge Mall in Rochester, New York, operate with different instructions for

daytime and nighttime performances. The computer running the piece is enclosed in a fifteen-foot-square room of glass located outside one of the doors to the shopping center. This computer-age garden is not only responsive to climate but also offers the viewer the possibility to interact with it by pushing an array of buttons that can change the program. Seawright has continued to develop his garden themes. Computers have become such an accepted part of our daily lives that, as in the environments Seawright constructs, man, nature, and digital technology peacefully coexist (plate 97).

Like Seawright, Wen-Ying Tsai was one of the first artists to explore the potential of interactive sculpture. Tsai came to the United States from China in 1950 and received a degree in mechanical engineering from the University of Michigan. Since 1963, however, when he was awarded the prestigious John Hay Whitney Opportunity Fellowship for painting, he has devoted all his time to making art. By 1968, his experiments with motorized sculpture won him second prize in the E.A.T. contest and selection for Hultén's *Machine* exhibition at The Museum of Modern Art. The following year, he was invited by Gyorgy Kepes to be a fellow at MIT's Center for Advanced Visual Studies, where he developed his stringent aesthetic and philosophical standards for applying modern technology to art. One of his teachers at MIT was the famed photographer and electronic engineer Harold Edgerton, who helped Tsai build large-scale strobes to illuminate his sculptures. Tsai has recalled with uneasiness the powerful impression made by Edgerton's observation "that the trigger devices which are used to synchronize the strobe light and the pulse of my cybernetic sculpture are basically the same that served to detonate the early A-bombs."[13] The idea discomfited Tsai, but instead of shunning technological art, he was motivated by the belief that "the only hope to harness the immense power of modern tools for the real benefit of mankind lies in the direction of artists working to reunite art and contemporary science and technology."[14]

Since 1965, Tsai's cybernetic sculptures have utilized vibrating steel rods, high-frequency electronic flash, and audiofeedback controls (plate 96). For approximately the past nine years, ever since the first inexpensive Radio Shack computer appeared on the market, he has been incorporating computer programs into his artistic projects. Computer technology has also enabled him to improve the operation of some of his earlier pieces, such as his elegant cybernetic sculptures that are composed of fiberglass columns constantly illuminated by a flashing stroboscopic light. In the systems that first ran these pieces, an audial multivibrator took external sound stimuli, such as clapping or voices, and instantly processed them into electronic impulses that controlled the speed of the strobe. The movement of the rods remained constant, but the strobe could create the illusion of different speeds and thereby radically alter the viewer's perception of the vibrating work. Recently, Tsai included a programmed memory that has enor-

mously refined the sensitivity of the pieces to external stimuli. The rate of the stroboscopic light is now determined by programmed time sequences that depend on the decible and frequency of external sounds. The choreography of the strobe and the graceful, glistening rods can vary from a slow lilt, like a field of wheat blowing in the wind, to a frenetic dance.

Tsai began developing a plan for another programmed sculptural piece, *Computerized Wall*, in 1980. The prototype for the wall is a single vertical column, twelve feet high and one foot wide, of twelve rectangular units, each of which is composed of forty different-colored panels illuminated by a black light. The panels are constructed by the Solari Company, which manufactures the schedule boards for railroad stations, and they can flip over in the same way that changes in train schedules are posted. The tempo is controlled by a computer. Sometimes only one panel of color flips; at other times, all of them flip simultaneously, creating a waterfall of bright color. Tsai's program allows for multiple color changes and the potential to create an almost unlimited number of effects. Like all his other current works, *Computerized Wall* is sound-activated once the computer that controls it has been turned on. Tsai can set the sculpture into motion by clapping his hands. His eventual plan is to construct an entire wall of changing components that will form a new image every two seconds. Computer technology, with its phenomenally fast processing speed and efficiency, has not only given him greater precision and control over complex visual effects, it also has become an integral part of his art.

Michigan artist James Pallas shares with fellow sculptors Tsai and Seawright the conviction that a dynamic interaction between viewers and artworks is among the most fertile aspects of the new technology. Since his first commission in 1968 for a kinetic sculpture sensitive to the sounds of a harpsichord, all of his pieces have been made with particular consideration for their cybernetic potential.

104. Bruce Nauman. *Double Poke in the Eye*. 1985. Computer-controlled neon bulbs, 14 × 28 × 6″. Courtesy Leo Castelli Gallery, New York

*A computerized timing mechanism precisely controls both the movement of the sculpture's four hands as well as the sequence of illumination for the differently colored physiognomic outlines.*

105. Keith Haring. *Messages to the Public.* Spectacolor light board. Courtesy Public Art Fund, Inc.

*In preparation for the computerization of a design, each artist chosen by the Public Art Fund to participate in the "Messages to the Public" project presents a storyboard in a meeting with a Spectacolor programmer, who explains the capabilities and limitations of the Spectacolor system on which their messages will be illuminated. The system, which controls the twenty- by forty-foot billboard, is limited not only in resolution but in color range as well. The screen is illuminated by a combination of red, green, blue, and white light bulbs arranged in rows. Yet, the messages on the Spectacolor board are tremendously varied. They range from a train explosion sequence by graffiti artist Johnny (Crash) Medos to images of jewels dissolving by John Torreano, the antiwar proclamations of Howardena Pindell, and the silhouetted figures—now animated by the computer—of Keith Haring.*

*(105–6) Hardware:* Spectacolor light board. *Software:* Spectacolor

106. Gary Falk. *Messages to the Public.* Spectacolor light board. Courtesy Public Art Fund, Inc.

**145**

*Falk created a sequence of images that directly reflected the everyday, urban environment in which they were shown.*

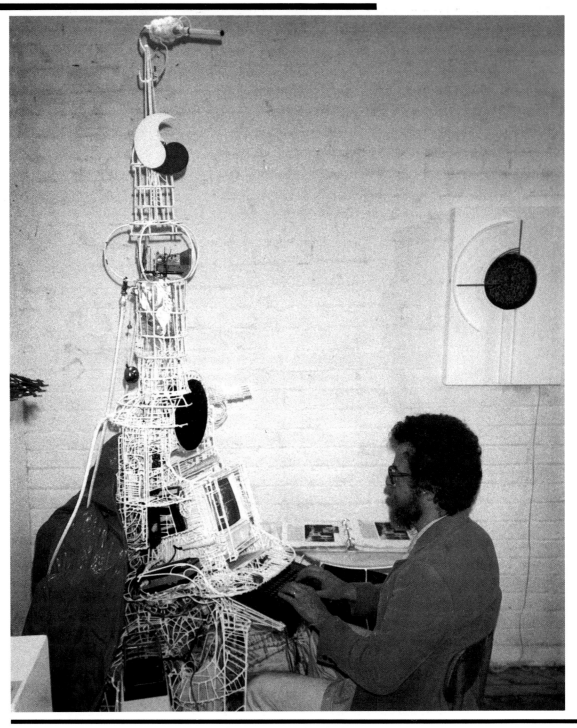

107. James Pallas. *Progmod*. 1980. Mixed-media construction, 90″ high

*James Pallas with* Progmod, *a computer-driven sculpture that can "see" and "hear." In response to audio or visual sensations, it creates abstract patterns on its circular screen while displaying the numerical data that control the patterns on its video monitor. The front of* Progmod *is designed as a convenient desk for writing programs; its monitor and keyboards are located close by.*

*Hardware:* Sym computer with d-ram. *Software:* Glo-1 by the artist, Rene Vega, and Randy Mims

Pallas developed a sophisticated knowledge of computer circuitry and has invented a number of whimsical sculptures that are responsive to sound, light, and movement. But in contrast to the two engineers, Pallas's formal aesthestic is fanciful. Indeed, he thinks of himself as a "Cybernetic Surrealist." Many of his sculptures share the unbridled fantasy of Max Ernst's *Personnages*. Using high-powered technology, Pallas literally brings his creatures to life.

*The Blue Wazoo* (1975–76), a six-foot-high sculpture of welded steel covered with several coats of acrylic paint and bearing some resemblance to an oversized ostrich, is among the most beguiling members of Pallas's exotic menagerie. This sculpture of "plastic shapes, circuitry, wires, light-emitting diodes, solenoids, a motor, cloth, horsehair, a feather" includes a small bead he refers to as "the bead of consciousness"—a token perhaps to soulful intentions.[15] *The Blue Wazoo* is programmed to respond to external stimuli by emitting its own light, making sounds, or moving some of its "limbs." The nature of the input determines the bird's activities.

Pallas's bizarre computer-driven conglomerate called *Progmod* (1980) includes among its amenities a work station, video monitor, keyboard, circular work surface, popcorn popper (to fortify the diligent worker late at night), and pencil sharpener (plate 107). *Progmod* uses radar, a microphone, and a photocell to receive input; it responds with abstract patterns displayed on its monitor. Fifteen years after *The Friendly Grey Computer* expressed Kienholz's satirical anxiety over the imminent, adversarial presence of the computer in society, *Progmod* demonstrates Pallas's collegial relationship with the machine. (He often uses *Progmod* as his work station.)

Interactive constructions have not been the exclusive domain of sculptors. Myron Krueger has applied his background in both computer science and computer graphics to create his interactive video environment *Videoplace*. The installation utilizes ten digital machines, each of which is several hundred times faster than a typical personal computer.[16] They all can perform different specialized functions. A video recorder perceives the viewer, transmits the image into the program, analyzes it in slow motion, and instantaneously responds with synthesized sound and computer graphics displayed on a video projection screen. *Videoplace* knows when the viewer leaves the screen or reenters it and when a second participant replaces the first. The system responds to each participant differently and is programmed with approximately a dozen interactive routines. In one response, as soon as a participant walks in front of the video camera, he is immediately confronted with his lifesize video image projected in brilliant orange on the screen and accompanied by a small green circular figure, nicknamed "critter." The critter playfully avoids the participant's attempts to catch it, thereby creating a simple interchange (plate 98). In the words of the artist, "Critter is a conceptual piece that affords a metaphor for one of the central dramas of our time: the encounter between humans and machines."[17]

147

Indeed, each of *Videoplace*'s programs establishes a different didactic relationship between the participant and the system. In "Finger Painting," the viewer can move his fingers through the air and "paint" on the video screen with the stream of flowing color that follows each digitized fingertip. The participant-artist can control the colors on the screen and create pictures of his fancy in bright video color. In some of *Videoplace*'s interactions, the images of several participants appear on the screen. Spontaneous interactions develop between the participants and their images. Krueger's environments are closely related to the increasingly popular concepts of interactive performance art, in which live action is often combined with real-time video imagery—the exemplification of harmonious man-machine relations.

In the no less spectacular collaborative installations and performances of Otto Piene, director of the Center for Advanced Visual Studies at MIT, and Paul Earls, a musician and artist who has been a fellow at the center since 1980, the interaction occurs between Piene's computer-controlled laser drawings and Earls's own electronic music. The frequency and loudness of the sounds control the movement and shapes of Piene's images. The laser actually plots the colorful forms like a standard plotting machine, following Earls's programming and moving so quickly that the lines appear to be continuous. Their laser drawings have been projected in indoor environments, onto a background of inflatable structures, as well as into the sky (plate 99).

In an extraordinary realization of cybernetic prophecy, a robot of Andy Warhol (plate 100) is being constructed for a theatrical production called *Andy Warhol's Overexposed: A No-Man Show*. An appropriate tribute to a man who so often claimed he wanted to be a machine, the computer-controlled robot is endowed with preprogrammed speech and fifty-four separate body movements that supposedly will be barely distinguishable from Warhol's. During the performance, the robot will be seated on a bed with a telephone next to him and two television sets behind him. There will be a continuous interaction between "Warhol," the phone, the television, and the audience. The robot will also respond to prepared questions from selected members of the audience who will be seated onstage. In addition, the robot can be programmed to appear on television talk shows. This robot belongs to a long tradition. Ever since the term was first coined by Czechoslovakian playwright Karel Capek for his 1921 play *R.U.R.*, in which artificial beings were constructed in human form, robots have captivated the imagination of artists. The Warhol robot surpasses the creations of Enrique Castro-Cid and Nam June Paik as a new symbol for the computer age.

## Computer Control

Artists attracted to the computer's cybernetic capabilities, but not to interactivity per se, have turned to digital technology to control the movement of light, objects, and other special effects. Used in this manner, the computer is replacing less sophisticated electromechanical devices.

Two artists, Tom Eatherton and Eric Staller, both of whom had a previous fascination with the artistic effects of light (Eatherton in his sculptural installations and Staller in his photography), have extended this interest to the creation of computerized light sculptures. Eatherton's most ambitious computerized installation, *Point* (1981), a wall-sized construction of flickering red LED lights on a black ground, is an electronic update of the optical effects painter Lawrence Poons explored in the late 1960s. Poons used elliptical applications of paint on contrasting fields to create almost disquieting sensations and afterimages. In *Point*, dozens of tiny LED lights flicker constantly. The program has so many possible variations that it would take a number of years for the same pattern to reappear.

In 1981, Eric Staller began making both movable and site-specific programmed light sculptures composed of between three thousand and eight thousand small handcolored light bulbs. Run by a computer-controlled solid-state relay, his large abstract sculptures are programmed with as many as fourteen different sequences (plate 102). To achieve a specific effect, Staller creates a program:

108. Jenny Holzer. *Under a Rock.* 1986. Electronic sign, 62 × 48 × 4″
*Holzer's poetry is shown on computer-controlled light boards that transmit her programmed messages.*

**149**      *Hardware:* Sunrise Systems, Inc. *Software:* by the artist

*Before I begin a light sculpture I think about a sensation I would like to evoke in its shape, color, and movement of the lights. I look for a different sensation or atmosphere in each one: hot, cool, velocity, suction, sinuous, soothing, nervous. I want each sculpture to put the viewer into another mood.*[18]

The computer-controlled light sculptures of Milton Komisar, a former fellow at the Center for Advanced Visual Studies, consist of carefully composed configurations of lights in space. His background in painting as well as sculpture has been crucial in the development of these festive three-dimensional structures. *Nisus* (1981), one of his most ambitious pieces, is a dramatic spheroid assemblage of hollow plastic pipes, polystyrene multicolored rods, and miniature light bulbs that rotate overhead, emitting a computerized light show accompanied by electronic sounds. Five smaller satellite structures of varied shapes, each with its own program, are located below and to the side of the main component. *Nisus* is programmed so that vertiginous patterns of lights appear at varying speeds throughout the entire structure. Approximately one thousand light patterns are produced by *Nisus* as it revolves about its own axis every seven minutes. Komisar's subsequent sculptures have utilized similar principles and fragmented, planar effects of light although not on quite such an elaborate scale (plate 101).

In some instances, where computer control offers little more than an increasingly precise way to control specific effects, the artist may have little to do with either the choice of the manner of construction or with the actual fabrica-

109. Jon Kessler. *Arthur P. Finster and the Nemesis of Praxis.* 1985. Mixed-media construction with lights, motors, and digital computer, 103 × 59 × 38". Collection Dakis St. Joannou, Athens, Greece

*Kessler began incorporating digital technology into his elaborate constructions several years ago, when he realized that it was the only way to achieve the lighting effects he desired. In this piece, both the dramatic lighting and the revolutions of the reflective, bespectacled figurine in the transparent globe are computer-controlled. For Kessler, who conceives his pieces much like theatrical plots, the function of the computer is similar to a stage manager, who controls special effects in theatrical productions. When the drama occurs on Kessler's stage, however, no one need be there to orchestrate the effects.*

*Hardware:* Microprint board. *Software:* by Jordan Plitteris

tion. This is quite different than the work of interactive artists or the work of Staller and Eatherton, for whom a thorough understanding of electronics is essential both to the aesthetic conception and the operation of a piece. Bruce Nauman's recent neon sculptures, for example, are not noticeably different to the observer than his previous noncomputerized work. However, computer-controlled timing mechanisms offer more precision and more variety in the sequencing of the illumination (plate 104).

The computer has become such a pervasive force in our everyday lives that its very presence is often taken for granted. Certainly, the most conspicuous computer-generated images in America are those that have been broadcast as "Messages to the Public" to over one million people a day on the Spectacolor light board in Times Square, the heart of the Manhattan theater district. Organized by the Public Art Fund and Spectacolor, who offered computer programming services, a number of artists had a chance to watch their "noncommercial messages of public interest" light up Broadway on a regular basis. (The rest of the time this computer-animated light board flashes commercial messages.) The artists who have participated in the project, including Keith Haring, John Torreano, Steven Gianakos, Gary Falk, and Howardena Pindell, were selected by a jury to represent a wide cross section of the creative talent in New York (plates 105 and 106). The purpose was to offer a fresh approach to the computer art field by introducing computer visualization techniques to artists with no previous experience. Frequently inaccessible computer technology was made available to creative artists for the benefit of a mass audience.

Poet Jenny Holzer was unfamiliar with computer technology until she was commissioned by the Public Arts Fund for a Spectacolor project. Holzer then wanted to see more of her work animated on a scale that could be accommodated in a home environment. Like Nauman, her computerized electronic signboards are fabricated for her (plate 108). Holzer now can bombard her audience with "news flashes": "YOU ARE TRAPPED ON EARTH SO YOU WILL EXPLODE"; "DANCE ON DOWN TO THE GOVERNMENT AND TELL THEM YOU'RE EAGER TO RULE BECAUSE YOU KNOW WHAT'S GOOD FOR YOU" are among the bulletins that repeatedly illuminate her fabricated screens. Her McLuhanesque applications of computer technology that appear in ticker-tape style aptly reflect her obsession with our information-age society.

Computers are now capable of implementing a whole new range of visual and interactive effects. Whether an artist desires to employ a computer to coordinate movement and light—creating works ranging in complexity from Komisar's elaborate constructions to Holzer's straightforward signs—or to develop the interactive potential of sophisticated computer systems capable of simulating limited human responses, computers are transforming both the appearance and the behavior of three-dimensional works of art.

## VI. *The Moving Image: Computer-Animated Film, Special Effects, Video, and Performance*

Computer technology has achieved some of its most stunning and popular successes in the creation of imagery for animations, special effects in feature films, videotapes, and live performances. Audiences are immediately seduced by the new, computer-generated look. Both two-dimensional and three-dimensional imaging techniques give animators more efficacious and versatile tools than ever before. Two-dimensional still images only intimate the computer's prowess, but in animation the full transformative power of a mathematically synthesized image can be revealed. Computer-generated special effects are appearing more frequently in feature films. Artists have been quick to respond, although — with the exception of those in academic settings or with jobs in commercial animation houses — their opportunities have been in the more accessible forums of performance and video, to which real-time processing capabilities can bring an unprecedented sense of immediacy and surprise.

## *Animation*

Computer animation, like computer graphics, is a catchall term, often misleading because of the variety of roles that the computer can play. The different animation functions performed by computers include the digitization of key drawings and the programming of complex objects that may be nonexistent or else virtually impossible to capture convincingly with traditional filmmaking methods. Motion can be created through "in-betweening," in which only key frames are composed and the computer generates the frames in between, an incredible timesaving device. Colorization of an entire frame or just isolated components can be achieved instantaneously. Computers can also control the movement of a camera and therefore can repeat motion with exceptional precision. During editing, computers are used in a variety of ways, including the fine-tuning or recomposition of frames or sequences of frames.

The basic distinction in animation, as in still graphics, is between two- and three-dimensional work, although the interface of these techniques is also increasingly prevalent. Two-dimensional animation has been produced either for educational purposes or by artists working in the tradition of the great abstract filmmakers Viking Eggeling, Hans Richter, and Oskar Fischinger, who approached film as a purely visual experience. The initial animations were made by scientists, and the imagery directly represented the latest technological developments in the field. The first computer-generated film was produced in 1963, the year that an electric microfilm recorder was introduced, providing a way to record and output images. The film was made by Edward E. Zajac at Bell Labs, using the same equipment on which Harmon and Knowlton two years later were to create their famous nude. Zajac was conducting a study to determine whether a satellite in space could be stabilized to have one of its sides constantly facing earth. He discovered animation was the logical way to present his findings, as opposed to

110. Edward E. Zajac. *Simulation of a Two-Gyro, Gravity-Gradient Attitude Control System.* 1963. Frame from film

*This scientific film, a study of satellite motion, is frequently credited with being the first computer animation. Previously, Zajac's research consisted only of statistical analyses. Inasmuch as this study concerned motion, once Zajac realized his data could be processed by computer, he found it only logical to present his results through animation. In 1963, it was considered remarkable that the computer could graphically represent motion.*

*Hardware:* IBM 7094 computer, Stromberg-Carlson 4020 microfilm recorder. *Software:* by the artist

difficult-to-decipher compilations of numbers. The result was *Simulation of a Two-Gyro, Gravity-Gradient Attitude Control System*, a four-minute black-and-white film that represents the movement of a satellite in the simplified form of a brick-shaped cube (plate 110).

In a paper he wrote in 1965, Zajac answered the question, "How does a computer make motion pictures?":

*First, one writes a program that computes the picture to be drawn. This is fed into a digital computer, usually by means of punched cards. . . . The computer translates the program into a series of commands for the electron beam on a cathode-ray tube and the film-advance mechanism in a camera. These commands are read onto magnetic tape. Next, the magnetic tape is read into a device consisting of a cathode-ray tube and a camera. As the tape is played into this device it*

111. Stanley VanDerBeek and Kenneth Knowlton. *Poem Field*. 1967–69. Frame from film

*VanDerBeek was the first artist to use Knowlton's computer animation language BEFLIX for artistic purposes. They collaborated on a number of films, including an eight-film series entitled* Poem Fields. *Early computer films were often composed of abstract forms that could be easily rearranged through computer programming into an almost infinite number of new configurations.*

*Hardware:* IBM 7094 computer, Stromberg-Carlson 4020 microfilm recorder. *Software:* BEFLIX by Kenneth Knowlton

*causes the cathode-ray tube to display the computed picture, which is recorded on the film of the camera. When the picture is complete, the film advance command on the tape goes to the camera, causing the film to advance to the next frame (the camera shutter is always open). The next picture on the tape is then traced out on the face of the cathode-ray tube and recorded on film, the film is advanced, and so on, frame after frame, until the film is complete.[1]*

The computer offered filmmakers certain advantages over conventional filmmaking techniques as well as the possibility of achieving otherwise impossible effects. Kenneth C. Knowlton was among a group of pioneers who produced a dozen computer films at Bell Labs between 1963 and 1967. He has written extensively on the subject of computer animation and produced a movie, *A Computer Technique for the Production of Animated Movies,* using the BEFLIX (derived from "Bell Flicks") movie system he designed for making computer films. According to Knowlton, "BEFLIX was the first attempt to make a general language for computer animation."[2] In his writings, he described the advantages of computers for filmmaking:

112. Larry Cuba. *Two Space.* 1979. Frame from film

*The heir to John Whitney, Sr.'s abstract film tradition, Cuba has produced only four films in thirteen years. This entire film consists of white dots moving on a field of black. The dots perform a series of rhythmically choreographed movements, accompanied by Javanese music.*

*Hardware:* PDP 10 computer, Information International Inc. FR80 display. *Software:* RAP graphics language

113. John Whitney, Sr. *Permutations*. 1967. Frame from film

*For Whitney, the most important aspect of the computer is its ability to visualize subtle variations in movements of forms. Throughout this film, dazzling images are rapidly transformed. Despite their illusion of complexity, these spectacular configurations are created with a very simple program.*

*Hardware:* IBM System 360 Model 75, IBM 2250 display unit. *Software:* by Jack Citron

114. James Whitney. *Lapis*. 1962–66. Frame from film

*James Whitney began making experimental films in the 1940s. The analog motion-control computer on which he created this film was constructed by his brother, John Whitney, Sr. Lapis, like all of James Whitney's films, was inspired by James's profound interest in Eastern religions. A mandala-shaped form composed of tiny dots is manipulated into different positions throughout the film.*

*Hardware:* analog motion-control machine

The computer and automatic film recorders, because of their high speeds of calculation and display, make feasible the production of some kinds of films that previously would have been far too expensive or difficult. Costs for the films cited have fallen in the range of $200 to $2,000 per minute; the cost for the corresponding hand-animated film would be at least twice as much in the easier cases; in other cases it would have been entirely impractical to undertake the job at all without a computer.

The computer offers these further advantages: there are few intermediaries and few delays between the producer and the filmmaking mechanism, thus tremendously speeding up the overall process and minimizing communication problems. This speed, ease, and economy of computer animation permits the moviemaker to take several tries at a scene—producing a whole family of film clips—from which he chooses the most appealing result, a luxury never before possible.[3]

Experimental filmmaker Stanley VanDerBeek quickly realized the computer could be used for artistic purposes, and his collaboration with Knowlton at Bell Labs in 1964 represented the first computer animation made for purely aesthetic purposes. The programmer has recalled the first few months of their collaboration:

I had hoped he would pick up my original BEFLIX language, with all its implicit generality, and begin to do great artistic things with it; he came with great designs in his head and hoped I would program them. We needed a new way of working together—which turned out to be a new language that grew from one of Stan's ideas about words and letters made out of words and letters.[4]

In spite of problematic beginnings, Knowlton and VanDerBeek collaborated on a number of films, including a short film for Expo '67 called Man and His World and a series entitled Poem Fields (plate 111). Each of these films uses Knowlton's BEFLIX system, which in contrast to the linear films of Edward Zajac constructs images from complex mosaiclike patterns and frequently integrates letters of the alphabet into geometric designs. The films were made in black and white, the only output then available on the Bell Labs system. Color was added at a later stage by technicians in a photography lab.

The Whitney family, comprised of the brothers James and John and John's three sons, John, Jr., Mark, and Michael, has made a major contribution to the history of computer film. John Whitney, Sr., generally recognized as the foremost computer film pioneer, began making experimental films in the 1940s. In 1966, his work on an analog computer that he had built from surplus parts of World War II anti-aircraft guns came to the attention of John Citron, a physicist and scientist at IBM.

115. John Whitney, Sr. Arabesque. 1975. Frames from film
*The design for generating the visual structure of this seven-minute film, which was inspired by Islamic geometric forms and calligraphy, is an array of 360 dots distributed about a circle. Larry Cuba's program permitted Whitney to explore both linear and pointillist effects.*

*Hardware:* Information International, Inc., FR80 computer. *Software:* by Larry Cuba

Between 1966 and 1969, Whitney's research into motion graphics was supported by IBM. A close collaboration developed between Whitney and Citron, who was particularly interested in the applications of computers to music and art. He wrote a program for Whitney that allowed a single elementary function to be varied in myriad ways, thereby describing a number of shapes, including rosettes, circles, cylinders, hyperboloids, and other curves. This simple program was the basis of Whitney's spectacular series of abstract films, including *Permutations* (1968; plate 113).

Each of Whitney's films with Citron's program was constructed from thousands of tiny dots that literally dance before the viewer's eyes, forming intricate and colorfully hypnotic configurations (plate 115). Whitney, who often draws an analogy between the visual effects in his computer-generated films and the experience of listening to music, has explained:

*I have been using the computer as if it were a new kind of piano. Using the computer to generate periodic visual action, with a mind to reveal harmonic, juxtaposed against enharmonic, phenomena. To create tensions and resolutions and to form rhythmic structures out of ongoing repetitive and serial patterns. To create harmonies in motion that the eye might perceive and enjoy.*[5]

In recent years, Whitney has realized his dream of playing "the computer in real time, as a musician plays an instrument."[6] He has designed an interactive program that lets the user see the images as they are created.

John Whitney, Sr.'s work is eloquently continued in the films of his former assistant Larry Cuba, who did the programming for *Arabesque*. Cuba's films, including *3/78* and *Two Space* (plate 112), are limited to a vocabulary of white dots on a field of black. In his most recent work, *Calculated Movements* (1985), he used a personal computer with a raster screen that for the first time permitted him solid areas of color instead of just dots.

Other noteworthy early animators utilized computer in-betweening to calculate the values between two linear drawings. In 1967, the Tokyo Computer Group explored this technique in *Running Cola Is Africa*, which, as the title says, transforms the outlined figure of a runner into first a Coke bottle and then a map of Africa. Canadian filmmaker Peter Foldes further developed this process in the film *Hunger* (1974), which received the Prix de Jury at the Cannes Film Festival in 1974. *Hunger* includes a scene with portraits of grotesquely overweight figures who are transformed into emaciated skeletons—an engrossing demonstration of the computer's sleight of hand. Foldes's transformation is reminiscent of Charles Csuri's metamorphosis of a young girl into an old woman.

Csuri himself began producing films almost as soon as he started making

116. John Whitney, Sr., animation pioneer in the early 1940s and computer filmmaker since the 1960s, in the showroom of IBM's New York building at 590 Madison Avenue. 1969

*Whitney, who was artist-in-residence at IBM in Los Angeles for several years, was one of the first artists to explore the aesthetic potential of computer graphics under the aegis of a major corporate sponsor. He was even given access to IBM's most sophisticated equipment in 1969–70 for his ongoing research into motion graphics.*

computer art. His early work included *Hummingbird* (1967), which was produced by digitizing his hand-drawn image of a hummingbird and then manipulating the stored X, Y coordinates so that the bird could be disassembled, reassembled, and multiplied through computer processing—a remarkable demonstration of the computer's capabilities. By 1970, Csuri had successfully developed a real-time film animation program on an IBM 1130 system. IBM was so impressed with Csuri's software that he was invited to New York and given access to equipment in their main mid-Manhattan showroom. For three days, Csuri and some of his associates manned an installation and demonstrated their software to interested passersby (one of whom was Salvador Dali). This installation was among the first, if not the first, opportunities for the general public to see such an interactive display.[7] Once a user called up an image on the display terminal with a light pen (a similar procedure to Sutherland's Sketchpad), the computer could be instructed either to put the object into motion or to change its shape and size. Csuri had designed the system with artistic applications in mind, and he considered his installation to be an interactive artwork. Indeed, it was the precursor of the art form rapidly gaining popularity today.

In a paper presented at a meeting of the Institute of Electrical and Electronics Engineers, Csuri discussed the interactive potential of works of art:

*Real-time computer art objects are an intellectual concept which can be visually experienced rather than a finalized materialized object. This kind of computer art exists for the time the participant and the computer with the CRT display are interacting as a process. The art object is not the computer or the display, but the interactivity of both interacting with the participant. . . . Real-time computer art objects are a unique art form.[8]*

Csuri and the Computer Graphics Research Group, which he founded at Ohio State University in 1970, continue to advance computer animation research. In 1971, Tom DeFanti, a graduate student at Ohio State, developed GRASS (Graphics Symbiosis System), the first easily programmable animation language. The Computer Graphics Research Group is highly acclaimed for their modeling of human body motion. They are currently creating a program of basic human body movements. Participants can choreograph a pattern of motion and see it immediately on the computer screen. The system already has the capability to represent the body movements of up to twenty figures at one time.[9]

The desire to animate some of her still graphics, along with the assistance and programming of Kenneth C. Knowlton, led Lillian Schwartz to her pioneering work in computer films. Her first composition, *Pixillation* (1970), was a combina-

117. Charles Csuri demonstrating the capabilities of his interactive computer graphics system with a light pen on a monitor connected to an IBM 1130 computing system. 1970

*With his program, Csuri was able to call up previously generated images from the data base and manipulate them on the screen. He could put them into motion or change their shapes and sizes. In this photograph, a view from inside the monitor, Csuri indicates with the light pen the position of a helicopter.*

*Hardware:* IBM 1130 computer, IBM 2250 display. *Software:* by the artist

tion of computer animation and hand-painted animation frames. Whereas Van-
DerBeek and Knowlton had sent their black-and-white film output to a lab to be
colorized, Schwartz herself supervised the coloration process. *Pixillation* is com-
posed of many series of abstract patterns fittingly accompanied by synthesized
electronic sound. The artist has referred to her films as "drumbeats on the
eyeballs": the pace of the imagery is so quick and the coloration so intense that she
often inserts black frames to give the viewer's eyes a rest.[10]

It is with three-dimensional animation techniques that the computer has
created some of the most spectacular visual effects. Each year animators work
virtually around the clock in the weeks before the celebrated SIGGRAPH conven-
tion in order to have their latest research included. The majority of films are made
for commercial purposes. The costs are so high that Robert Abel's captivating

118. Robert Abel. *High Fidelity*. 1984. Frame from film

*Robert Abel's integration of computer-generated imagery with live-action performance has revolutionized the art of
television commercials and has captivated audiences with its innovative look. Some of his most memorable commer-
cials were for 7-Up and Levi Strauss and Company. In this witty animation, the colorful, three-dimensionally modeled
figure of Ava revolves gracefully through fairyland settings explicitly, demonstrating the impressive powers of three-
dimensional animation. In this scene Ava is dancing with her umbrella. The texture on her body was first digitized as a
flat two-dimensional image and then wrapped around her body using the Evans and Sutherland PS2 System. The sky
was hand-painted using a paint program.*

*Hardware:* Digital Equipment Corporation VAX 11/750 computer, Evans and Sutherland Picture System 2, Ikonas frame
buffers. *Software:* Robert Abel and Associates proprietary

*High Fidelity* (plate 118), for example, a love story between the three-dimension-ally modeled characters Tom and Ava (which was made as a test of in-house software), is the only noncommercial film Abel's highly successful company has ever made.

SIGGRAPH's awards are no longer awaited only by the computer community. Television audiences and moviegoers everywhere are waiting to see what the art of the future brings. In 1986, Digital Productions' *Hard Woman* (pages 2–3) replaced Abel's *Sexy Robot* of the previous year as the SIGGRAPH heartthrob.

119. Michael Sciulli, James Arvo, and Melissa White. *Quest (A Long Ray's Journey into Night).* 1985. Frame from film

*Quest was generated entirely by ray tracing, a highly sophisticated computer-imaging technique with exceptional abilities to render scenes realistically. Ray tracing can adeptly handle complex images with highlights, shadows, reflections, refractions, translucence, and textures. Conventional animation techniques could never have achieved the glistening surfaces, lustrous reflections, and agile movements of the objects in this fanciful film. Unfortunately, ray tracing is not yet practical for commercial purposes.* Quest *took fifty-thousand hours of computing time to process.*

*Hardware:* Apollo DOMAIN family of workstations. *Software:* by James Arvo

*Sexy Robot* was the star of a television commercial entitled *Brilliance* that was made for the Canned Food Information Council. The robot's graceful body movements and the allure of her glistening metal body slithering through the thirty-second commercial won her the epithet "sexy." This year, she found her match in Digital's supercomputer creation *Hard Woman*, a landmark piece produced with the Digital Scene Simulation process developed by John Whitney, Jr., and Gary Demos, who founded Digital Productions in 1982. With the realistic simulation of the natural world as their goal, they developed this process, which requires a Cray X-MP supercomputer capable of performing 400 million mathematical calculations per second. The computational demands for the creation of realistic computer-simulated scenes are staggering:

*Lighting and rendering algorithms require 1 to 10,000 calculations per color. Thus, anywhere from 864 million to 8.64 trillion calculations are needed to*

120. Cranston/Csuri Productions. *Computer Animation*. 1986. Frame from film

*For the computer community, the most prestigious event of the year is the film and video review at the annual SIGGRAPH (Special Interest Group for Graphics) conference. This witty animation about a computer room introduced the 1986 review.*

*Hardware:* Digital Equipment Corporation VAX 11/780 computer, Pyramid Technological Corporation 90X computer.
*Software:* Cranston/Csuri animation and rendering software

*produce one second of animation. The Cray, at 200 million floating-point instruc-
tions per second, takes anywhere from three seconds to 10 hours to generate one
second of film.*[11]

The complexity of such calculations is understandably difficult to comprehend.
Indeed, the computation necessary to propel a planet through space or to move a
human figure across a computer screen can only be fully appreciated by someone
in the field. The convincing portrayal of human body movement has remained so
elusive that the figure of his wife painstakingly digitized by Edwin Catmull, now
president of Pixar, at the University of Utah in the mid-1970s has been borrowed
by many others in the field in order not to have to execute the labor-intensive
process of faithfully recording a figure in a data base themselves.

Others in the scientific domain also contributed significantly to three-dimen-

121. Rebecca Allen and Paul Heckbert. Computer Graphics Laboratory, New York Institute of Technology. *Rotating Masks*. 1983. Frame from videotape

*These masks were part of a music video,* Adventures in Success *(Island Records), directed by Rebecca Allen for musician Will Powers (whose features were texture-mapped onto the masks). As the masks rotate, an optical illusion occurs in which they appear to reverse direction.*

*Hardware:* Digital Equipment Corporation Vax 11/780 computer, Evans and Sutherland Picture System, Ikonas frame buffer. *Software:* New York Institute of Technology proprietary

sional computer animation. Loren Carpenter's film *Vol Libre*, a breathtaking depiction of a hang-glider's flight through a fractal mountain range, was created while Carpenter was at Boeing Computer Services in 1980.

When Nelson Max's film *Carla's Island* made its debut at SIGGRAPH in 1981, it was the sensation of the industry, radically advancing techniques for portraying natural phenomena that were evading filmmakers' computational abilities (plates 122 and 123). This four-and-one-half-minute movie depicts an aerial view of an island throughout the course of a day, from sunrise to sunset to moonset. It was created on a Cray-I supercomputer, using ray-tracing techniques developed by Max. The film's success earned him an invitation to participate in the *Electra* exhibition at the Musée d'Art Moderne de la Ville de Paris in 1983, where an interactive version was displayed on a computer terminal with a keyboard. Using the eight function buttons on the keyboard, the viewer could change and restore colors, speed up or slow down the simulation, and change the time of day at will. Through the capacities of this interactive display, the viewer participated in the creation of the landscape, at least within the parameters of the program.

Max, like Melvin Prueitt, is a scientist who became involved in computer graphics as a way of visualizing mathematical concepts. Also like Prueitt, the computer endows him with artistic skills that otherwise he might not possess. "You see, I can't paint," he has explained, "but I can do the mathematics and the programming [necessary to generate a simulated scene on a computer display], so the computer allows me to create fictional worlds I would not otherwise be able to."[12] Max never thought of himself as an artist until people repeatedly commented on the beauty of his images. His landscapes, however, are never without educational value: they always demonstrate the capability of specific algorithms

122–23. Nelson Max. *Carla's Island.* 1981. Frames from film. (Interactive computer installation, 1984)

*Max is a scientist who has pioneered a number of algorithms that are used in the convincing depiction of naturalistic light and shade. When* Carla's Island *was first shown, its simulation of reality through ray-tracing algorithms represented the most sophisticated application of animated computer graphics, and it still ranks among the most advanced. The three-minute film depicts the island and its watery setting over the course of twenty-four hours—from sunrise to sunset to moonlit nighttime. It is a didactic demonstration of the computer's ability to transform a scene. Recently, Apollo Computers has made an interactive version of this animation, which allows the viewer to select the time of day at will.*

*Hardware:* Cray® 1 computer, Dicomed D-48 color film recorder. *Software:* by the artist

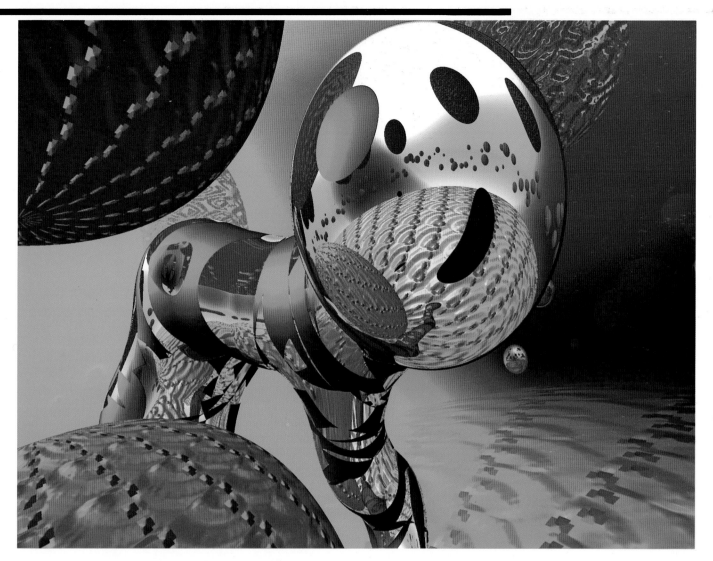

to simulate different effects of light and shade.

One of the foremost computer graphics artists in the world is Japanese artist Yoichiro Kawaguchi. Unusually, his background is specifically in computer graphics filmmaking as an art form. His breathtaking simulations of underwater life are influenced by diving trips in the East China Sea. Yet, unlike most computer animators, who strive to attain approximations of reality, Kawaguchi is after "realistic" depictions of his fantasies (plate 124). He patterns his algorithms on the laws that determine the growth patterns of seashells and other objects in the natural world, such as "horns, claws, fangs, and spiraling plants [that] exhibit a repetitive pattern in both colorizing and form."[13]

124. Yoichiro Kawaguchi. Ocean. *1986. Frame from film*

*Kawaguchi's most recent animation shows his abiding interest in the metamorphosis of organic forms and the use of iridescent colors. In the computer's palette, he has found a perfect match for the splendor of nature.*

*Hardware:* LINKS-1 computer. *Software:* by the artist

125. Nam June Paik. *Family of Robots: Baby*. 1986. Thirteen television sets, half-inch VHS player, and half-inch thirty-minute tape (*Heart Channel for Robot*), 52½ × 38 × 13¼". Courtesy Carl Solway Gallery, Cincinnati, and Holly Solomon Gallery, New York

*Whereas the Mom, Dad, Aunt, Uncle, Grandma, and Grandpa of Paik's new Robot family are composed of witty constellations of old televisions, the Baby is appropriately constructed of sixteen tiny, spanking new color sets. Computer-processed images blaze across these monitors, in keeping with Paik's tradition of multiple television installations.*

## Video

Numerous artists are exploring the computer-video interface through the integration of computer-generated imagery with video and the manipulation of video with computer-processing effects. Video, in contrast to film, is shot with a camera at thirty frames a second, using real-time techniques. Video affords the instantaneous recording and processing of an image, unlike film where there is always a delay in processing. The demands of broadcasters, entertainers, and advertisers have created a seemingly insatiable demand within the television industry for digital video effects. The most frequently used effects include colorization, keying (the collaging of multiple video images), and the construction of three-dimensional imagery using two-dimensional video planes. Artists have been able to take these broadcast tools, which were originally developed to create

126. Ed Emshwiller. *Sunstone.* 1979. Frame from videotape

*Emshwiller, an important experimental filmmaker, collaborated with Alvy Ray Smith at the New York Institute of Technology on this video, which utilized many newly written capabilities in Smith's paint program. The sunlike disc is repeatedly transformed with washes of digital paint. The most memorable scene occurs when faces appear on each interior and exterior plane of the cube.*

*Hardware:* Digital Equipment Corporation PDP 11/34 computer. *Software:* New York Institute of Technology proprietary

network logos or to squeeze a weathermap over the shoulders of the anchorman on the nightly news, and apply them to their own aesthetic investigations. Indeed, computer technology is so integral to video effects today that it encompasses the work—both in single channel (seen on one monitor) or multiple channel (seen in installations of two or more monitors)—of most of those in the field.

The artist recognized for the development of video as an art form is Nam June Paik, who began experimenting with the medium in 1955—a full decade before the introduction of the portapak (a portable video recorder) made the video camera a viable tool. Because of the newness of the medium itself, video artists have not shared the reticence and hostility of their counterparts in painting and sculpture toward the new technology. Artists interested in video have more than willingly explored whatever equipment was available to them. The idea of experimentation was intrinsic to the medium.

From the beginning of its short history (Paik's purchase of a portable video camera in October 1965 and his film made later the same day of Pope John Paul IV's visit to New York is credited as the medium's debut as an art form), video, unlike still computer graphics and animation, has had a network of interested proselytizers making the equipment available to artists who wanted to explore the medium. Video as an art form was a product of the 1960s. Video's supporters waved the flag of "Art for the People," and its popularization was one of many such art-related causes. Like early computer art, it is often difficult to disassociate the experimentation in video with the facilities that made it possible. The highly influential Television Laboratory at WNET, the New York Public Broadcasting Service Station, served "a sort of guerrilla function: to mess things up; to take television back to its formative stage; to recreate television; to tap the artistic drives that create forms instead of the commercial ones."[14] Among the many artists who have worked with the digital equipment at the Television Laboratory are Ed Emshwiller, Nam June Paik, Lillian Schwartz, and Doris Chase.

In contrast to the world of computer imaging, many of the processing devices in video were actually developed and built by the artists themselves rather than by technicians. The first generation of video artists was composed of experimenters who learned out of necessity to develop the tools of the craft well before they ever got to begin making images. Artist Bill Etra, who built the Rutt/Etra synthesizer, explained, "For my own work, I never produced more than ten minutes a year I ever showed, and that's an awful little, but it's an awful lot if you think that most of the machines they were shown on had to be built before the tapes could be made."[15]

Etra was far from unique: Nam June Paik collaborated with Abe to build the Paik/Abe synthesizer; Dan Sandin built the Sandin Image Processor; Erich Siegel built a color synthesizer capable of adding color to black-and-white video signals; and Stephen Beck completed his Direct Video Synthesizer in 1971: "As Beck saw

127. Woody Vasulka. *Hybrid Hand Study*. 1984. Frame from videotape

*Woody and his wife, Steina Vasulka, cofounded The Kitchen, a media theatre and exhibition space in New York, in 1970. They have been investigating computer-controlled video since 1974. With Jeffy Schier, Woody built the Vasulka Imaging System, or Image Articulator, a hybrid of analog and digital technologies. The hand was first captured in video and then manipulated and colorized by computer-processing techniques. The hybrid techniques used to create the textures are reflected in the title.*

*Hardware:* Image Articulator by Jeffy Schier and Woody Vasulka, Rutt/Etra scan processor. *Software:* by the artist

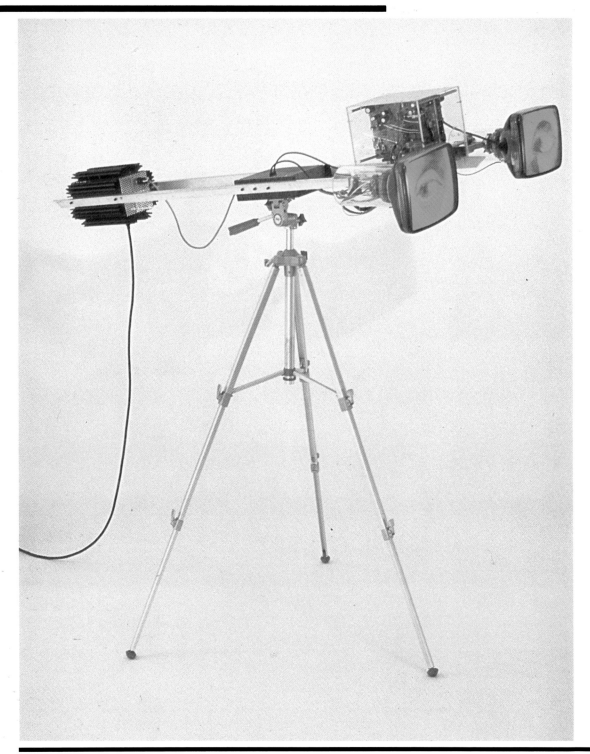

128. Alan Rath. *Voyeur*. 1986. Tripod, aluminum, steel, acrylic, and electronic video tubes, 12 × 29 × 59″

*The moving eyes on the two cathode-ray tubes were generated by a computer graphics system designed and constructed by the artist.*

*Hardware:* customized computer system with 2-80 microprocessor. *Software:* by the artist

129–31. Gary Hill. *Happenstance.* 1982–83. Frames from videotape. Copyright 1983 by Gary Hill

*Happenstance is a complex interweaving of abstract images, written and spoken text, and other sounds, accomplished by a combination of analog control and digital sequencing and switching.*

*Hardware: Rutt/Etra video synthesizer, Serge music modules*

it, the essential difference between his tool and a colorizer-mixer like the Paik/ Abe was the difference between synthesis and fragmentation. The Direct Video Synthesizer was designed to produce nonobjective, archetypal imagery, not to manipulate a representational camera image."[16] Most importantly, Beck's system enabled the user to synthesize patterns directly in video without having to reset them with a camera. In 1974, the Electronic Music Studio in London introduced the first digital video effects device, engineered by artist Richard Monkhouse, as a system specifically for musicians and artists. Vibeke Sorensen and Thomas De-Witt were among the first to experiment on this system. Another major development in 1974 was the interface of Thomas DeFanti's GRASS language with Sandin's Image Processor. The resulting GRASS/Image Processor introduced many video artists to computer graphics. Among the first of many users of this low-cost, easy-to-use interactive system were Phil Morton, Jane Veeder, Joann Gillerman, and Barbara Sykes. In 1976, Grass Valley, Inc., a video hardware

```
••TIMESHARING SERVICE
4/1/88 PLEASE LOG ON

I AM NEW TO THIS TYPE OF
COMMUNICATION. I ONLY
HOOKED UP A MODEM TO MY
TELEPHONE THIS MORNING.
I KNOW I'M TAKING A
```

```
I WOULDN'T HAVE DIALED
THIS NUMBER, WOULD I?
WELL, HERE GOES.
I AM 31, I HAVE DARK
HAIR, I THINK I'M
ATTRACTIVE. I HAVE LOTS
OF ACADEMIC INTERESTS.
I AM RECENTLY DIVORCED
```

132–33. Douglas Davis. *Two Text.* 1984. Videotape and two monitors

*Two Text is a dialogue between two monitors (each of which is pictured here) who meet via a personal-computer network line, converse, and — we are led to believe — fall in love. Critic Douglas Davis has utilized both the language and the medium of the computer age to express his message.*

company, introduced a prototype for a digital video-effects device. For the first time, a color video image of a box, for example, could be "squeezed" (stretched on either the X or Y axis) or moved about the screen. Such objects were not yet truly three-dimensional in computer graphics terms but only appeared to be so and were constructed from flat, two-dimensional images that were pieced together. The real breakthrough came in 1979, when the English Company MCI/Quantel introduced its digital video-effects device, the first unit widely accepted by the broadcast industry to create digital special effects. Subsequently, a number of devices were developed for the broadcast industry that have been used increasingly by artists, including the Fairlight, the ADO, and the Mirage. Another major development has been the interface of modeled computer graphics with video. What was before the domain of special effects could now be created in true three-dimensional animation. Ko Nakajima, Rebecca Allen, and Vibeke Sorensen are among the relatively few artists who have been able to effectively utilize these tools.

Yet, many artists are still more interested in the degree of interactivity popu-

134. Mark Lindquist. *The Loop*. 1985. Frame from film

*The* Loop *depicts a day in the life of a New York artist through a combination of live-action video and computer-generated imagery. This scene was digitally painted and recorded, then combined with film through optical compositing and dissolves.*

*Hardware:* Lekidata frame buffer, Dicomed film recorder. *Software:* Video Palette 4 by Digital Effects

larized in video-game technology than in three-dimensional animation techniques. The system that has done the most to enhance this aesthetic is DeFanti's ZGRASS, a later version of GRASS developed for the Bally Corporation. Copper Giloth and Jane Veeder are among those who have utilized ZGRASS for the video-game-like installations that have become an almost common art form. Veeder's *Warpitout* (1982), which features the real-time color graphics processing of the participant's face, is among the most popular of these installations.

In the late 1960s, the hybrid genre of performance video developed. Artists who worked in this medium conceive of performances specifically to record them on tape. Video artist and electrical engineer Dean Winkler and artist John Sanborn have produced some of the most outstanding performance videos. In collaboration with composer Philip Glass, their videotape *Act III* (plate 137) has been among the most successful. Throughout the six-minute tape, the seemingly flawless integration of live and video-processed images is synchronized with the music so that musical and visual transitions are paralleled. Exploding cubes open to reveal other exploding cubes—now a video cliché, easily achieved with three-dimensional modeling, but three years ago it was an innovative effect ingeniously constructed from flat, two-dimensional elements—and mysterious revolving balls whirl above live video images of the New York skyline. Much of the imagery

135. Ed Paschke, Carole Ann Klonarides, and Lynn Blumenthal. *Arcade.* 1984. Frame from videotape
*Klonarides and Blumenthal began this collaborative videotape with tapes that artist Paschke had recorded off his television set.* Arcade *interweaves Paschke's prerecorded imagery with additional footage of the artist's favorite haunts in Chicago. Each scene has been interfaced with images created interactively by Paschke using a paint system.*

*Hardware:* Quantel Paintbox, ADO, CMX editing system

was made possible by the use of the digital ADO special-effects device, introduced by Ampex in 1982. Two-dimensional images were only able to move on two-dimensional planes before ADO, but with the system, they could be moved in three-dimensional space. *Video Wallpaper* (1983), an approximately one-hour collaboration of Winkler and Sanborn with artists Bill Etra, Vibeke Sorensen, and Thomas DeWitt, was commissioned by a New York nightclub as the visual equivalent to dancing music (plate 140).

Computer-generated imagery and digital video effects are pervasive throughout the music video industry. In the music video, the computer medium has found its most popular art form. Bette Midler and Mick Jagger are among the many rock stars who have recognized the computer's unsurpassed talent as a special effects device. Some of the most outstanding examples of this genre include Dean Winkler's collaboration with singer Laurie Anderson and art director Perry Hoberman for *Sharkey's Day* (1984); Digital Productions' collaboration with Mick

136. Dan Sandin, Thomas DeFanti, and Mimi Shevitz. *Spiral Five P. T. L. (Perhaps the Lost)*. 1981. Frame from videotape

*This video was made with the Sandin Image Processor, built in 1971–74, using a computer graphics program by Thomas DeFanti and a highly popular synthesizer (Sandin will send the do-it-yourself instructions for the processor to anyone who requests them). In this collaboration, Sandin provided the video synthesis, DeFanti the computer graphics, and Shevitz the sound synthesis. The three collaborators produced a tape in which a Y-shaped configuration is transformed into numerous variations of its original form—a spiral among them—but always returns to its basic shape. The imagery responds to Shevitz's synthesized sounds. Earlier versions of this tape, first created in 1974, were made to be played on multiple monitors accompanied by live music.*

*Hardware: Sandin GRASS/Image Processor, Digital Equipment Corporation PDP 11/45 with Vector General display.*
*Software: GRASS graphics language*

Jagger for *Hard Woman*; (1985) and Emmy award-winning animator Rebecca Allen's *Musique Non-Stop* (1986) for Kraftwerk's album *Electric Café*.

*Sharkey's Day* (plate 138) was inspired by performances of Bauhaus choreographer Oskar Schlemmer's work and was meant to reflect his most noted characteristics: "A medley of sense and nonsense, characterized by 'Colour, Form, Nature and Art; Man and Machine, Acoustics and Mechanics.'"[17] In the videotape, digital special effects are combined with traditional cell animation "because there's something about the rickety quality of film animation" Anderson likes.[18] The most spectacular scene in this video is one in which a figure that appears to be Anderson (but which isn't her at all; it is digital video feedback) is transformed into a cloud of smoke.

137. Dean Winkler and John Sanborn; music by Philip Glass. *Act III*. 1983. Frame from videotape

*To create Act III, Sanborn and Winkler, who have collaborated on a number of music videos, spent over three hundred hours on-line at VCA Teletronics, a New York postproduction facility. Although the geometrically patterned orbs above the New York skyline have the appearance of three-dimensional modeled graphics, they were patched together with two-dimensional planes of video using the ADO digital video-effects device.*

*Hardware:* Quantel DPE 5000 Plus real-time image-processing system with additional frame store, Grass Valley Group GVG 300 video switch, Ampex Digital Optics real-time image processor, Teletronics V1² Communications Control System, Sony BVH 2000 video recorder *Software:* Ampex version 4.2 operating system, Quantel version 4 operating system with enhanced BBC teletrack, Teletronics V1² operating system version 12.3

138. Laurie Anderson, Dean Winkler, and Perry Hoberman. *Sharkey's Day*. 1984. Frame from videotape

*Dean Winkler created the special effects for this music video, which uses digital video feedback to transform Anderson into a smoke screen.*

*Hardware:* Quantel DPE 5000 Plus real-time image-processing system with additional frame store, Grass Valley Group GVG 300 video switch, Ampex Digital Optics real-time image processor, Teletronics V1² Communications Control System, Sony BVH 2000 videotape recorder. *Software:* Ampex version 4.2 operating system, Quantel version 4 operating system with enhanced BBC teletrack, Teletronics V1² operating system version 12.3

139. Doris Chase. *Jonathan with Circles*. 1977. Choreography by Jonathan Hollander. Frame from videotape

*Chase is one of the most outstanding artists working in the field of performance video. The original computer graphics for this video were made on film in 1971 using a program written by William A. Fetter of the Boeing Company. Chase then expanded upon Fetter's original program for choreographing forms by colorizing, multiplying, and solarizing simple computer-generated circles. Morton Subotnik composed a musical score for the videotape, and in 1977 Jonathan Hollander choreographed a dance to accompany the graphics.*

*Hardware:* Chromacade system. *Software:* by William A. Fetter

140. Tom DeWitt, William Etra, John Sanborn, Vibeke Sorensen, and Dean Winkler. *Video Wallpaper*. 1983. Frame from videotape

*Part of the mystique of the images produced in this collaborative effort is created by the trails that follow the abstract forms in their interplanetary travels. Rings, for example, were created by the celestial bodies as they circled the planets. These effects were achieved by programming the frame buffer so that it would remember the position of each form from frame to frame. Two frame buffers were used—one to remember the movement and another to create the animation.*

*Hardware:* Quantel DPE 5000 Plus real-time image processing system with additional frame store, Grass Valley Group GVG 300 video switch, Ampex Digital Optics real-time image processor, Teletronics V1² Communications Control System, Sony BVH 2000 videotape recorder *Software:* Ampex version 4.2 operating system, Quantel version 4 operating system with enhanced BBC teletrack, Teletronics V1² operating system version 12.3

## Special Effects in Film

Hollywood has used ingenious devices to achieve special effects ever since Georg Méliès, who is recognized as the father of special effects, began devising cinematic techniques to fool audiences at the turn of the century.[19] Today, computer animation is becoming an increasingly viable option for film sequences that are difficult, dangerous, or even impossible to achieve using conventional photography. Computers have been utilized particularly effectively for science fiction movies—a forum quite in keeping with the eerie scale of the computational requirements.

In 1981, Information International, then one of the leaders in computer graphics research and development, produced the computer graphics for Michael Crichton's film *Looker*, the first time that three-dimensional computer graphics techniques were used in a feature film. The method used on screen to digitize and transform actress Susan Dey into a data base is similar to the process used by the filmmakers to synthesize the three-dimensional model of Dey that appears in the film.

Some of the most acclaimed computer-generated movie sequences have been created by the Computer Graphics Project division of Lucasfilms, Ltd., in collaboration with Industrial Light and Magic, the special effects division of Lucasfilms. They include *Star Trek II* and *Return of the Jedi*. The computer graphics division

141. Lucasfilm, Ltd. *Return of the Jedi: Death Star Hologram Sequence.* Frame from film. Copyright Lucasfilm, Ltd. (LFL) 1983. All rights reserved. Courtesy of Lucasfilm Ltd.

*The "holographic display" used by the Rebel forces aboard Admiral Ackbar's flagship to plan an attack on the Empire's new Death Star was produced by Lucasfilm's Computer Graphics Project, a group responsible for some of the most spectacular computer-generated special effects. This thirty-seven-second sequence took four months to complete.*

*Hardware:* Digital Equipment Corporation VAX 11/750 computer. *Software:* by Lucasfilm Computer Graphics Project

was established in 1979 by motion picture producer and director George Lucas in order to bring high technology to filmmaking. The "holographic display" in *Return of the Jedi* (plate 141), used by the rebel forces aboard Admiral Ackbar's flagship to plan an attack on the empire's new Death Star, is a thirty-seven-second sequence that took William Reeves and Tom Duff four months to complete, including compositing and writing the animation program. *Star Trek II* contains a sixty-eight-second sequence called the "Genesis Effect." After Admiral Kirk successfully passes a retina identification test, he is allowed to see the "Genesis demo" videotape. For over a year after it was made, this sequence was heralded as one of the most sophisticated applications of computer graphics. The graphics were programmed by different members of a large team, each contributing separate components, including fractals, particle systems, bump mapping, motion blur, splines, quadric surfaces, bicubic patch surfaces, and matting. The Computer Graphics Project of Lucasfilms designed the Pixar Image Computer in response to a number of image-processing capabilities used by Industrial Light and Magic. Among Pixar's recent accomplishments is the computer-generated sequence known as "Glassman" in the Paramount Pictures film *Young Sherlock Holmes* (1985). In this sequence, a stained glass window in a church is shattered by a sword-wielding soldier emerging from the glass, who then chases a startled priest into the street. Usually such effects are filmed directly off a CRT. For the first time in a feature film, however, this sequence was scanned with a laser directly onto the film, creating an image of much greater vibrancy and detail than was possible with previous computer-generated special effects.

Fifteen minutes of Walt Disney's *TRON*, released in 1982, was computer-generated—the first feature film to contain more than a few minutes of digitally generated imagery (plate 142). Although it was a box office failure—which had a major impact on diminishing Hollywood's appetite for digital effects—*TRON* was a staggering computational success. "There was nothing done with the computers on *TRON* that could not have been done with conventional animation given 45 million dollars and one hundred years,"[20] according to Bill Kroyer, one of the computer animation choreographers for the film. Not only was Disney incapable of the computer animation required by the script (in which a young computer whiz trying to solve the mystery of his stolen video game program finds himself dematerialized and trapped inside a computer), but in order to execute all the computation for the different scenes they enlisted the services of four of the leading high-resolution commercial production companies: Robert Abel, MAGI SynthaVision, Information International, and Digital Effects.

The future of computer-generated imagery and special effects in film is still uncertain. Some prophecise the replacement of live performers by computer-synthesized actors and the possibility of performances by actors, whose essential data are stored in a computer, long after their natural lives are over. Although

there are many who are either skeptical of or frightened by simulation techniques, Gary Demos is not daunted, and he has even greater expectations for the future evolution of computer systems. He expects to make remote interactive scene simulation possible over cable television channels within the next decade:

*The real-time simulation channel would be a direct feed from a supercomputer like the Cray-1 running twenty-four hours a day and available on a subscription basis. So you just tune in and connect your home computer to the central computer by phone modem and you become a part of the movie. The Image Utility presents the generic possibilities and you make variations based on your own personality and abilities. You control things, create a custom movie that will never be seen by anyone else. The entertainment value of interactive characters more beautiful than those in Disney animation, all customed to your commands, would be incredible! . . . The AT&T of the future is the company that sells custom visual simulation. I am certain it will be common in ten to fifteen years.*[21]

Artist, viewer, and computer technology seem ordained to have increasing interdependency.

142. MAGI SynthaVision for Disney Studios. *TRON: Light Cycles and Tanks Sequence.* 1982. Frame from film. © 1982 by The Walt Disney Company

*The fifteen computer-generated minutes in this Walt Disney extravaganza required the resources of four of the leading high-resolution computer graphics production companies. MAGI SynthaVision in Elmsford, New York, created one of the film's sensational computer-generated sequences, a race between motorcycle-like vehicles, called light cycles. The SynthaVision method, which is adept at producing realistic motion, constructs objects from a data base of twenty-five three-dimensional shapes (including spheres, cubes, cylinders, and cones). All the shapes in this image are configurations of this basic vocabulary.*

## Performance

The transformation of artistic performances by computers closely parallels the evolution of three-dimensional objects or environments in that electronic technology may function simply as a more effective tool or as a live partner. Computer-controlled lighting systems today are fairly commonplace on stage. None of the available systems has the incredible variety and flexibility, however, of the CORTLI system designed by sculptor James Seawright, electronic musician Emmanuel Ghent, programmer William Hemsath, and choreographer Mimi Garrard for the Mimi Garrard Dance Company. The prototype for the current system was designed in 1968–69 by Seawright, Garrard, and Ghent, who was then at Bell Labs, using a real-time interactive music system developed by Max Matthews at Bell. The tapes were prepared at Bell and then brought to the theater, where they were played on a homemade computer constructed by Seawright — among the first of its kind. CORTLI synchronizes lighting and computer-generated music with a precision not yet possible on any other system. Since the company's first piece, *Phosphones*, was performed in 1969, Garrard has choreographed about fifteen additional works with the system (plate 143).

Artist Darryl Sapien's sets for the San Francisco Ballet's *Pixellage* (plate 148), which premiered in 1983, was the first time that computer-generated imagery was

143. Mimi Garrard Dance Company: Mimi Garrard, choreography; Emmanuel Ghent, lighting and music; Emmanuel Ghent, William Hemsath, and James Seawright, computer-controlled lighting system. *Phosphones.* 1969

*Throughout this performance, the movement of the dancers is punctuated by bright lights carefully synchronized to the tempo of the electronic music. The computer-controlled lighting system, called CORTLI, that coordinates these effects is the most sophisticated of its kind. It is the product of a collaboration between Ghent, who is investigating real-time music systems (created by Max Matthews, his colleague at Bell Labs), Seawright, who is well known for his interactive sculptures, and programmer William Hemsath. The distinguishing feature of this theatrical lighting system is that it has versatile capabilities and can reflect the subtle innuendoes of the music.*

**181**  *Hardware:* customized by James Seawright. *Software:* CORTLI

combined with a live performance in a major opera house. The project was initiated when choreographer Betsy Erickson saw one of Sapien's presentations combining performance and film projections. On an Aurora Systems computer, which was loaned to him for the project, Sapien created an eighteen-minute computer animation on the general theme of coexistence between man and computers. The images he created were projected on a screen behind the dancers as they performed. Both the movements of the dancers and the music were carefully coordinated with the computer animation. Sometimes the animation echoed the choreography—silhouetted figures with outstretched legs appeared in the animation at the same time as the dancers executed this movement onstage—at other times, the computer-generated imagery functioned as a more traditional scenic backdrop.

Patrice Regnier, artistic director of the Mark Rush Dance Group, considers the incorporation of advanced technology in her choreography to be her mandate. In 1984, she collaborated with Rebecca Allen of the New York Institute of Technology Computer Graphics Laboratory on a dance called RAB (the name stood for the last names of Regnier, Allen, and Carter Burwell, who provided the electronic music). Lest anyone mistake the importance of the computer to this dance, an actual computer is onstage in the opening scene, with one of the dancers expressing simultaneous fascination and fear of the machine. Throughout the captivating performance, Allen's computer-generated, trunkless dancer is projected on a screen onstage. The live dancers are as mesmerized by this figure as the audience is. This interaction between choreographed live motion and computer-generated imagery continues the work Allen pioneered in her 1983 collaboration with choreographer-dancer Twyla Tharp in a film version of *Catherine's Wheel* (plate 144). Regnier plans to incorporate a robot as well as a randomly programmed screen of lights in her next choreographed piece.

The concept of the computer as a live or real-time collaborator is central to a number of performance pieces, including those of Edward Tannenbaum, Joann Gillerman, and Thomas DeWitt. Tannenbaum both constructs installations and plans live performances. Like Myron Krueger's *Videoplace*, in Tannenbaum's installations and performances a live video camera digitizes the performers, who see mirror images of themselves on a video screen as soon as they enter the camera's range of vision. Whereas Krueger is specifically concerned with the development of artificial intelligence, Tannenbaum, whose background is in fine

144–47. Rebecca Allen and Twyla Tharp; music by David Byrne. *Catherine's Wheel.* 1983. Frame from videotape

*When this video was made, the computer model of a human figure that Allen had produced at the New York Institute of Technology Computer Graphics Laboratory represented the most intricate example of computer-animated human motion possible. This videotape intersperses choreographed live dancing with computer-generated frames. In certain sequences, the wire-frame model of a dancer representing St. Catherine takes center stage and becomes a performer as engrossing as the dancer, Sara Rudner. Tharp found the computer the perfect vehicle to represent the noncorporeal nature of this fourth-century saint.*

*Hardware:* Digital Equipment Corporation VAX 11/780 computer. *Software:* New York Institute of Technology proprietary

arts, is more concerned with specific pictorial effects. For Krueger the interaction is always spontaneous; the performance occurs each time but in a more private realm between the participants and the system itself. Tannenbaum, on the other hand, frequently employs his system in performances for live audiences. In the installations, such as *Recollections* (which he developed at the Exploratorium in San Francisco in 1982 and a version of which is now permanently installed at the Science Museum in Queens, New York), the participants interact with it according to a preprocessed program, and their movements are spontaneous. In performance, the movements are carefully choreographed with the visual effects. Tannenbaum controls a more complex range of visual effects in real time as the dancer performs.

In lavish productions or on off-off Broadway, computer technology is playing an increasingly prominent role. Within the confines of preset parameters, computers encourage a surprising degree of improvisation. As performers, collaborators, or special effects devices, they are altering our theatrical experiences as radically as they are altering every other aspect of our creative and art-viewing lives.

148. Darryl Sapien, Betsy Erickson (choreographer), and the San Francisco Ballet. Dancers: Zoltan Peter, Carmela Zeggarelli, Kirk Peterson, Evelyn Cisneros, Mark Silver, Victoria Morgan. *Pixellage.* 1983. Performance of the San Francisco Ballet. Photograph by Lloyd Englert

Pixellage *was the first time that computer-generated imagery was combined with live performers in an opera house. Working on an Aurora Systems computer, which was lent to him for this project, video-performance artist Darryl Sapien created an eighteen-minute animation based on the theme of coexistence between humans and computers, which was projected on a screen behind the performers as they danced. Both the movements of the dancers and the orchestration of the music were carefully synchronized with the computer animation.*

*Hardware:* Aurora Systems computer, Dunn film recorder. *Software:* by Tom Hahn

# Notes

## CHAPTER I

1. Nam June Paik, interview with Cynthia Goodman, 11 November 1986.
2. Milton Komisar, interview with Cynthia Goodman, 25 January 1987.
3. Thomas DeFanti, "Foreword," in Robert Rivlin, *The Algorithmic Image: Graphic Visions of the Computer Age* (Redmond, Washington: Microsoft Press, 1986), p. xi.
4. Alvy Ray Smith, quoted in Philip Elmer, "The Love of Two Desk Lamps," *Time*, 1 September 1986, p. 66.
5. These questions were among those posed by moderator Joan Truckenbrod at a panel on "The Aesthetics of Computer Art" at the August 1986 meeting in Dallas of the Special Interest Group for Graphics of the Association for Computing Machinery (SIG-GRAPH). The other participants on this panel were the author, Darcy Gerbarg, and Russell Gant.

## CHAPTER II

1. Douglas Davis, *Art and the Future* (New York: Praeger, 1973), p. 98. Prior to Laposky's extensive experimentation with the medium, little had been done with computer imaging. Several experimental abstract movies that featured electronic oscillograms in motion constituted the sum total of computer graphics.
2. Dale Peterson, *Genesis II* (Reston, Virginia: Reston Publishing Co., 1983), p. 68.
3. Ibid., p. 56.
4. Robert Rivlin, *The Algorithmic Image: Graphic Visions of the Computer Age* (Redmond, Washington: Microsoft Press, 1986), p. 15.
5. Ibid., p. 14.
6. Russell A. Kirsch, letter to Cynthia Goodman, 16 October 1985. For more information, see R. A. Kirsch, L. Cahn, C. Ray, and G. H. Urban, "Experiments in Processing Pictorial Information with a Digital Computer," in *Proceedings of the Eastern Joint Computer Conference* (New York: The Institute of Radio Engineers, 1957). pp. 221–29.

7. Rivlin, *The Algorithmic Image*, p. 19.
8. Ibid., p. 28.
9. A. Michael Noll, interview with Cynthia Goodman, October 1986.
10. "Computer-Generated Pictures," *Time*, 23 April 1965.
11. "Computer-Generated Pictures," *The New York Herald Tribune*, 10 April 1965.
12. Stewart Preston, "Reputations Made and in Making," *The New York Times*, 18 April 1965.
13. Noll, letter to Leslie Mezei, quoted in Leslie Mezei and Arnold Rockman, "The Electronic Computer as an Artist," *Canadian Art*, November 1964, p. 366.
14. Ibid., p. 5.
15. Noll, "Human or Machine? A Subjective Comparison of Piet Mondrian's *Composition with Lines* and a Computer-Generated Picture," *The Psychological Record*, January 1966, p. 9.
16. Meyer Schapiro, *Modern Art, 19th and 20th Centuries: Selected Papers* (New York: George Braziller, 1978), pp. 253–54.
17. See also Noll, "Choreography and Computers," *Dance Magazine*, January 1967; M. C. King, A. M. Noll, and D. H. Berry, "A New Approach to Computer-Generated Holography," *Applied Optics*, February 1970, pp. 417–75.
18. Leslie Mezei, "Electronic Computer: New Tool for the Artist," *Arts Canada*, February 1967, p. 109.
19. Ibid.
20. Robert Rauschenberg, quoted in Lawrence Alloway, *Robert Rauschenberg* (Washington, D.C.: National Collection of Fine Arts, 1977), p. 17.
21. Alex Hay, quoted in Simone Whitman, "Theatre and Engineering: An Experiment," *Artforum*, February–April 1967, p. 29.
22. Rauschenberg, quoted in Henry Lieberman, "Art and Science Proclaim Alliance in Avant-Garde Loft," *The New York Times*, 11 October 1967.
23. Billy Klüver, interview with Cynthia Goodman, January 1984. Other organizations, modeled on E.A.T., were also founded. One of the most active was C.A.S.T. (Collaborations in Art, Science, and Technology), which was organized by Joseph and Patsy

Scala in Syracuse, New York, in 1970.
24. Leon Harmon and Kenneth C. Knowlton, "Computer-Generated Pictures," in *Cybernetic Serendipity: The Computer and the Arts* (New York: Praeger, 1968), Jasia Reichardt, ed., p. 87.
25. Those who submitted these artworks included Leon Harmon, Manfred Schroeder, Kenneth C. Knowlton, Aaron Marcus, Earl Reibach, Duane Palyka, and Kurd Alsleben.
26. K. G. Pontus Hultén, *The Machine as Seen at the End of the Mechanical Age* (New York: The Museum of Modern Art, 1968), p. 190.
27. Edward Keinholz, quoted in Hultén, *The Machine*, p. 190.
28. Lowell Nesbitt, "Notes Concerning My Painting on the IBM Computer," in *Sao Paolo 9: United States of America* (Sao Paolo: Sao Paolo Biennale, 1970), p. 91.
29. Jasia Reichardt, ed., *Cybernetic Serendipity: The Computer and Art* (New York: Praeger, 1968), p. 70. The highly varied works on display included computer films by John Whitney, Sr., and Kenneth C. Knowlton; A. Michael Noll's acclaimed Mondrian experiment; several examples of Charles Csuri's transformations; computer poetry by Allison Knowles, James Tenney, and Marc Adrian; robots by Nam June Paik and Bruce Lacey; cybernetic sculptures by James Seawright, Wen-Ying Tsai, and John Billingsley; and computer-generated music.
30. Klüver, interview with Cynthia Goodman, January 1984.
31. Maurice Tuchman, *A Report on the Art and Technology Program of the Los Angeles County Museum* (Los Angeles: Los Angeles County Museum of Art, 1971), p. 9.
32. Ibid., p. 11.
33. Jack Burnham, *Software, Information Technology: Its New Meaning for Art* (New York: The Jewish Museum, 1970), p. 10.
34. It was not until the third time he exhibited this work, at Dokumenta, the international art fair in Kassel, West Germany, in 1972, that Haacke finally saw the piece realized. In this version, visitors to Dokumenta filled out forms containing twenty multiple-choice questions of a demographic and social/political nature. These questionnaires

149. Juan Downey. *J.S. Bach*. 1986. Frame from videotape

*Most of this video was shot in eastern Germany, where Bach lived. Downey, like most video artists, bases his videos on images of the real world, but he achieved the lush layering of these pictures with a digital video special-effects device.*

*Hardware:* ADO

were processed for Haacke by the Kasseler Gebietsrechenzentrum, the regional computer center of the city of Kassel, and a printout of their answers was distributed once or twice a week at the fair.

**35.** Thomas B. Hess, "Gerbils ex Machina," *ArtNews*, December 1970, p. 23.

**36.** Klüver, interview with Cynthia Goodman, December 1986.

**37.** For a full listing of these publications and events see Herbert W. Franke, *Computer Graphics-Computer Art* (New York: Verlag, 1986), pp. 105–10. Some important early additions to Franke's list include *Cybernetic Serendipity* at The Corcoran Gallery in Washington, D.C., in 1969; *The First International Festival of Computer Art* at The Kitchen in New York City in 1973; and *Interactive Sound and Visual Systems*, organized by Charles Csuri at Ohio State University in Columbus, Ohio, in 1970 (an ambitious exhibition that explored the interactive potential of film, sound, video, and light).

# CHAPTER III

**1.** Ray Bradbury, "Em Squared," in *David Em at OCCA* (Orange County, California: Orange County Center for Contemporary Art, 1984), p. 6.

**2.** Kenneth C. Knowlton, "Collaborations with Artists – A Programmer's Reflections," in *Graphic Languages*, Frieder Nake and A. Rosenfeld, eds. (typescript, 1972), p. 399.

**3.** Noll, "Art ex Machina," *IEEE Student Journal*, September 1970, p. 13.

**4.** Lillian Schwartz, interview with Cynthia Goodman, 24 October 1984.

**5.** Ruth Leavitt, interview with Cynthia Goodman, 23 January 1987.

**6.** Donald Greenberg et al., *The Computer Image: Applications of Computer Graphics* (Reading, Massachusetts: Addison-Wesley, 1982), p. 7.

**7.** Alan Saret, "From One to Infinity: The Arithmetic Harmonic," typescript, April 1986, p. 4.

**8.** Manfred Mohr, quoted in Jacqueline Lipsky, *On Art and Design* (Lincoln, Nebraska: Sheldon Memorial Art Gallery, 1983). Although Mohr's programs have three-dimensional capabilities, he utilizes them exclusively to generate two-dimensional forms.

**9.** Mohr, interview with Cynthia Goodman, 26 January 1987.

**10.** Mohr, *Divisibility* (Montreal: Galerie Gilles Gheerbrant, 1981), n. p.

**11.** Mohr, quoted in Lipsky, *On Art and Design*, n.p.

**12.** Colette Bangert and Charles Bangert, "Experiences in Making Drawings by Computer and by Hand," *Leonardo*, Winter 1974, p. 269.

**13.** Colette Bangert, in Colette Bangert and Jeff B. Bangert, "And More Questions for Our Friends," typescript, 27 February 1982, p. 5.

**14.** Enrique Castro-Cid, interview with Cynthia Goodman, 9 December 1986.

**15.** John Pearson, interview with Cynthia Goodman, 23 July 1986.

**16.** Ibid.

**17.** Pearson, "Artist's Comments," in Cynthia Goodman, *John Pearson: Paintings, Constructions 1985–86* (New York: Bertha Urdang Gallery, 1986), p. 8.

**18.** Harold Cohen, quoted in Moira Roth, "Harold Cohen on Art and the Machine," *Art in America*, September–October 1978, p. 109.

**19.** Ibid.

**20.** Harold Cohen, "Off the Shelf," *Visual Computer*, July 1986, p. 193.

**21.** Leroy Neiman, interview with Cynthia Goodman, March 1984.

**22.** Darcy Gerbarg, "Artist's Statement," typescript, 23 September 1981.

**23.** Philip Pearlstein, interview with Cynthia Goodman, 6 February 1986.

**24.** Jerry Whiteley, quoted in "IMC's Pearlstein Video Slated for Fall Release," *Video Computing*, 1 September 1984, n.p.

**25.** Pearlstein, interview with Cynthia Goodman. 5 January 1986.

**26.** Barbara Nessim, interview with Cynthia Goodman, 29 January 1987.

**27.** Rivlin, *The Algorithmic Image*, p. 165.

**28.** Thomas Porett, typescript of unpublished interview for *The New Art Examiner*, 1983, p. 2.

**29.** Ibid.

**30.** Les Levine, interview with Cynthia Goodman, 12 October 1984.

**31.** Levine, excerpt from press release (Carpenter and Hochman Gallery, New York, 1986), p. 2.

**32.** Joseph Nechvatal, "Theoretical Statement Concerning Computer/Robotic Paintings," typescript (New York: Brooke Alexander Gallery), p. 2.

# CHAPTER IV

**1.** The Goethe Institute recently circulated the exhibition *Chaos into Order* on an international tour. All the pictures in this exhibition were the outgrowth of research into fractals conducted by Heinz-Otto Peitgen and Peter H. Richter at the University of Bremen. This exhibition and the publication that accompanied it, *The Beauty of Fractals* (Berlin: Springer Verlag, 1986), greatly contributed to the popularization of the aesthetics of fractal geometry.

**2.** Phillip S. Mittelman, interview with Cynthia Goodman, 5 April 1987.

**3.** John Lewell, "Ray Tracing Goes 'Full Length,'" *Computer Pictures Magazine*, May–June 1986, p. 1.

**4.** Melvin Prueitt, quoted in "Cray on Art," *Discover*, November 1983, p. 69.

**5.** Vibeke Sorensen, quoted in *The Artist and the Computer III* (Louisville: Louisville Art Gallery, 1986), n.p.

**6.** Sorensen, interview with Cynthia Goodman, 29 January 1987.

**7.** Jaacov Agam, interview with Cynthia Goodman, December 1983.

**8.** Peter Struycken, "On My 'Free' Work," in A. van der Woud, *Struycken: Beelden en Projeten* (Otterlo: Rijksmuseum Kroller-Muller, 1977), p. 9.

**9.** Skidmore, Owings & Merrill, *Computer Capability* (Chicago: SOM, 1980), p. 8.

**10.** Ibid., p. 10.

# CHAPTER V

**1.** Norbert Wiener, quoted in Reichardt, *Cybernetic Serendipity*, p. 9.

**2.** Robert Mallary, "Computer Sculpture: Six Levels of Cybernetics," *Artforum*, May 1969.

**3.** Myron Krueger, *Artificial Reality* (Reading, Massachusetts: Addison-Wesley, 1983), pp. xii–xiii.

**4.** Jack Burnham, *Beyond Modern Sculpture* (New York: George Braziller, 1968) p. 341.

**5.** Reichardt, *Cybernetic Serendipity*, p. 45.

**6.** Jonathan Benthall, "Edward Ihnatowicz's *Senster*." *Studio International*, July 1971, p. 174.

**7.** Burnham, *Beyond Modern Sculpture*, p. 343.

**8.** Ibid., p. 344.

**9.** James Seawright, quoted in Davis, *Art and the Future*, p. 155.
**10.** Ibid.
**11.** Seawright, interview with Cynthia Goodman, 2 February 1987.
**12.** Seawright, interview with Cynthia Goodman, October 1983.
**13.** Wen-Ying Tsai, interview with Cynthia Goodman, 28 January 1986.
**14.** Wen-Ying Tsai, quoted in *Electra* (Paris: Musée d'Art Moderne, 1984), p. 166.
**15.** James Pallas, *"The Blue Wazoo," Page*, November 1977, p. 39.
**16.** Krueger, interview with Cynthia Goodman, 14 December 1986.
**17.** Krueger, *Artificial Reality*, p. 1.
**18.** Eric Staller, letter to Cynthia Goodman, 1983.

## CHAPTER VI

**1.** Edward E. Zajac, "Computer Animation: A New Scientific and Educational Tool," *Society of Motion Pictures and Television Engineers Journal*, November 1965, p. 1006.
**2.** Kenneth C. Knowlton, interview with Cynthia Goodman, 8 February 1987.
**3.** Knowlton, "Computer-Animated Movies," in Reichardt, *Cybernetic Serendipity*, p. 67.
**4.** Knowlton, "Collaborations with Artists—A Programmer's Reflections," in *Graphic Languages*, p. 399.
**5.** John Whitney, Sr. "Computer Art and the Video Picture Wall," *Art International*, September 1971, p. 35.
**6.** Whitney, quoted in IBM, *Experiments in Motion Graphics* (New York: IBM Corporation, 1969), p. 3.
**7.** Charles Csuri, interview with Cynthia Goodman, 27 January 1987.
**8.** Csuri, "Computer Graphics and Art," *IEEE Proceedings*, April 1974, p. 511.
**9.** Csuri, interview with Cynthia Goodman.
**10.** Lillian Schwartz, interview with Cynthia Goodman, September 17, 1985.
**11.** W. Mike Tyler, "3-D Images for the Film Industry," *Computer Graphics World*, July 1984, p. 64.
**12.** Nelson Max, quoted in "Computing for Art's Sake," *Science News*, 20 November 1982, p. 331.
**13.** Yoichiro Kawaguchi, *Morphogenesis* (Tokyo: JICC Publishing Co., 1985), p. 138.
**14.** David Loxton, quoted in Debra Weiner, "Test-Tube Television," *American Film*, March 1979, p. 32.
**15.** William Etra, interview with Darcy Gerbarg, December 1983.
**16.** Stephen Beck, "Video Synthesis," in *The New Television*, Douglas Davis and Allison Simmons, eds. (Cambridge, Massachusetts: MIT Press, 1977), p. 48.
**17.** Roselee Goldberg, *Performance: Live Art, 1909 to the Present* (New York: Harry N. Abrams, 1979), p. 64.
**18.** Laurie Anderson, quoted in Lynnette Taylor, *"Sharkey's Day—A New Video," Artcom*, 1984, p. 38.
**19.** Christopher Finch, *Special Effects: Creating Movie Magic* (New York: Abbeville, 1984), pp. 18–19.
**20.** Bill Kroyer, quoted in Richard Patterson, "Computer Imagery for TRON," *American Cinematographer*, August 1982, p. 803.
**21.** Gary Demos, quoted in Gene Youngblood, "A Medium Matures: The Myth of Computer Art," in SIGGRAPH '83 (Chicago: SIGGRAPH, 1983).

### Captions for pages 1–7

PAGE 1: Rebecca Allen, Computer Graphics Laboratory, New York Institute of Technology, with Steve DiPaola, Robert McDermott, (technical assistance). Front and back covers of Kraftwerk's album *Electric Café*. 1986. Cibachrome prints of computer-generated, three-dimensional models. *Hardware*: Digital Equipment Corporation VAX® 11/780 computer, Evans and Sutherland Picture System, Ikonas frame buffer. *Software*: New York Institute of Technology proprietary.

PAGES 2–3: Mick Jagger and Digital Productions. *Hard Woman*. 1985. Frame from videotape. Copyright 1985 by Promotone B.V. All rights reserved. *Hardware*: Cray X-MP® computer. *Software*: Digital Scene Simulation℠, Digital Productions proprietary.

PAGES 4–5: Mark Wilson. *CTM E20*. 1986. Plotter painting: acrylic pen on canvas, 44 × 84″. *Hardware*: IBM PC with Color/Graphics Adapter, Alphanumerics plotter. *Software*: by the artist.

PAGES 6–7: Stefan Roloff with Larry Shirley (technical assistance). *Pianopeace*. 1986. Computer-generated color Xeroxes, oil, and tempera on wood, 18½ × 60″. *Hardware*: Images II+ system, Computer Graphics Laboratories, Inc. *Software*: Images II+.

## *Photograph Credits*

# Selected Bibliography

## BOOKS, EXHIBITION CATALOGS, AND UNPUBLISHED MANUSCRIPTS

Benthall, Jonathan. *Science and Technology in Art Today.* London: Thames and Hudson, 1972.

Blinn, James. "Computer Display of Curved Surfaces." Ph.D. thesis, University of Utah, 1978.

Boettger, Susan. *Vital Signs: The Sculpture of Milton Komisar.* San Jose, California: San Jose Museum of Art, 1983.

Burnham, Jack. *Beyond Modern Sculpture.* New York: George Braziller, 1968

————. *Software, Information Technology: Its New Meaning for Art.* New York: The Jewish Museum, 1970.

————. *The Structure of Art.* New York: George Braziller, 1971.

Capron, H. L., and Brian K. Williams. *Computers and Data Processing.* Menlo Park, California: The Benjamin/Cummings Publishing Company, 1982.

Chamberlain, Marcia. *CADRE '84.* San Jose, California: San Jose State University Press, 1983.

Cohen, Harold. *Drawing.* San Francisco: San Francisco Museum of Modern Art, 1979.

————. *Harold Cohen.* Pittsburgh: Buhl Science Center, 1984.

Cohen, Harold, Becky Cohen, and Penny Nii. *The First Artificial Intelligence Coloring Book.* Los Altos, California: William Kaufman, 1984.

Coqart, Roger. *Aspecten: De Computer in de Visuele Kunst.* Brussels: Uitgever, 1981.

Csuri, Charles. *Interactive Sound and Visual Systems.* Columbus: Ohio State University Press, 1970.

————. *Real-Time Film Animation.* Columbus: Ohio State University Press, 1973.

Curtis, David. *Experimental Cinema.* New York: Delta, 1971.

Davis, Douglas. *Art and the Future.* New York: Praeger, 1973.

Deken, Joseph. *Computer Images.* New York: Stewart, Tabori, and Chang, 1983.

Dunlap, Sue. *The Computer as an Art Tool.* Greenwich, Connecticut: Hurlbutt Gallery, 1986.

Everson Museum of Art. *CAST Projects on Exhibition.* Syracuse, New York: Everson Museum of Art, 1975.

*Experiments in Motion Graphics.* New York: IBM Corporation, 1969.

Felguerez, Manuel, and Mayer Sasson. *La Maquina Estetica.* Mexico: Universidad Nacional Autonoma de Mexico, 1983.

Finch, Christopher. *Special Effects: Creating Movie Magic.* New York: Abbeville, 1984.

Foley, James D., and Andries Van Dam. *Fundamentals of Interactive Computer Graphics.* Reading, Massachusetts: Addison-Wesley, 1982.

Franke, Herbert W. *Computer Graphics, Computer Art.* Oxford, England: Phaidon, 1971. Revised edition. New York: Springer Verlag, 1986.

Giorgio, Aldo, and Wei-Chung Chen. *Interfaces.* Lafayette, Indiana: Purdue University Press, 1975.

Goodman, Cynthia. *John Pearson.* New York: Bertha Urdang Gallery, 1986.

————. *Isaac Victor Kerlow.* Mexico City: Museo de Arte Moderno, 1986.

Greenberg, Donald, Aaron Marcus, Allan Schmidt, and Vernon Gorter. *The Computer Image: Applications of Computer Graphics.* Reading, Massachusetts: Addison-Wesley, 1982.

Halas, John, and Roger Manvell. *The Technique of Film Animation.* New York: Hastings House, 1976.

Hanhardt, John. *Nam June Paik.* New York: Whitney Museum of American Art, 1982.

Hiller, Isaacson. *Experimental Music.* New York: McGraw-Hill, 1959.

Huffman, Kathy Rae. "Video Art: More Than a Decade." *Video: A Retrospective 1974–1984.* Long Beach, California: Long Beach Museum of Art, 1984.

Hultén, K. G. Pontus. *The Machine as Seen at the End of the Mechanical Age.* New York: The Museum of Modern Art, 1968.

IEEE Computer Society. *Proceedings of the Annual Symposium on Small Computers in the Arts,* 1–6. Philadelphia: IEEE Computer Society Press, 1980–86.

Kawaguchi, Yoichiro. *Morphogenesis.* Tokyo: JICC Publishing Co., 1985.

Kerlow, Victor Isaac and Judson Rosebush. *Computer Graphics for Designers and Artists.* New York: Van Nostrand Reinhold, 1986.

Kirkpatrick, Diane. *Eduardo Paolozzi.* Greenwich, Connecticut: New York Graphic Society, 1979.

Klüver, Billy, J. Martin, and Robert Rauschenberg. *Some More Beginnings: An Exhibition of Submitted Works Involving Technical Materials and Processes.* New York: Brooklyn Museum and the Museum of Modern Art and Technology, 1968.

Kranz, Stewart. *Science and Technology in the Arts.* New York: Van Nostrand Reinhold, 1974.

Krueger, Myron. *Artificial Reality.* Reading, Massachusetts: Addison-Wesley, 1983.

Kunii, Tosiyasu. *Computer Graphics: Theories and Applications.* New York: Springer Verlag, 1983.

Leavitt, Ruth. *Artist and Computer.* New York: Harmony, 1976.

Lipsky, Jacqueline, ed. *On Art and Design.* Lincoln: Sheldon Memorial Art Gallery, 1983.

Magnenat-Thalman, Nadia, and Daniel Thalman. *Computer Animation.* New York: Springer Verlag, 1985.

Malina, F. *Visual Art, Mathematics and Computers.* Elmsford, New York: Pergamon, 1979.

Marcus, Aaron. *Soft Where, Inc.: The Work of Aaron Marcus.* Reno, Nevada: West Coast Poetry Review, 1975.

Meyers, Roy. *Microcomputer Graphics.* Reading, Massachusetts: Addison-Wesley, 1982.

Mohr, Manfred. *Divisibility.* Montreal: Galerie Gilles Gheerbrant, 1981.

————. *Divisibility II.* Koln: Galerie Teufel Koln, 1985.

————. *Divisibility III.* Stuttgart: Galerie D + C Mueller Roth, 1987.

————. *Generative Drawings.* Paris: Galerie Weiller, 1977.

————. *Dimensions.* Stuttgart: Galerie D + C Mueller Roth, 1979.

————. *Computer Graphics.* Paris: Musée d'Art Moderne, 1971.

Nees, George. *Generative Computergraphik.* Berlin and Munich: Siemens AG, 1969.

Newman, W. M., and R. F. Sproull. *Principles of Interactive Computer Graphics.* New York: McGraw-Hill, 1973.

150. Leon Harmon and Kenneth Knowlton. *Studies in Perception: Gargoyle.* 1967. Photograph, 8½ × 11″

Peitgen, H. O., and P. H. Richter. *The Beauty of Fractals.* New York: Springer Verlag, 1986.

Popper, Frank. *Electra.* Paris: Musée d'Art Moderne de la Ville de Paris, 1984.

Prueitt, Melvin. *Computer Graphics.* New York: Dover, 1975.

————. *Art and the Computer.* New York: McGraw-HIll, 1984.

Reichardt, Jasia. *The Computer and Art.* New York: Van Nostrand Reinhold, 1971.

————. *Cybernetic Serendipity.* New York: Praeger, 1968.

————. *Cybernetics, Art and Ideas.* Greenwich, Connecticut: New York Graphic Society, 1971.

Rhodes, Lynette I. *Science Within Art.* Bloomington: Indiana University Press, 1980.

Rieser, Dolf. *Art and Science.* New York: Van Nostrand Reinhold, 1972.

Rivlin, Robert. *The Algorithmic Image.* Redmond, Washington: Microsoft Press, 1986.

Rogers, David F., and Alan Adams. *Mathematical Elements for Computer Graphics.* New York: McGraw-Hill, 1976.

Russett, Robert, and Cecile Starr. *Experimental Animation.* New York: Van Nostrand Reinhold, 1976.

Sanders, Donald. *Computers in Society.* New York: McGraw-Hill, 1977.

Sheridan, Sonia Landy. *Energized Artscience.* Chicago: Museum of Science and Industry, 1978.

SIGGRAPH. *SIGGRAPH.* 6 vols (annual art show catalogues). Chicago: SIGGRAPH, 1981–86.

Signh, Jagit. *Great Ideas in Information Theory.* New York: Dover, 1966.

*The Silicon Valley Festival of Electronic Art.* San Jose, California: The Cadre Institute, 1986.

Smith, Cyril Stanley. *From Art to Science.* Cambridge, Massachusetts: MIT Press, 1980.

Smith, Thomas G. *Industrial Light and Magic: The Art of Special Effects.* New York: Ballantine Books, 1986.

Struycken, Peter. *Beelden en Projecten.* Otterlo: Rijksmuseum Kroller-Muller, 1977.

————. *Structuur, Verscheidenheid en Verandering.* Groningen, The Netherlands: Groningen Museum, 1984.

————. *Structuur-Elementen 1969–1980.* Stuttgart: Deutsches Verlag, 1968.

Sumner, Lloyd. *Computer Art and the Human Response.* Charlottesville, Virginia: Paul B. Victorius, 1968.

Tuchman, Maurice. *A Report on the Art and Technology Program of the Los Angeles County Museum of Art.* Los Angeles: Los Angeles County Museum of Art, 1971.

Waite, Mitchell. *Computer Graphics Primer.* Indianapolis, Indiana: Howard W. Sams, 1979.

Warren, Lynne. *John Kessler.* Chicago: Museum of Contemporary Art, 1986.

Whitney, John, Sr. *Digital Harmony.* Peterborough, New Hampshire: Byte Books, McGraw-Hill, 1980.

Wiener, Norbert. *Cybernetics, or Control and Communication in the Animal and Machine.* Cambridge, Massachusetts: MIT Press, 1948.

Williams, Roberta. *The Artist and the Computer.* Louisville, Kentucky: Louisville Art Gallery, 1985.

Youngblood, Gene. *Expanded Cinema.* London: Studio Vista, 1970.

Zientara, Marguerite. *The History of Computing.* Framingham, Massachusetts: CW Communications, 1981.

## ARTICLES

*(Abbreviations of technical journal titles are standard CASSI references.)*

Abramson, Dan. "Computer-Controlled Effects." *VideoPro*, September 1983, pp. 25–29.

Ahl, David H. "Art and Technology." *Creative Computing*, October 1979, pp. 74–75.

Akchin, Don. "High-Tech Is Invading the Art World." *USA Today*, 1 August 1983, pp. 1–2.

Ancona, Victor. "Shalom Gorewitz: Metaphoric Image Manipulator." *Videography Magazine*, November 1980, n.p.

————. "Vibeke Sorensen: Demystifying Video Technology." *Videography Magazine*, February 1979, pp. 66–68.

Anderson, John. "Movie Maker." *Creative Computing*, April 1984, pp. 106–115.

Ansen, David. "When You Wish upon a 'Tron.'" *Newsweek*, 5 July 1982, pp. 64–68.

Atkins, Neal, and Enrique Castro-Cid. "A Homebrew Graphics Digitizer." *BYTE*, February 1982, pp. 72–86.

Badler, Norman, and Timothy W. Finin. "Computer Graphics and Expert Systems." *IEEE Proceedings*, November 1985, pp. 25–27.

Baecker, Ron. "Digital Video Displays and Dynamic Graphics." *Computer Graphics*, August 1979, pp. 48–56.

Bangert, Colette, and Charles Bangert. "Experiences in Making Drawings by Computer and by Hand." *Leonardo*, Winter 1974, pp. 289–296.

Begley, Sharon. "The Creative Computers." *Newsweek*, 5 July 1982, pp. 58–62.

Benthall, Jonathan. "Anatomy and Anomaly." *Studio International*, July–December 1971, pp. 63–64.

————. "Technology and Art 15: Computer Graphics at Brunel." *Studio International*, January–June 1970, pp. 246–249.

Bernard, April, and Mimi Thompson. "Video Tunes In." *Vanity Fair*, February 1984, pp. 30–31.

Blair, Iain. "Computer-Generated Imagery." *On Location*, February 1983, pp. 102–106.

Borrell, Jerry. "Computer Graphics. Beat the Drum . . . Slowly." *Business Screen*, 19 December, 1980, pp. 42–45.

Burnham, Jack. "Problems of Criticism." *Artforum*, January 1971, pp. 40–45.

Buxton, William. "The Role of the Artist in the Laboratory: Computer-Assisted Filmmaking." *American Cinematographer*, August 1982, n.p.

————. "Computers as Artists." *Discover Magazine*, January 1980, n.p.

Caruso, Denise. "Computerized Choreography." *InfoWorld*, 5 March 1984, pp. 29–30.

Catmull, Edwin. "A Hidden-Surface Algorithm with Anti-Aliasing." *Computer Graphics*, August 1978, pp. 6–10.

Chandler, John. "Art and Automata." *Arts Magazine*, December–

January 1969, pp. 42–45.

Charbonnier, Georges. "L'ordinateur l'art." *Connaissance des Arts*, February 1974, pp. 70–75.

Cohen, Harold. "Computer Response." *Art in America*, September 1972, p. 31.

——. "On Purpose: An Enquiry into the Possible Roles of the Computer in Art." *Studio International*, January 1974, pp. 9–16.

——. "Three Behaviors for the Partitioning of Space." *Art International*, May 1972, pp. 24–25.

Cook, R. L., and K. E. Torrence. "A Reflectance Model for Computer Graphics." *Computer Graphics*, August 1981, pp. 307–316.

Cooper, Ann. "Special Effects Powerhouse." *Advertising Age*, 30 May 1985, pp. 5–9.

Cornock, Stroud, and Ernest Edmonds. "The Creative Process Where the Artist Is Amplified or Superseded by the Computer." *Leonardo*, Winter 1973, pp. 11–16.

Crow, F. C. "Shadow Algorithms for Computer Graphics." *Computer Graphics*, Summer 1977, pp. 242–248.

Csuri, Charles. "Computer Graphics and Art." *IEEE Proceedings*, April 1974, pp. 503–515.

Cuba, Larry. "The Rules of the Game." *Arts Review*, September 1979, pp. 52–55.

Cuttance, Chris. "Computers and Art." *EFE*, March–April 1979, pp. 26–30.

Davis, Douglas. "Art and Technology—The New Combine." *Art in America*, January–February 1968, pp. 28–47.

DeFanti, Thomas. "The Digital Component of the Circle Graphics Habitat." *NCC Proceedings*, 1976, pp. 195–203.

——. "Language Control Structures for Easy Electronic Visualization." *BYTE*, November 1980, pp. 90–106.

Denes, Agnes. "Politics." *Artforum*, December 1970, p. 37.

DeVoss, David. "A Sizzling New Sell." *The Los Angeles Times Magazine*, 11 May 1986.

Dewar, Robert. "Computer Art: Sculptures of Polyhedral Networks Based on an Analogy to Crystal Structures Involving Hypothetical Carbon Atoms." *Leonardo*, Spring 1982, pp. 96–103.

Dietrich, Frank. "Visual Intelligence: The First Decade of Computer Art (1965–1975)." *IEEE Proceedings*, July 1985, pp. 33–45.

Dietrich, Frank, and Zsuzanna Molnar. "Pictures by Funny Numbers." *Creative Computing*, June 1981, n.p.

Emmett, Arielle. "Universal Studios' Computer Graphics." *Computer Graphics World*, February 1986, pp. 26–32.

Etra, Bill. "Colorizers Come of Age." *Videography*, April 1979, pp. 30–33.

Fiori, Bob, and Barbara Javis. "Software Battle." *Artforum*, November 1970, pp. 41–42.

Franke, H. W., ed. "Computer Graphics—Computer Art." *The Visual Computer*, July 1986, entire issue.

——. "The New Visual Age: The Influence of Computer Graphics on Art and Society." *Leonardo*, Spring 1985, pp. 105–107.

Furlong, Lucinda. "Color My World." *AfterImage*, October 1982, pp. 18–20.

——. "A Manner of Speaking: An Interview with Gary Hill." *AfterImage*, March 1983, pp. 9–16.

——. "Notes Toward a History of Image-Processed Video." *AfterImage*, December 1983, pp. 12–17.

Gardner, Paul. "Think of Leonardo Wielding a Pixel and a Mouse." *The New York Times*, 22 April 1984.

Giloth, Copper, and Jane Veeder. "The Paint Problem." *IEEE CG&A*, July 1985, pp. 66–75.

Gouraud, H. "Computer Display of Curved Surfaces." *IEEE Transactions on Computers*, June 1971, pp. 623–628.

Hachem, Damir. "A Time for Fusion of Technology and Style." *Millimeter Magazine*, February 1983, n.p.

Hagen, Charles. "Breaking the Box: The Electronic Operas of Robert Ashley and Woody Vasulka." *Artforum*, March 1985, pp. 54–59.

Halas, John. "Animation: Its Scope Today." *Animafilm 1* (Warsaw, Poland), October–December 1978, n.p.

Haller, Robert. "Camera Eye: The Vasulka." *American Film*, December 1981, pp. 27–30.

Harries, John. "Personal Computers and Noted Visual Art." *Leonardo*, Autumn 1981, pp. 299–301.

Hart, Claudia. "Electronic Spirits." *Industrial Design*, January–February 1985, pp. 46–51.

Helmick, Richard. "The Unlikely Birth of a Computer Artist." *ROM*, October 1977, pp. 55–58.

Hill, Anthony. "Art and Mathesis: Mondrian's Structures." *Leonardo*, July 1968, pp. 233–241.

Hockenhull, James. "Courting the Digital Muse—With a Little Help from Microspeed." *Creative Computing*, February 1982, pp. 84–94.

Hornbacher, Sara, ed. "Video: The Reflexive Medium." *Art Journal*, Fall 1985, entire issue.

Hutchenson, David. "The Digital Brush." *Creative Computing*, May–June 1978, pp. 97–99.

Johns, Alison. "Special Effects Artists: Part II." *Millimeter*, October 1986, pp. 201–210.

Johnson, Rory. "Computer Is Leading Artists into New Trains of Thought." *Computer Weekly*, 26 February 1981, n.p.

Kagan, Andrew. "Ben Laposky: A Midwestern Pioneer of Absolute Light Form." *Arts Magazine*, June 1980, pp. 125–127.

Kawaguchi, Yoichiro. "A Morphological Study of the Form of Nature." *ACM SIGGRAPH '82 Conference Proceedings*, 1982, pp. 223–232.

# List of Artists

*The following artists have examples of their work represented in the book.*

Abel, Robert (American, b. 1936)
Allen, Rebecca (American, b. 1953)
Agosti, Jean-Paul (French, b. 1948)
Anderson, Laurie (American, b. 1947)
Armajani, Siah (American, b. Iran, 1939)
Bangert, Charles J. (American, b. 1938)
Bangert, Colette (American, b. 1934)
Barbadillo, Manuel (Spanish, b. 1929)
Bartlett, Jennifer (American, b. 1943)
Bender, Gretchen (American, b. 1951)
Blinn, James (American, b. 1948)
Borofsky, Jonathan (American, b. 1942)
Burson, Nancy (American, b. 1948)
Castro-Cid, Enrique (Chilean, b. 1937)
Chase, Doris (American, b. 1923)
Cohen, Harold (British, b. 1928)
Collery, Michael (American, b. 1954)
Csuri, Charles (American, b. 1922)
Cuba, Larry (American, b. 1950)
Davis, Douglas (American, b. 1933)
Davis, Ronald (American, b. 1937)
DeFanti, Thomas (American, b. 1948)
DeWitt, Thomas (American, b. 1944)
Downey, Juan (Chilean, b. 1940)
Duru, Jean-Noël (French, b. 1951)
Earls, Paul (American, b. 1934)
Em, David (American, b. 1953)
Emshwiller, Ed (American, b. 1925)
Etra, William (American, b. 1947)
Falk, Gary (American, 1954–1986)
Garrard, Mimi (American)
Gerbarg, Darcy (American, b. 1949)
Gianakos, Steven (American, b. 1938)
Haring, Keith (American, b. 1958)
Harmon, Leon (American, b. 1922)
Hill, Gary (American, b. 1951)
Hockney, David (British, b. 1937)
Hodgkin, Howard (British, b. 1932)
Holzer, Jenny (American, b. 1950)
Huitric, Hervé (French, b. 1945)
Kawaguchi, Yoichiro (Japanese, b. 1952)
Kerlow, Isaac Victor (Mexican, b. 1958)
Kessler, Jon (American, b. 1957)
Kienholz, Edward (American, b. 1927)
Knowlton, Kenneth C. (American, b. 1931)
Komisar, Milton (American, b. 1935)
Krueger, Myron (American, b. 1942)
Laposky, Ben F. (American, b. 1914)
Leavitt, Ruth (American, b. 1944)
Levine, Les (Irish, b. 1936)

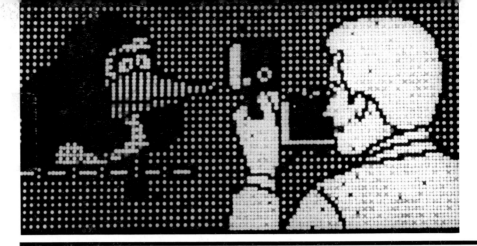

151. Steven Gianakos. *Messages to the Public*. Spectacolor light board. Courtesy Public Art Fund, Inc.

*Hardware:* Spectacolor light board. *Software:* Spectacolor

Lindquist, Mark (American, b. 1958)
Lipski, Donald (American, b. 1947)
Lovejoy, Margot (Canadian, b. 1930)
Mallary, Robert (American, b. 1917)
Max, Nelson (American, b. 1943)
Miller, Steve (American, b. 1951)
Miss, Mary (American, b. 1944)
Mohr, Manfred (German, b. 1938)
Nahas, Monique (French, b. 1940)
Nake, Frieder (German, b. 1938)
Nauman, Bruce (American, b. 1941)
Nechvatal, Joseph (American, b. 1953)
Nees, George (German, b. 1926)
Nesbitt, Lowell (American, b. 1933)
Nessim, Barbara (American, b. 1939)
Nolan, Sir Sidney (Australian, b. 1917)
Noland, Kenneth (American, b. 1924)
Noll, A. Michael (American, b. 1939)
O'Rourke, Michael (American, b. 1947)
Paik, Nam June (Korean, b. 1932)
Pallas, James (American, b. 1941)
Paschke, Ed (American, b. 1939)
Pearlstein, Philip (American, b. 1924)
Pearson, John (American, b. England, 1940)
Piene, Otto (American, b. Germany, 1928)
Porett, Thomas (American, b. 1942)
Prueitt, Melvin (American, b. 1932)
Rath, Alan (American, b. 1959)
Rauschenberg, Robert (American, b. 1925)
Resch, Ronald (American, b. 1939)
Rivers, Larry (American, b. 1925)
Robbin, Tony (American, b. 1943)
Roloff, Stefan (German, b. 1953)
Sanborn, John (American, b. 1954)

Sandin, Dan (American, b. 1942)
Sapien, Darryl (American, b. 1950)
Saret, Alan (American, b. 1944)
Schapiro, Miriam (American, b. Canada, 1923)
Schwartz, Lillian (American, b. 1927)
Sciulli, Michael (American, b. 1956)
Seawright, James (American, b. 1936)
Sheridan, Sonia Landy (American, b. 1925)
Shevitz, Mimi (American, b. 1953)
Slayton, Joel (American, b. 1954)
Sletten, Byron (American, b. 1952)
Snelson, Kenneth (American, b. 1927)
Sorensen, Vibeke (American, b. 1954)
Staller, Eric (American, b. 1947)
Stenger, Nicole (French, b. 1947)
Struycken, Peter (Dutch, b. 1939)
Sutherland, Ivan (American, b. 1938)
Tannenbaum, Ed (American, b. 1953)
Truckenbrod, Joan (American, b. 1945)
Tsai, Wen-Ying (American, b. China, 1928)
VanDerBeek, Stanley (American, 1927–1984)
Vasulka, Woody (Icelandic, b. Czechoslovakia, 1937)
Voss, Richard (American, b. 1948)
Warhol, Andy (American, 1930–1987)
White, Melissa (American, b. 1951)
Whitney, James (American, 1922–1982)
Whitney, John, Sr. (American, b. 1917)
Wilson, Mark (American, b. 1943)
Winkler, Dean (American, b. 1957)
Youngerman, Jack (American, b. 1926)
Zajac, Edward E. (American, b. 1926)